HOW TO DRAW MANGA

Costume Encyclopedia Vol. 2
Intimate Apparel

HOW TO DRAW MANGA:
Costume Encyclopedia Vol. 2
Intimate Apparel
by Hikaru Hayashi & Kimiko Morimoto

This book was first designed and published in 2002 by Graphic-sha Publishing Co., Ltd.
This English edition was published in 2005 by
Graphic-sha Publishing Co., Ltd.
1-14-17 Kudan-kita, Chiyoda-ku, Tokyo 102-0073 Japan

Drawing & Production: Takehiko Matsumoto, Naoko Matsumoto, Kazuaki Morita,
 Kozue Onishi, Rio Yagizawa, Haruto, Midori Satowo
 Hiroko Shioda, Masatoshi Ota, Yukako Ishizawa, Yasuo Matsumoto
Cover Drawing & Coloring: Kazuaki Morita, Kimiko Morimoto
Scenario & Composition: Hikaru Hayashi & Kimiko Morimoto (Go Office)
Production Assistance: Takumi Takahashi, Kozue Onishi
Production Cooperation: Hiroko Nire, Morio Harada, Kento Shimazaki, Shigeru Sakata
English Title Logo Design: Hideyuki Amemura
English Edition Layout: Shinichi Ishioka
English Translation Management: Língua fránca, Inc. (an3y-skmt@asahi-net.or.jp)
Japanese Edition Editor: Motofumi Nakanish (Graphic-sha Publishing Co., Ltd.)
Foreign Language Edition Project Coordinator: Kumiko Sakamoto (Graphic-sha Publishing Co., Ltd.)

First printing: January 2005

ISBN: 4-7661-1433-7
Printed and bound in China

HOW TO DRAW MANGA

Costume Encyclopedia Vol. 2
Intimate Apparel

How to make the most of this book

Use this book to create designs the way you imagined them.

Feminine Fashions

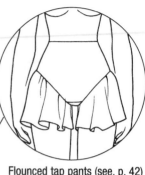

The key to a garment's design or shape is not to become blindly rooted in "function"—for example, in the case of "pants," not to think of them solely as "something worn on the legs," but rather, to take careful note of the shape and silhouette—to start with the shape and let your imagination run.

An early brassiere from the 1910s (see p. 201)

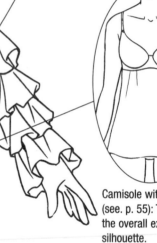

Flounced tap pants (see. p. 42)

Camisole with under bra (see. p. 55): This affects the overall exterior silhouette.

Long, feminine slip (see p. 148): I used the ruffle design you see here in the model character.

Use frills and ruffles when seeking to achieve a feminine look.

Long-sleeved, ruffled nightgown (see. p. 148). I applied the same shape and texture of the gown (i.e. overall silhouette) to the pant legs.

Here, I used the same flounces on the tap pants above for the hem of the pants and matched them with the sleeves.

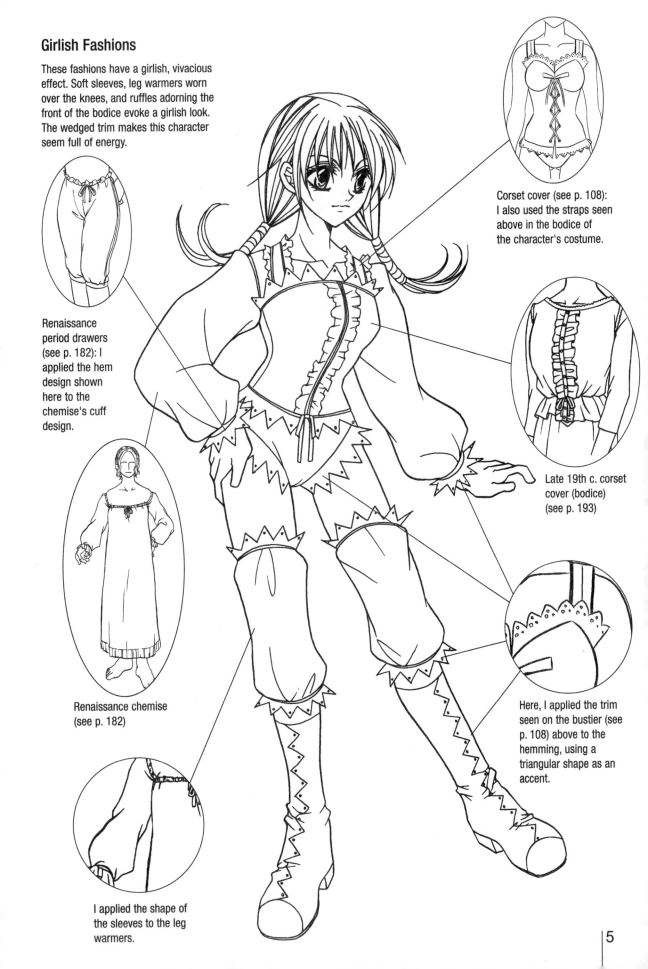

Girlish Fashions

These fashions have a girlish, vivacious effect. Soft sleeves, leg warmers worn over the knees, and ruffles adorning the front of the bodice evoke a girlish look. The wedged trim makes this character seem full of energy.

Corset cover (see p. 108): I also used the straps seen above in the bodice of the character's costume.

Renaissance period drawers (see p. 182): I applied the hem design shown here to the chemise's cuff design.

Late 19th c. corset cover (bodice) (see p. 193)

Renaissance chemise (see p. 182)

Here, I applied the trim seen on the bustier (see p. 108) above to the hemming, using a triangular shape as an accent.

I applied the shape of the sleeves to the leg warmers.

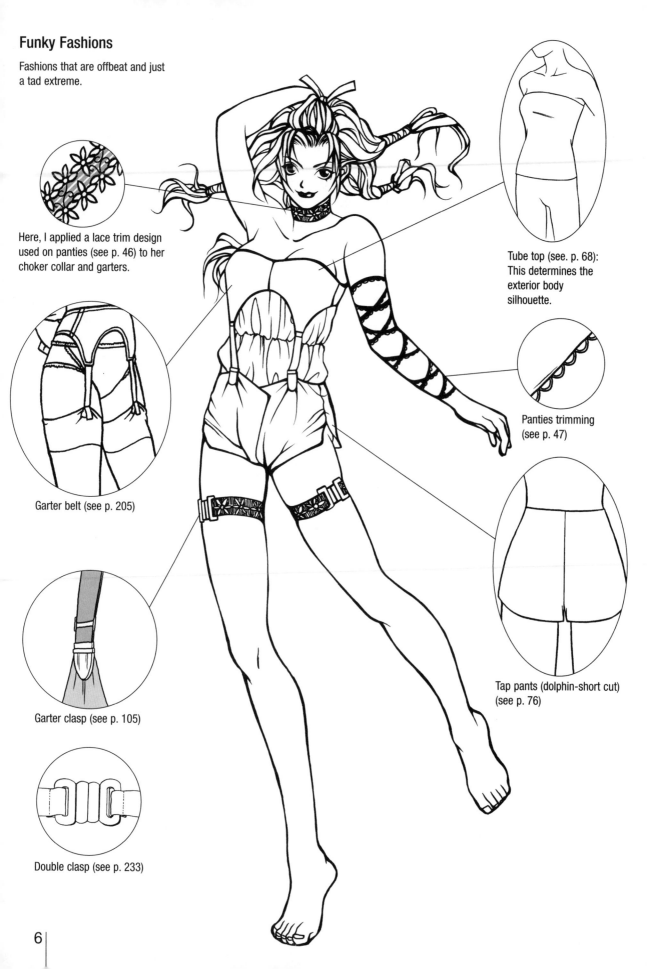

Funky Fashions

Fashions that are offbeat and just a tad extreme.

Here, I applied a lace trim design used on panties (see p. 46) to her choker collar and garters.

Garter belt (see p. 205)

Garter clasp (see p. 105)

Double clasp (see p. 233)

Tube top (see. p. 68): This determines the exterior body silhouette.

Panties trimming (see p. 47)

Tap pants (dolphin-short cut) (see p. 76)

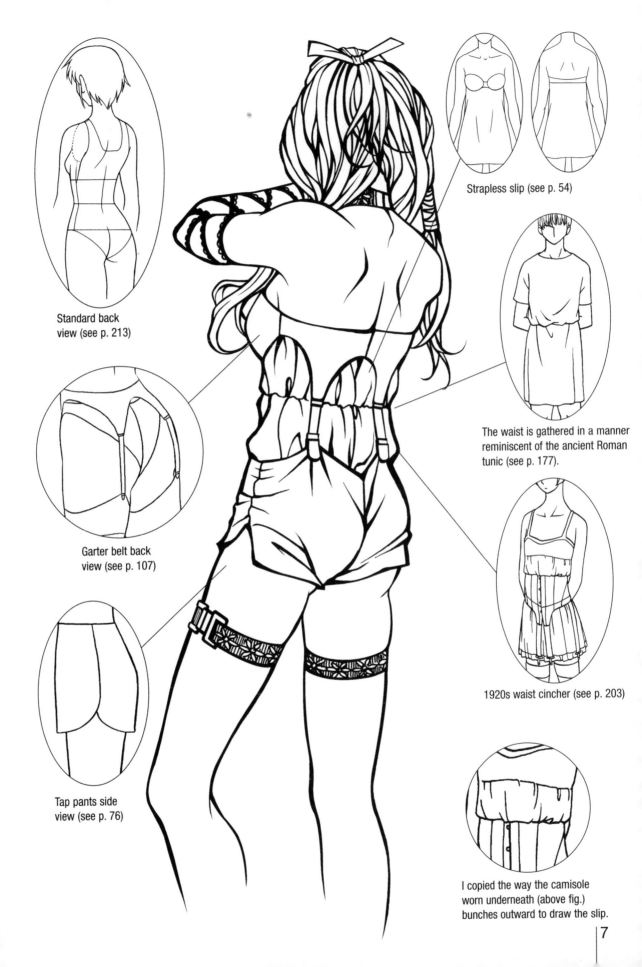

Standard back
view (see p. 213)

Garter belt back
view (see p. 107)

Tap pants side
view (see p. 76)

Strapless slip (see p. 54)

The waist is gathered in a manner
reminiscent of the ancient Roman
tunic (see p. 177).

1920s waist cincher (see p. 203)

I copied the way the camisole
worn underneath (above fig.)
bunches outward to draw the slip.

Common Fashions

Undergarment designs can also be used to create everyday fashions.

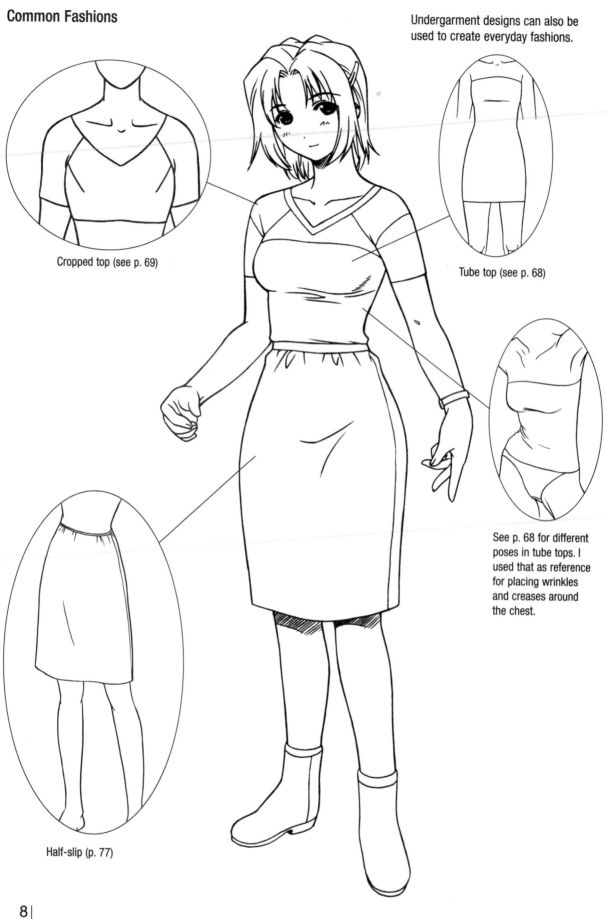

Cropped top (see p. 69)

Tube top (see p. 68)

Half-slip (p. 77)

See p. 68 for different poses in tube tops. I used that as reference for placing wrinkles and creases around the chest.

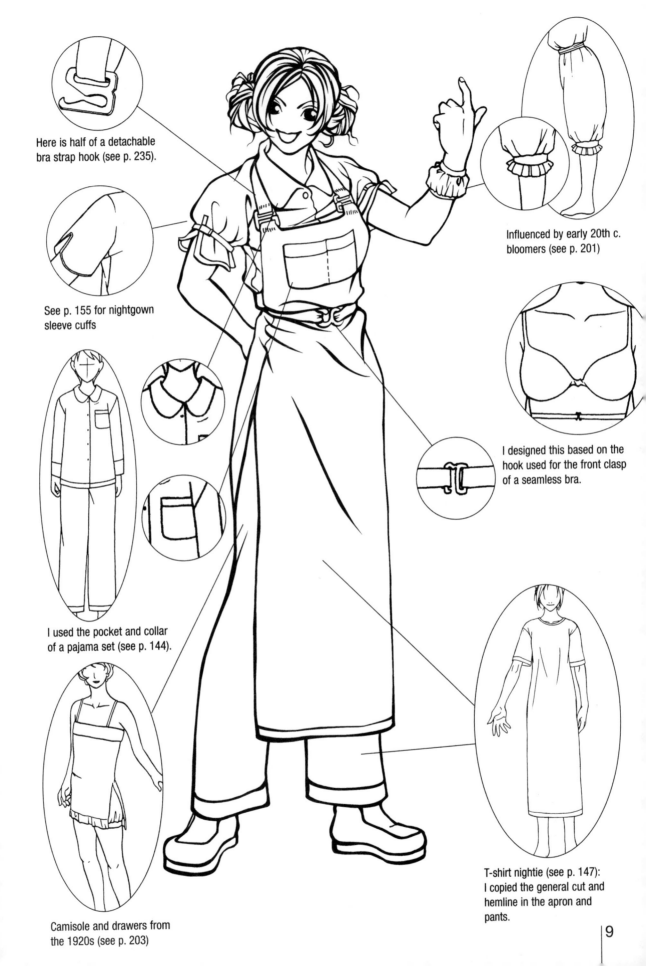

Here is half of a detachable bra strap hook (see p. 235).

See p. 155 for nightgown sleeve cuffs

I used the pocket and collar of a pajama set (see p. 144).

Camisole and drawers from the 1920s (see p. 203)

Influenced by early 20th c. bloomers (see p. 201)

I designed this based on the hook used for the front clasp of a seamless bra.

T-shirt nightie (see p. 147): I copied the general cut and hemline in the apron and pants.

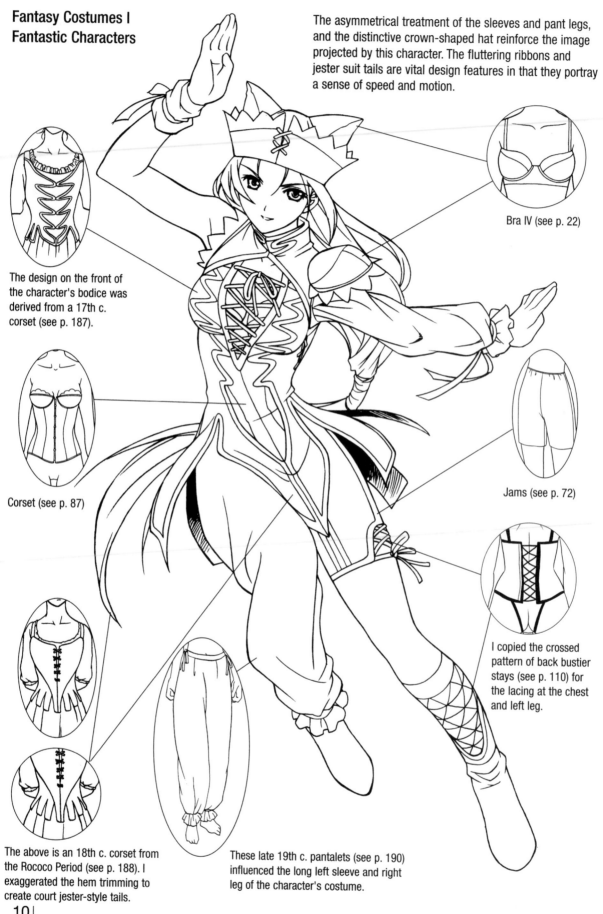

Fantasy Costumes I
Fantastic Characters

The asymmetrical treatment of the sleeves and pant legs, and the distinctive crown-shaped hat reinforce the image projected by this character. The fluttering ribbons and jester suit tails are vital design features in that they portray a sense of speed and motion.

Bra IV (see p. 22)

The design on the front of the character's bodice was derived from a 17th c. corset (see p. 187).

Corset (see p. 87)

Jams (see p. 72)

I copied the crossed pattern of back bustier stays (see p. 110) for the lacing at the chest and left leg.

The above is an 18th c. corset from the Rococo Period (see p. 188). I exaggerated the hem trimming to create court jester-style tails.

These late 19th c. pantalets (see p. 190) influenced the long left sleeve and right leg of the character's costume.

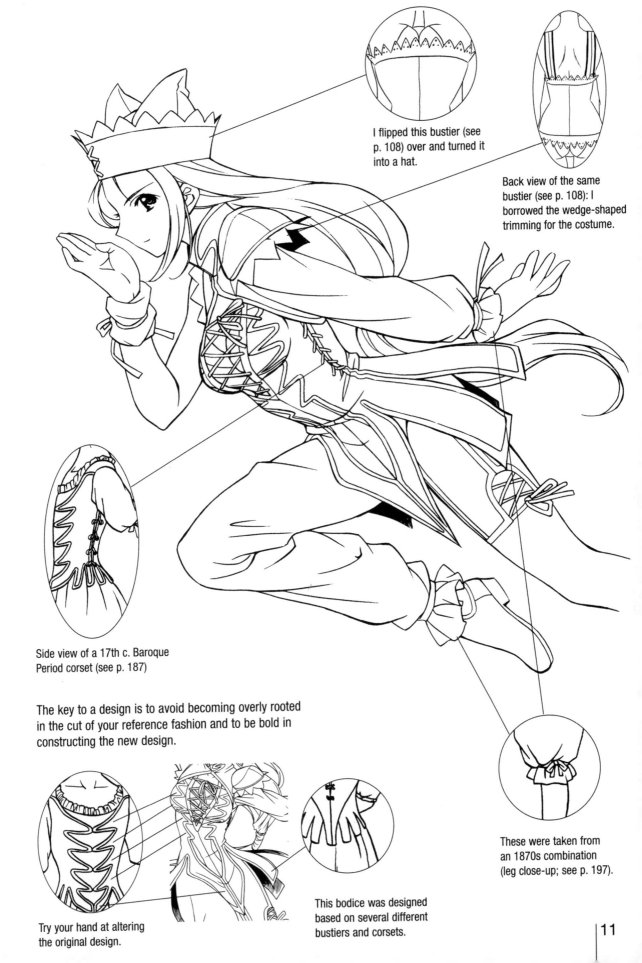

I flipped this bustier (see p. 108) over and turned it into a hat.

Back view of the same bustier (see p. 108): I borrowed the wedge-shaped trimming for the costume.

Side view of a 17th c. Baroque Period corset (see p. 187)

The key to a design is to avoid becoming overly rooted in the cut of your reference fashion and to be bold in constructing the new design.

These were taken from an 1870s combination (leg close-up; see p. 197).

Try your hand at altering the original design.

This bodice was designed based on several different bustiers and corsets.

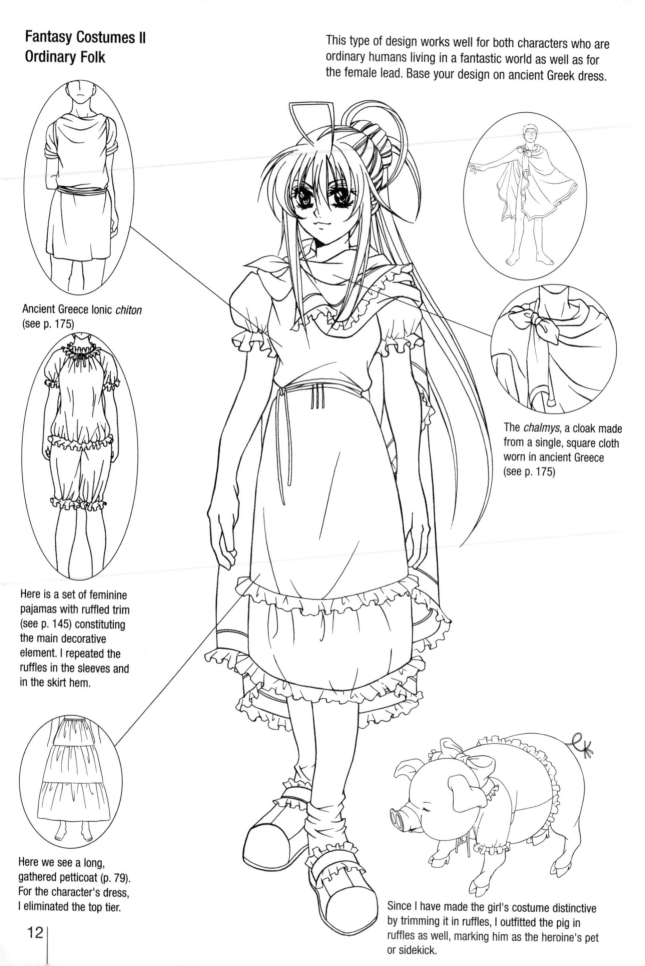

Fantasy Costumes II
Ordinary Folk

This type of design works well for both characters who are ordinary humans living in a fantastic world as well as for the female lead. Base your design on ancient Greek dress.

Ancient Greece Ionic *chiton*
(see p. 175)

Here is a set of feminine pajamas with ruffled trim (see p. 145) constituting the main decorative element. I repeated the ruffles in the sleeves and in the skirt hem.

The *chalmys*, a cloak made from a single, square cloth worn in ancient Greece (see p. 175)

Here we see a long, gathered petticoat (p. 79). For the character's dress, I eliminated the top tier.

Since I have made the girl's costume distinctive by trimming it in ruffles, I outfitted the pig in ruffles as well, marking him as the heroine's pet or sidekick.

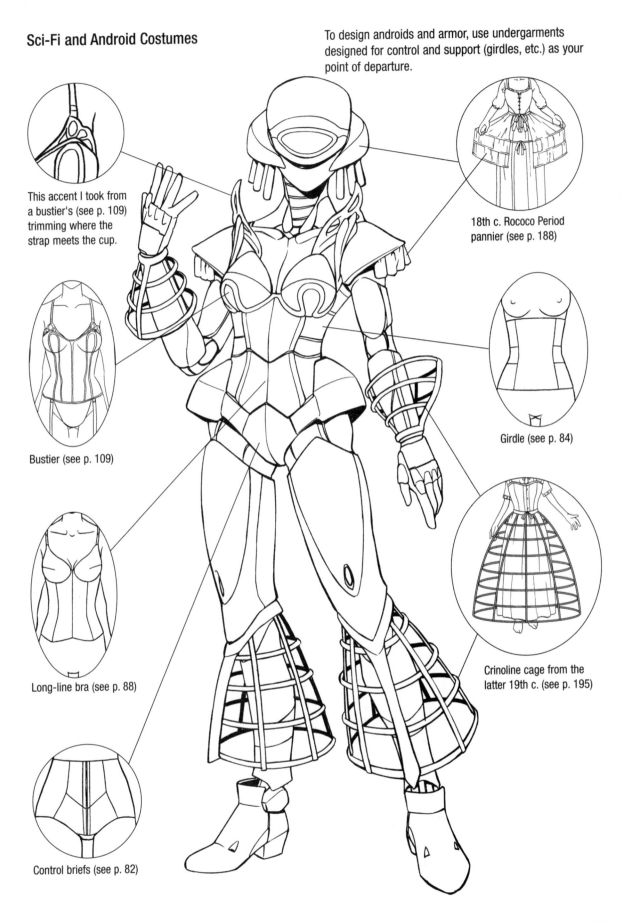

Sci-Fi and Android Costumes

To design androids and armor, use undergarments designed for control and support (girdles, etc.) as your point of departure.

This accent I took from a bustier's (see p. 109) trimming where the strap meets the cup.

18th c. Rococo Period pannier (see p. 188)

Bustier (see p. 109)

Girdle (see p. 84)

Long-line bra (see p. 88)

Crinoline cage from the latter 19th c. (see p. 195)

Control briefs (see p. 82)

──Table of Contents──

Chapter 1
All About Intimate17

Brassieres ...18

Panties ..34

Slips ..50

Tops ...66

Bottoms ...72

Tap Pants, Half-slips, and Petticoats..............76

Control and Support82

Stockings ...96

Garter Belts.......................................105

Bustiers...108

Coordinating Tops and Bottoms.....................116

Sleepwear ...142

Robes..156

Bodysuits, Cat Suits, and Body Stockings.....160

Men's Undergarments................................162

Chapter 2
An Intimate History169

Antiquity..170

Middle Ages179

Renaissance, Baroque, and Rococo Periods.....182

Modern Day I190

Modern Day II................................193

The 20th Century201

Under and Inner Wear208

Chapter 3
Drawing Intimates211

Basic Figure Forms Useful to Drawing.........212

Drawing Undergarments I222

Drawing Undergarments II................225

Basic Forms for Drawing Men's Underwear ...228

Differences between Underwear and Swimwear..232

Undergarment Structure....................234

Chapter 1
All About Intimates

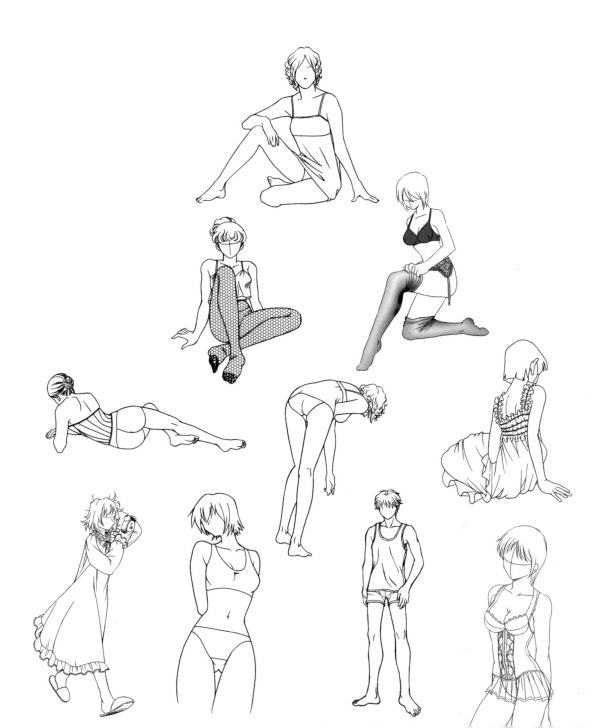

Brassieres

Brassieres serve to conceal and cover the breasts as well as enhance and sculpt their shape. They are worn selected to the occasion (e.g. sports, dressy dinner, etc.) and to match the fashions worn over them. They may also be worn as a fashion statement.

Bras to Cover Half the Chest

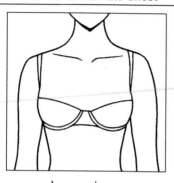

1/2-Cup Bra
Also known as a "demi bra," 1/2-cup bras are worn under widely scooping necklines, with summer fashions, etc.

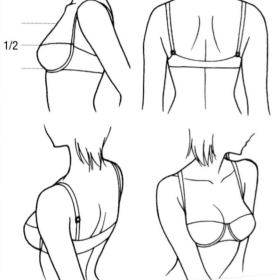

1/2

The minimal size of this bra makes it virtually invisible, depending on the clothing worn on top. This bra serves to enhance the wearer's cleavage.

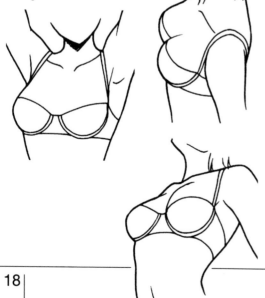

Brassieres to Cover More Than Half of the Chest

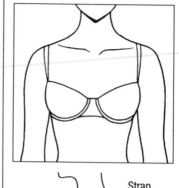

3/4-Cup Bra
These have a regular fit and are the most commonly worn form of bra.

This bra is secured to the body by a wide strip of cloth, which wraps around the trunk

Strap

3/4

Stretchable strip of cloth

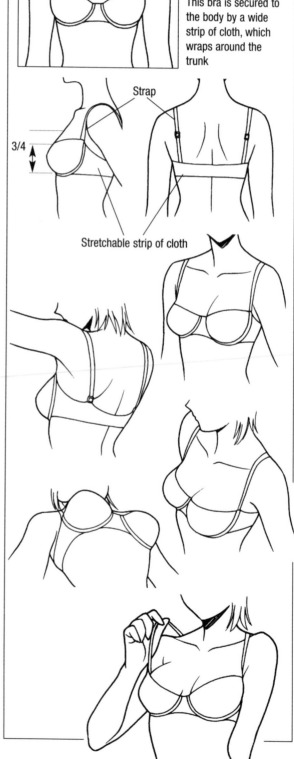

Full-Cup Bra
The cup covers the breast in its entirety, restricting movement, affording the wearer a sense of comfort. On the downside, the abundance of fabric means this bra may make the wearer uncomfortably hot.

Long-Line Bra
Extending to the waist, this bra was designed to have slimming and sculpting affects. They give the appearance of a bra fused with a girdle. Athletic versions are often known as "long bras."

Underwire cup

This bra is worn by pulling it over the head (pullover bra). Many hooks form the back closure.

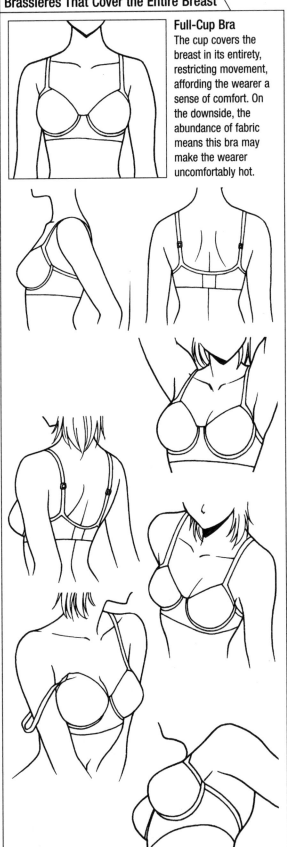

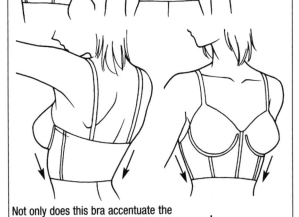

Not only does this bra accentuate the breasts, it also slims the waist, giving the wearer an attractive figure.

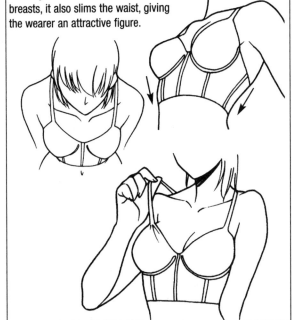

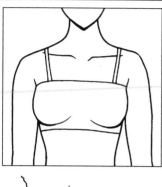

Crop Top
Intended to hide the wearer's cleavage, while accentuating breast size, this bra is like a wide band of cloth wrapped around the chest. It can also be worn as exterior, leisurewear.

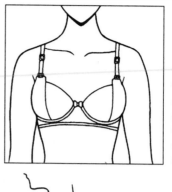

Reinforced Sides
While the standard bra is designed to sculpt and shape the bustline, this bra functions to enhance it even further. This bra gives a less-endowed wearer the appearance of having an average or even large bust size.

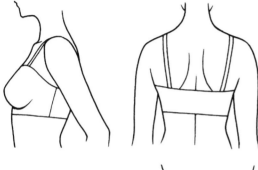

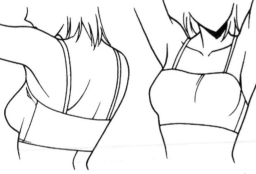

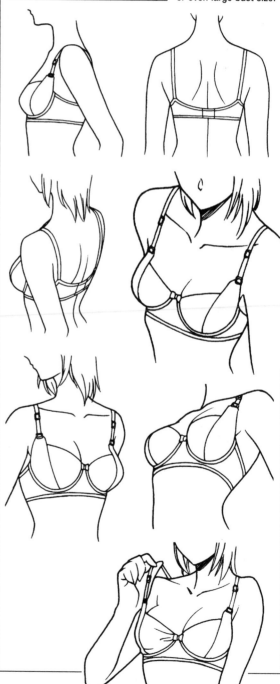

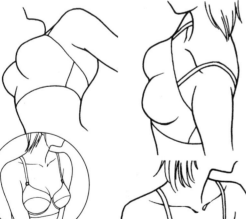

Standard bra

This bra causes even casual poses to make the chest stand out more than a regular bra would.

Bikini Top-Style Brassieres

Bra I

The round, seamless bra accentuates the breast's natural fullness. Fabric bunching occurs naturally at the base of the cups.

Decorated Cups

Bra II

These bras feature a seam, which is often used as a guideline for decorating the cups with lace. The positioning of this seam forms a key point in the bra's design.

Lace decorating lower portion of cup

Lace decorating upper portion of cup

Cups with Short Underwires

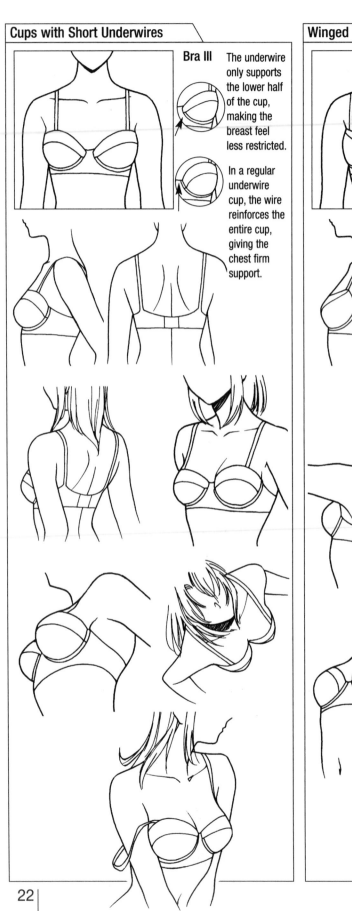

Bra III The underwire only supports the lower half of the cup, making the breast feel less restricted.

In a regular underwire cup, the wire reinforces the entire cup, giving the chest firm support.

Winged Cups

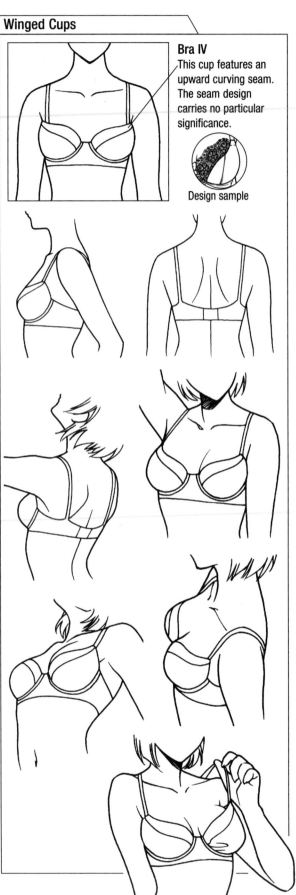

Bra IV This cup features an upward curving seam. The seam design carries no particular significance.

Design sample

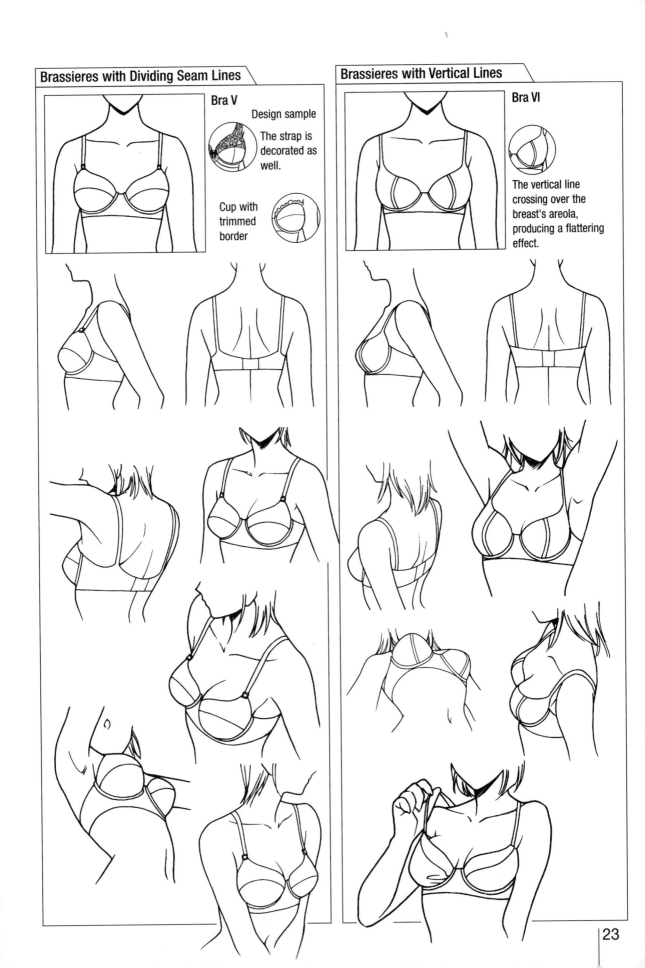

Brassieres with Dividing Seam Lines

Bra V

Design sample

The strap is decorated as well.

Cup with trimmed border

Brassieres with Vertical Lines

Bra VI

The vertical line crossing over the breast's areola, producing a flattering effect.

23

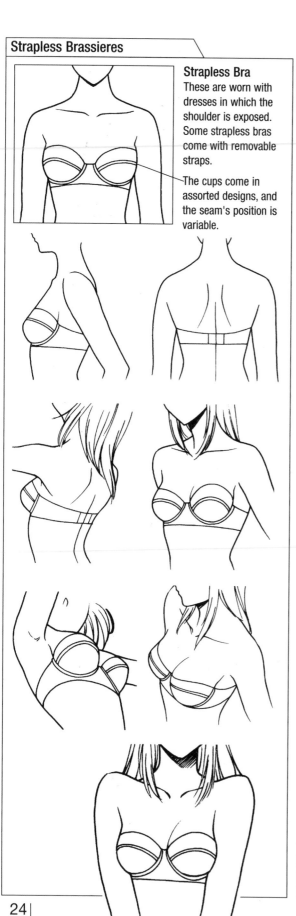

Strapless Bra
These are worn with dresses in which the shoulder is exposed. Some strapless bras come with removable straps.

The cups come in assorted designs, and the seam's position is variable.

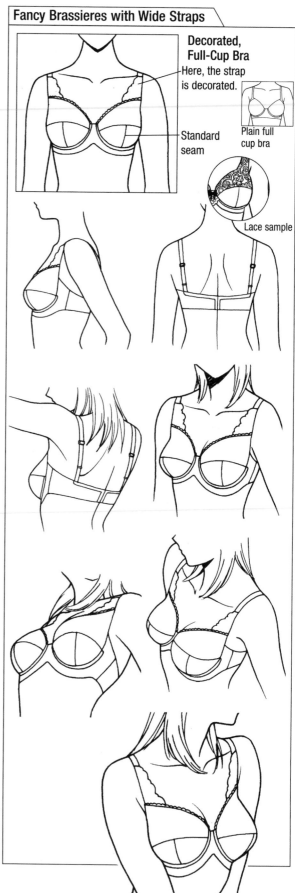

Decorated, Full-Cup Bra
Here, the strap is decorated.

Standard seam

Plain full cup bra

Lace sample

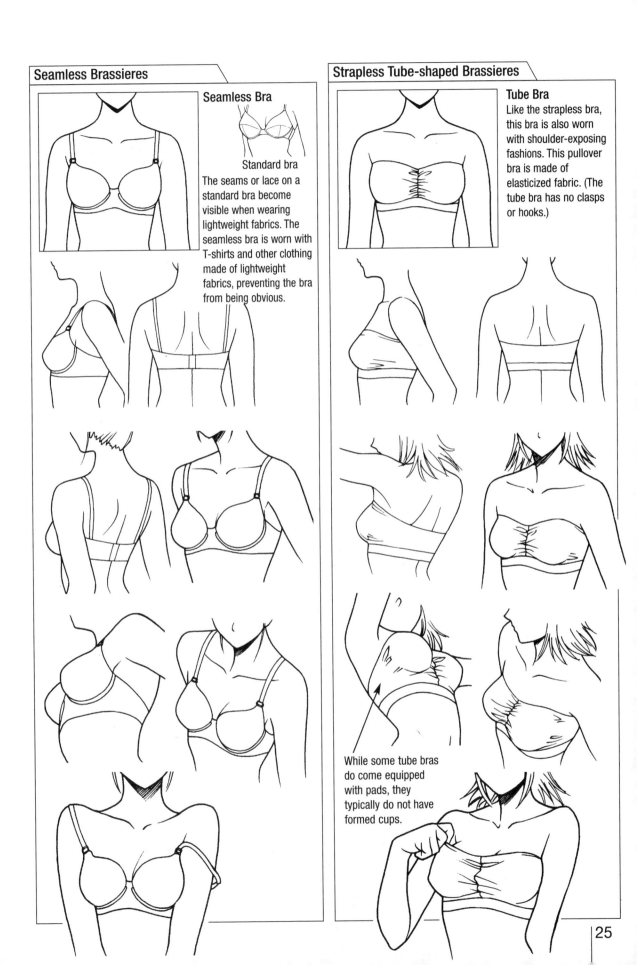

Seamless Brassieres

Seamless Bra

Standard bra

The seams or lace on a standard bra become visible when wearing lightweight fabrics. The seamless bra is worn with T-shirts and other clothing made of lightweight fabrics, preventing the bra from being obvious.

Strapless Tube-shaped Brassieres

Tube Bra

Like the strapless bra, this bra is also worn with shoulder-exposing fashions. This pullover bra is made of elasticized fabric. (The tube bra has no clasps or hooks.)

While some tube bras do come equipped with pads, they typically do not have formed cups.

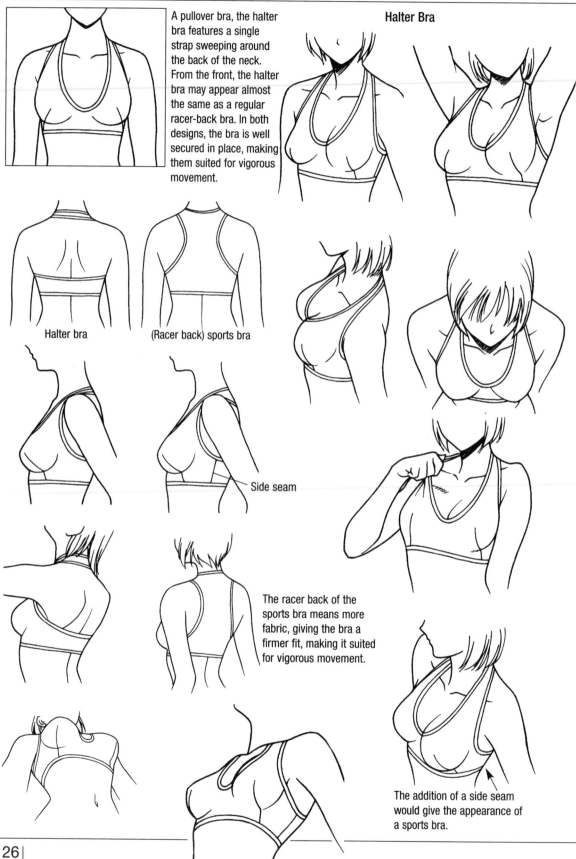

A pullover bra, the halter bra features a single strap sweeping around the back of the neck. From the front, the halter bra may appear almost the same as a regular racer-back bra. In both designs, the bra is well secured in place, making them suited for vigorous movement.

Halter Bra

Halter bra

(Racer back) sports bra

Side seam

The racer back of the sports bra means more fabric, giving the bra a firmer fit, making it suited for vigorous movement.

The addition of a side seam would give the appearance of a sports bra.

Crisscross Brassieres

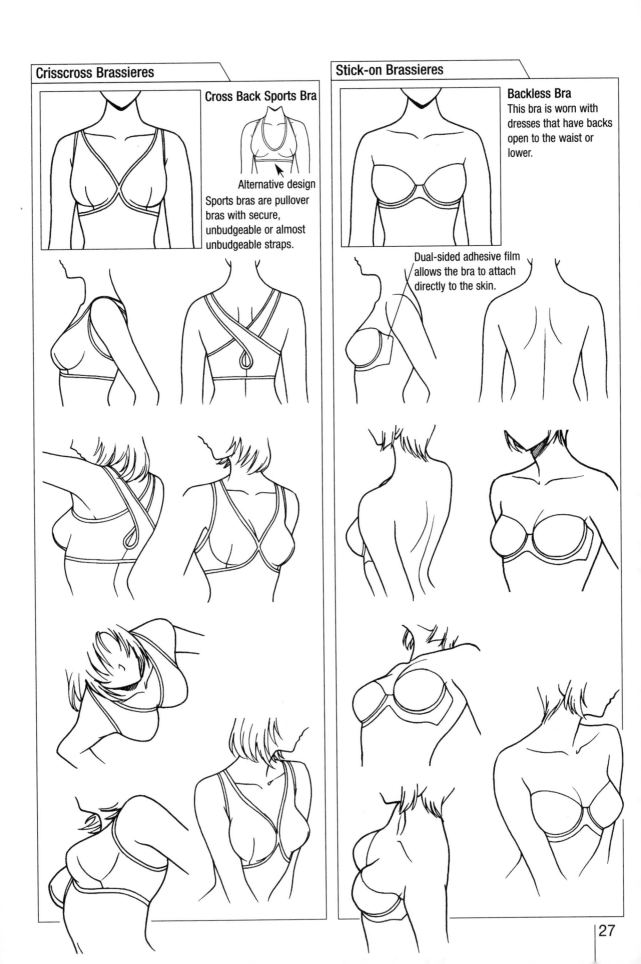

Cross Back Sports Bra

Alternative design

Sports bras are pullover bras with secure, unbudgeable or almost unbudgeable straps.

Stick-on Brassieres

Backless Bra

This bra is worn with dresses that have backs open to the waist or lower.

Dual-sided adhesive film allows the bra to attach directly to the skin.

Brassieres That Fasten below the Chest

This bra is worn with open-back clothing, when the back of a standard bra would be visible. Front-hook styles are also available.

— Exposed skin

— Strap

"Lineless Bra"

Standard back

Stretchable back

Front hook

Stretchable Bras

The rear body support tends to be wider on bras without front hooks.

Front-Hook Bras

Exposed skin

Exposed skin

The straps crisscross around the back and hook in the front.

Hook

Standard bra

Long-line bra

The strap lies above the waist.

Brassieres with Full Fronts and Open Backs

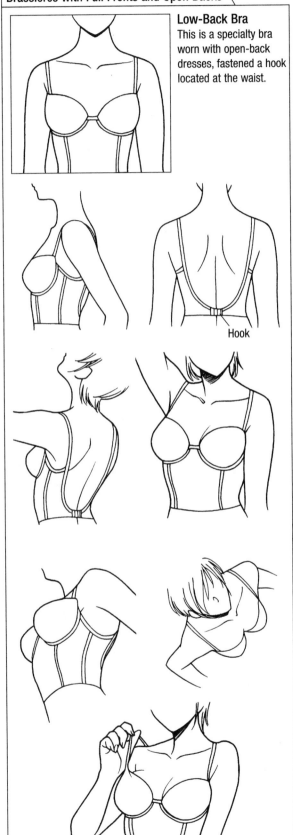

Low-Back Bra
This is a specialty bra worn with open-back dresses, fastened a hook located at the waist.

Hook

Brassieres with the Torso Band Shaped in an Inverted V

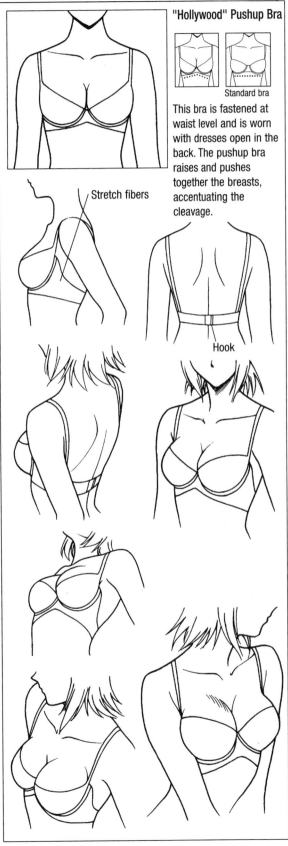

"Hollywood" Pushup Bra

Standard bra

This bra is fastened at waist level and is worn with dresses open in the back. The pushup bra raises and pushes together the breasts, accentuating the cleavage.

Stretch fibers

Hook

Using Seams as Borders

Not only do unmentionables come in plain, unadorned fabrics, but many are also available decorated in various lace designs. Furthermore, the addition of lace helps undergarments look more like undergarments (i.e. helps you distinguish them from swimwear).

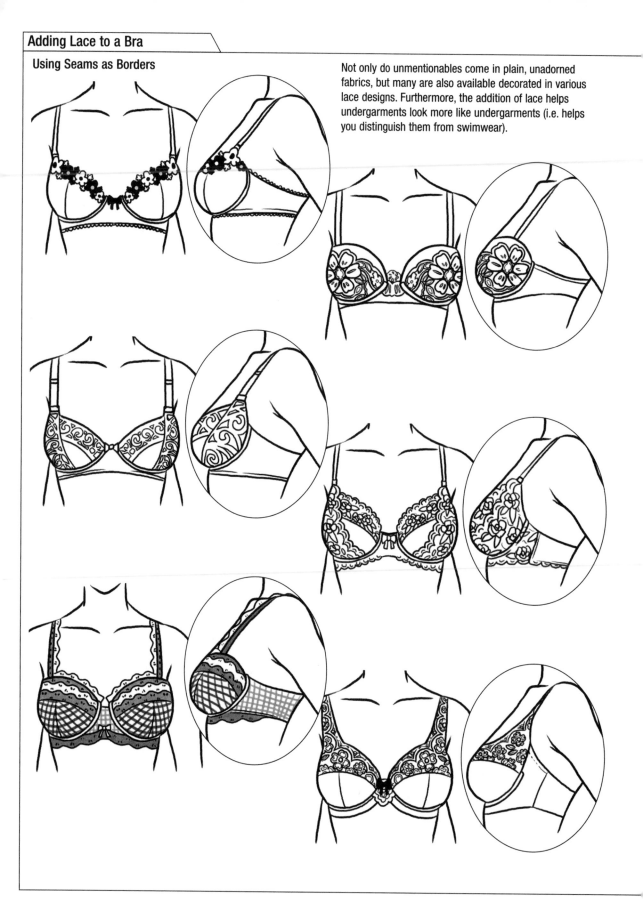

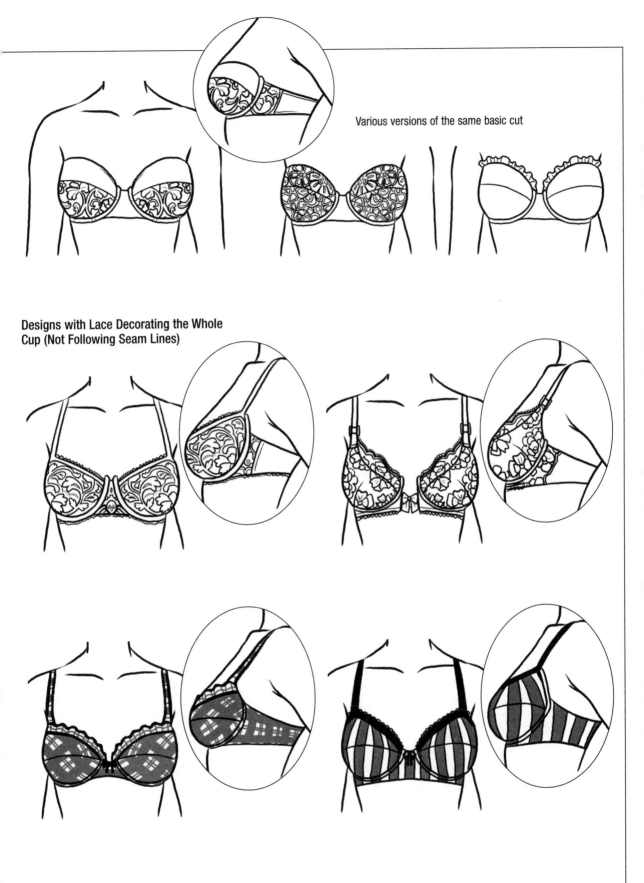

Various versions of the same basic cut

Designs with Lace Decorating the Whole
Cup (Not Following Seam Lines)

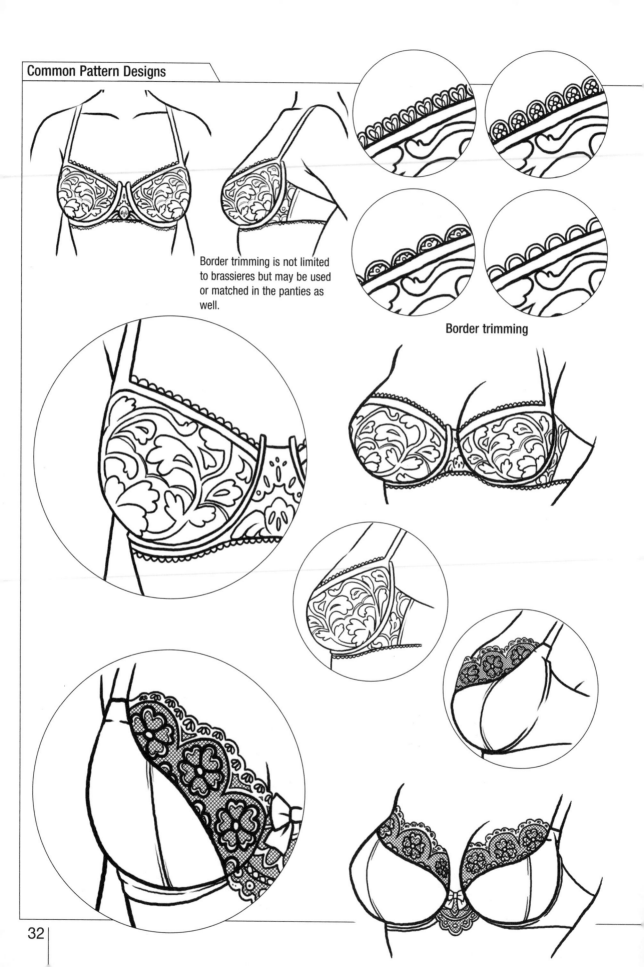

Border trimming is not limited to brassieres but may be used or matched in the panties as well.

Border trimming

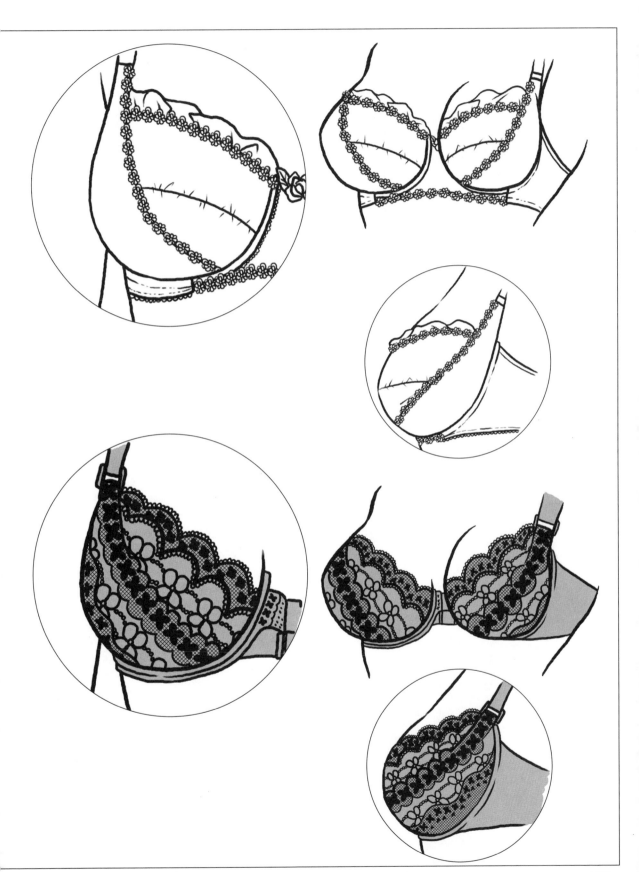

Panties

Briefs

Women's briefs hug closely to the skin. Smaller panties (low cut panties) are known as bikini briefs.

Wider coverage at the hips

The low leg means a less dramatic angle.

Standard Brief (Higher Waist)

Bikini (Lower Waist)

Standard brief

Bikini

Minimal coverage at the hips

Moderate high leg

The cotton-lined gusset is less expansive.

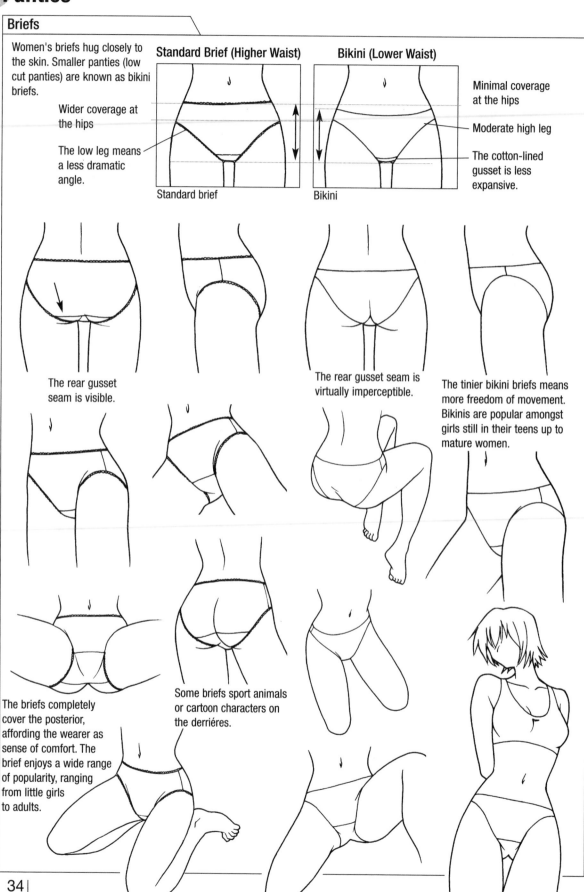

The rear gusset seam is visible.

The rear gusset seam is virtually imperceptible.

The tinier bikini briefs means more freedom of movement. Bikinis are popular amongst girls still in their teens up to mature women.

The briefs completely cover the posterior, affording the wearer as sense of comfort. The brief enjoys a wide range of popularity, ranging from little girls to adults.

Some briefs sport animals or cartoon characters on the derriéres.

Bikini Bottom (Swimwear)

Bikini Brief

Bikini bottom

These are basically briefs made of less fabric.

The bikini bottom covers more of the posterior than its intimate apparel counterpart.

Since the bikini bottom is swimwear, there is no gusset seam. There is a seam in the bottom center, however.

Bikini brief

From a moderately high angle, they appear almost identical to the standard briefs.

The swimwear version can be distinguished from its underwear counterpart by omitting gusset seams.

Undies Shaped Like the Letter T from the Front

While the underwear version is called "high-leg briefs," the "high leg" design originated in swimsuits and leotards with the intention of making the leg appear longer.

These are worn with shorts, when regular briefs or tap pants might be visible from underneath.

High-Leg Briefs

Sample with lace

Without the gusset seam, these will appear to be the bottom half of a high-leg bikini.

This pair snugly covers the posterior and has a sharply cut leg from the front.

High-leg briefs have about 2/3 the fabric coverage of standard briefs.

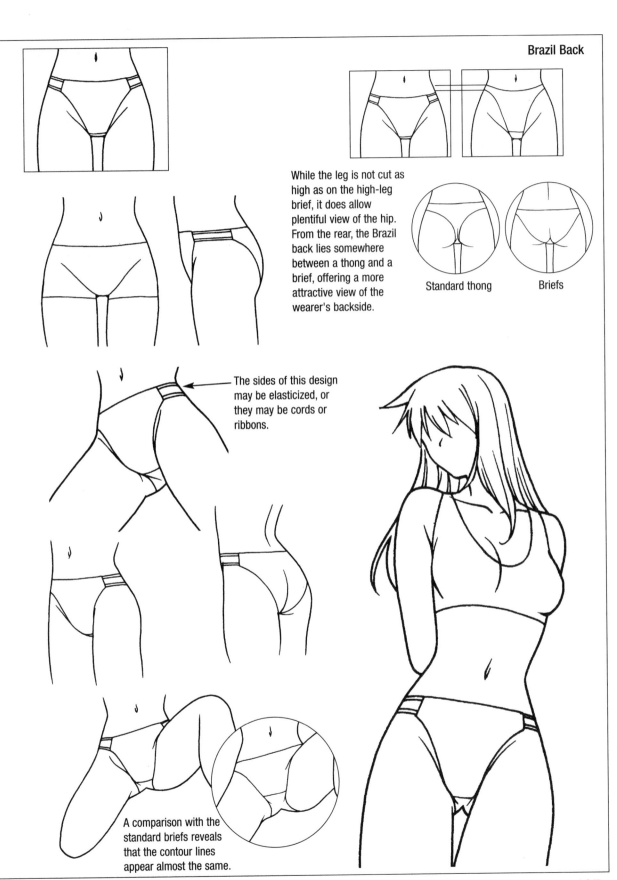

Brazil Back

While the leg is not cut as high as on the high-leg brief, it does allow plentiful view of the hip. From the rear, the Brazil back lies somewhere between a thong and a brief, offering a more attractive view of the wearer's backside.

Standard thong

Briefs

The sides of this design may be elasticized, or they may be cords or ribbons.

A comparison with the standard briefs reveals that the contour lines appear almost the same.

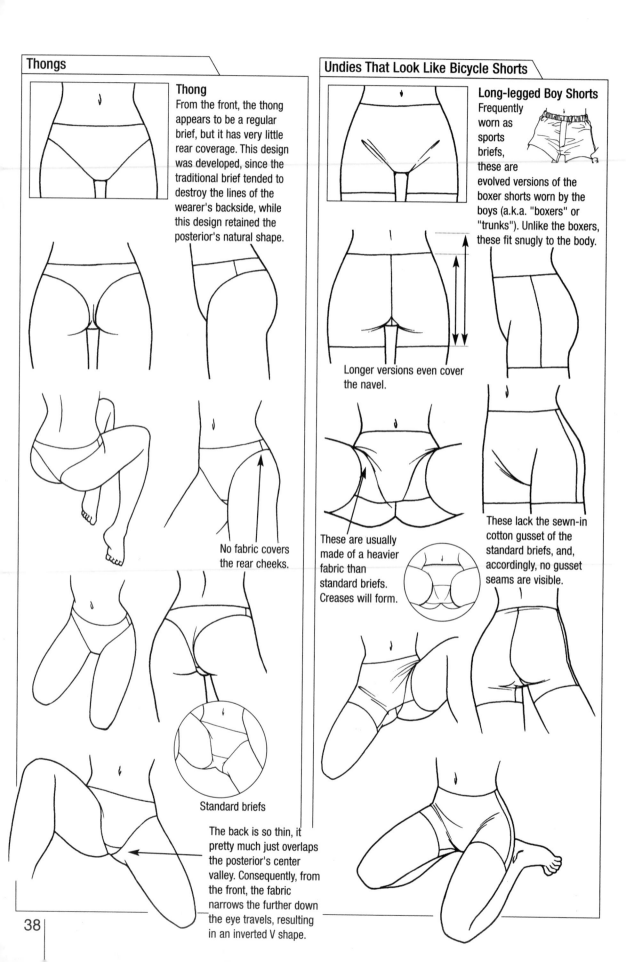

Thongs

Thong

From the front, the thong appears to be a regular brief, but it has very little rear coverage. This design was developed, since the traditional brief tended to destroy the lines of the wearer's backside, while this design retained the posterior's natural shape.

No fabric covers the rear cheeks.

Standard briefs

The back is so thin, it pretty much just overlaps the posterior's center valley. Consequently, from the front, the fabric narrows the further down the eye travels, resulting in an inverted V shape.

Undies That Look Like Bicycle Shorts

Long-legged Boy Shorts

Frequently worn as sports briefs, these are evolved versions of the boxer shorts worn by the boys (a.k.a. "boxers" or "trunks"). Unlike the boxers, these fit snugly to the body.

Longer versions even cover the navel.

These are usually made of a heavier fabric than standard briefs. Creases will form.

These lack the sewn-in cotton gusset of the standard briefs, and, accordingly, no gusset seams are visible.

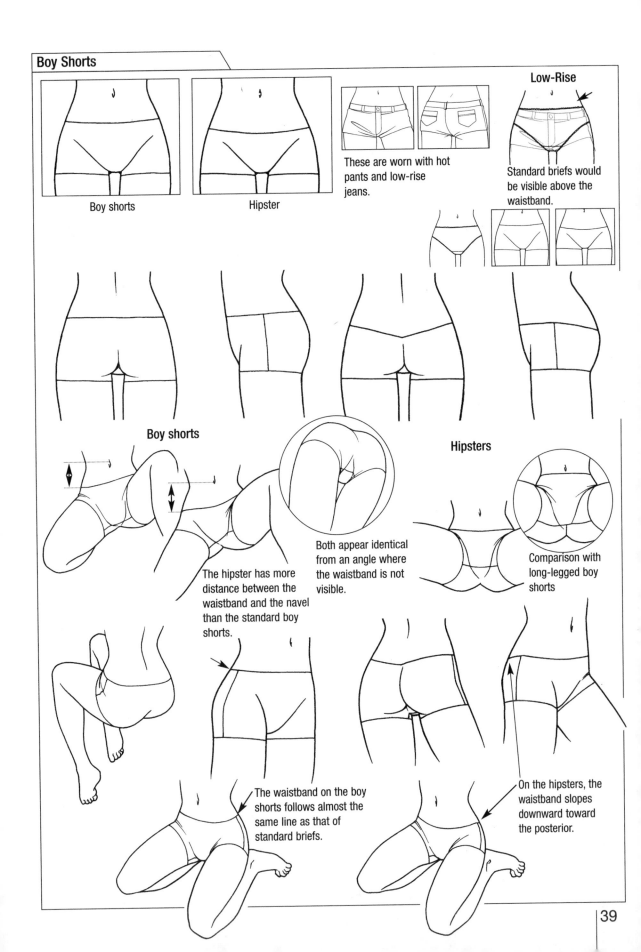

Boy Shorts

Boy shorts

Hipster

These are worn with hot pants and low-rise jeans.

Low-Rise

Standard briefs would be visible above the waistband.

Boy shorts

Hipsters

The hipster has more distance between the waistband and the navel than the standard boy shorts.

Both appear identical from an angle where the waistband is not visible.

Comparison with long-legged boy shorts

The waistband on the boy shorts follows almost the same line as that of standard briefs.

On the hipsters, the waistband slopes downward toward the posterior.

Glorified *Loincloths*

Most of these have string ties and are reminiscent of the *loincloth*. With the cut of the high leg or thong taken to the extreme, the string bikini exemplifies emphasis on fashion over function.

String Bikini

High-leg briefs

Here, they are compared with high-leg briefs. The string bikini back follows almost the same contours as the thong.

The string bikini is made of a heavier fabric than the thong, but it still consists of a narrow panel in the front, only covering limited, strategic areas.

Thong

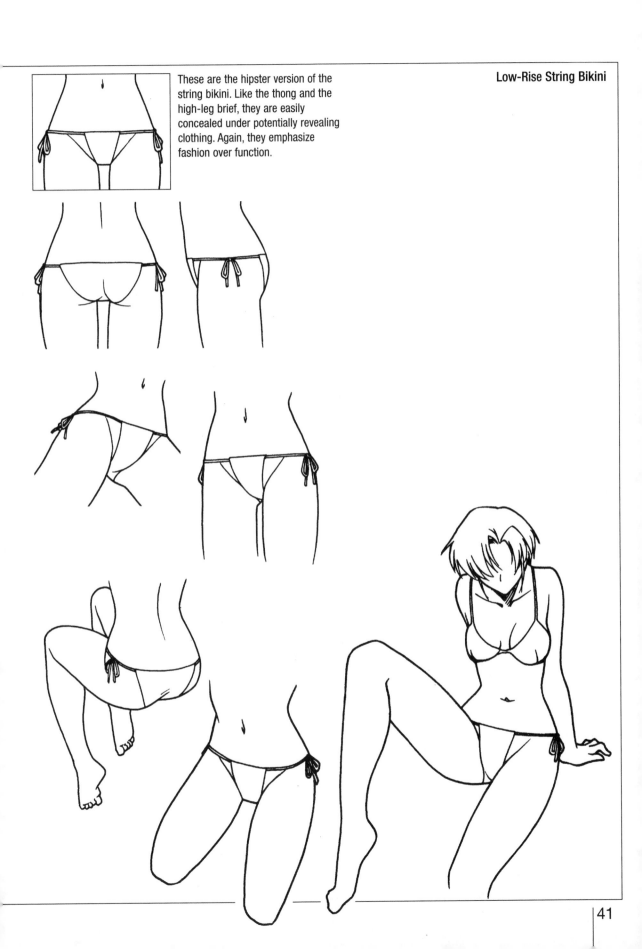

These are the hipster version of the string bikini. Like the thong and the high-leg brief, they are easily concealed under potentially revealing clothing. Again, they emphasize fashion over function.

Low-Rise String Bikini

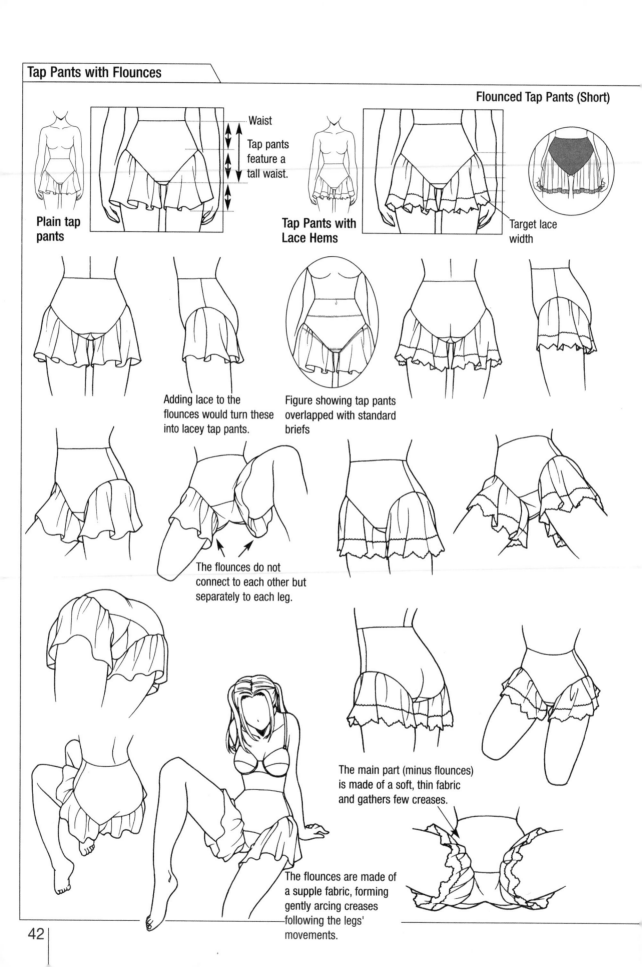

Flounced Tap Pants (Short)

Waist

Tap pants feature a tall waist.

Plain tap pants

Tap Pants with Lace Hems

Target lace width

Adding lace to the flounces would turn these into lacey tap pants.

Figure showing tap pants overlapped with standard briefs

The flounces do not connect to each other but separately to each leg.

The main part (minus flounces) is made of a soft, thin fabric and gathers few creases.

The flounces are made of a supple fabric, forming gently arcing creases following the legs' movements.

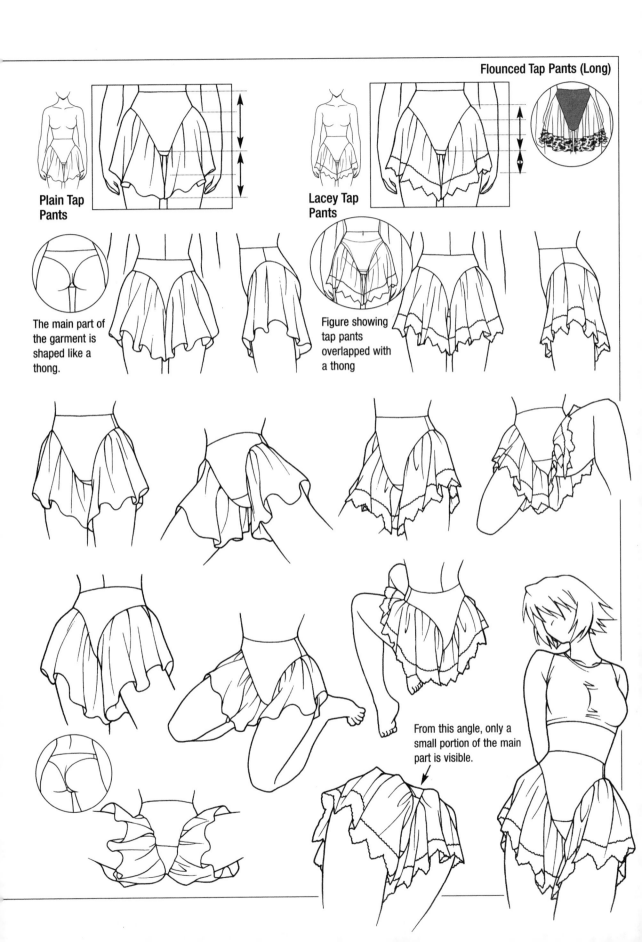

Flounced Tap Pants (Long)

Plain Tap Pants

Lacey Tap Pants

The main part of the garment is shaped like a thong.

Figure showing tap pants overlapped with a thong

From this angle, only a small portion of the main part is visible.

Partial Lace Decoration

Lace at the Waistband

Elaborate Full Frontal Decoration

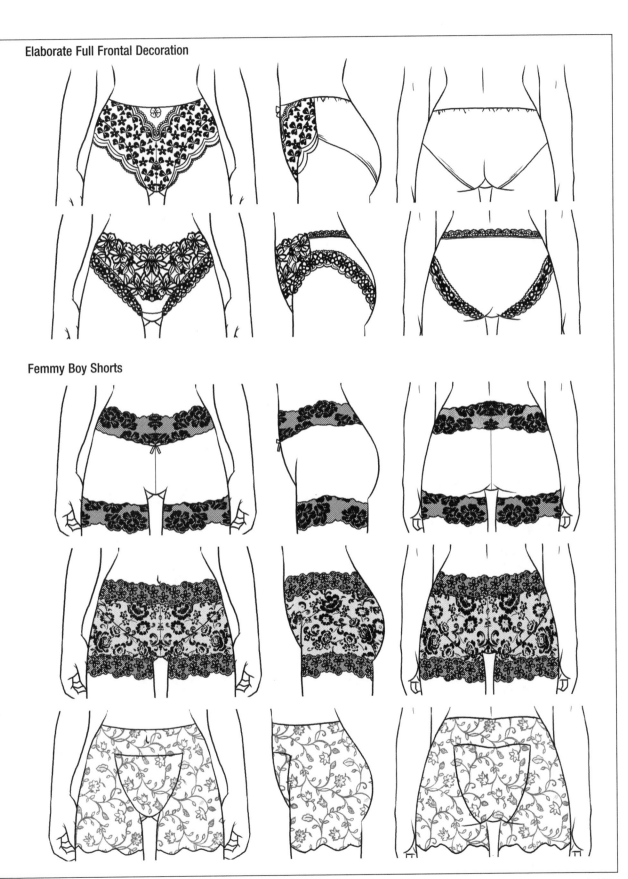

Femmy Boy Shorts

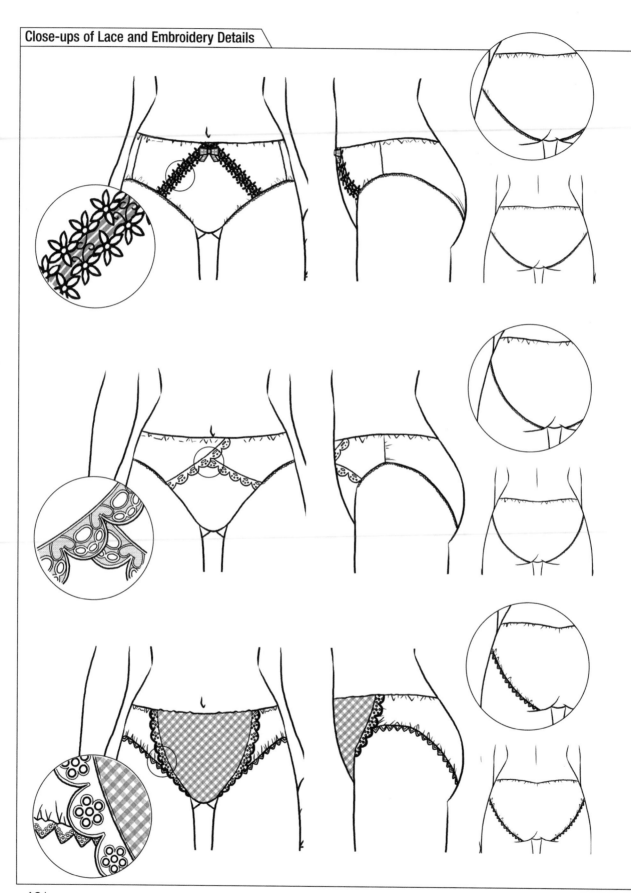

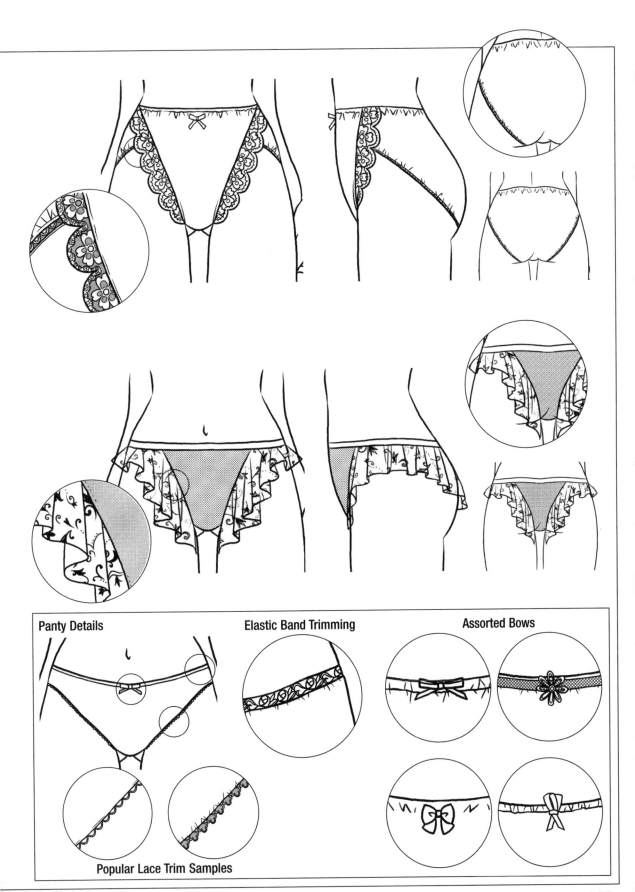

Panty Details

Elastic Band Trimming

Assorted Bows

Popular Lace Trim Samples

Flounced Tap Pants with Lace

Flounced Tap Pants (Short)

The simple addition of a solid (dot) screen tone creates the illusion of lace.

Standard Tap Pants

Lace embellishment usually ends somewhere beneath the crotch.

Flounced Tap Pants (Long)

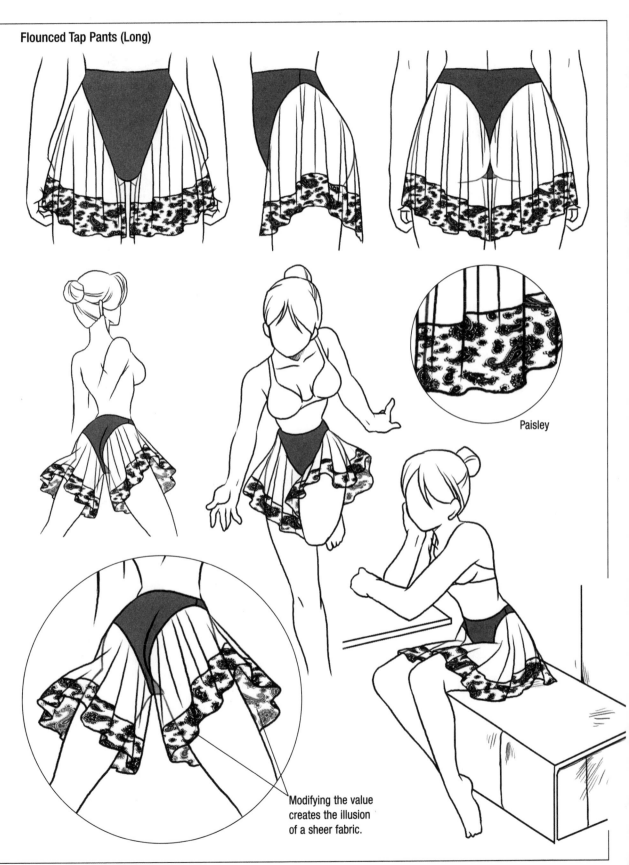

Paisley

Modifying the value
creates the illusion
of a sheer fabric.

Slips

Slips are worn under clothing (primarily dresses) and are intended to make clothing more comfortable, so they improve the look and feel of the outer clothing over that if they were worn directly against the skin. Slips often feel "slippery" to the touch. Wearing a slip underneath a dress improves the look of the dress. Slips come in varying lengths depending on the clothing worn on top.

Full Slips That Extend beyond the Knee

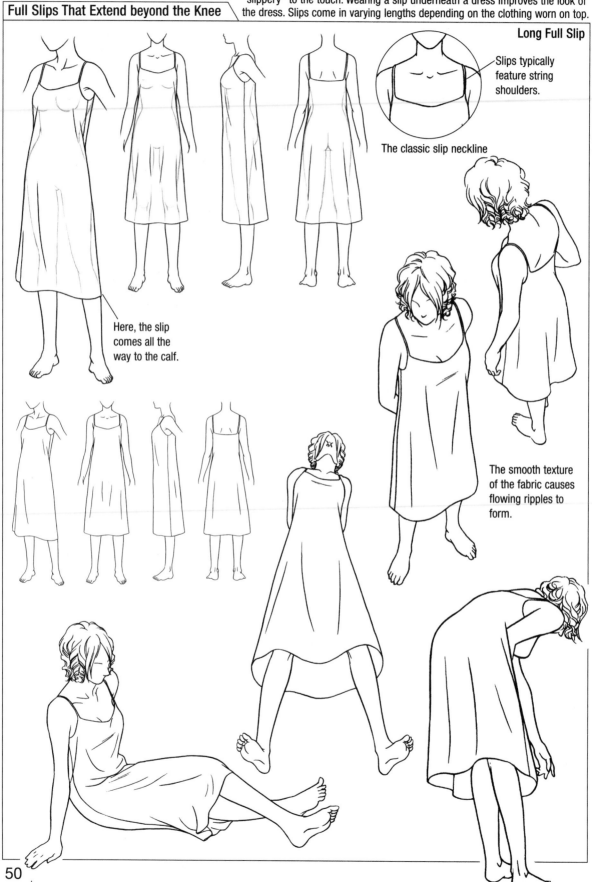

Long Full Slip

Slips typically feature string shoulders.

The classic slip neckline

Here, the slip comes all the way to the calf.

The smooth texture of the fabric causes flowing ripples to form.

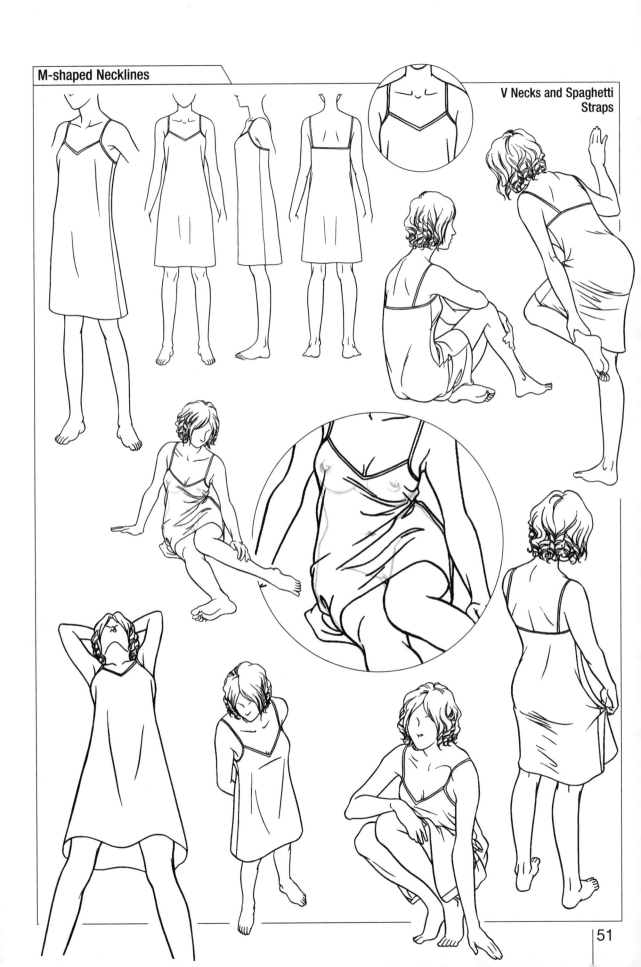

V Necks and Spaghetti
Straps

Mini Full Slip

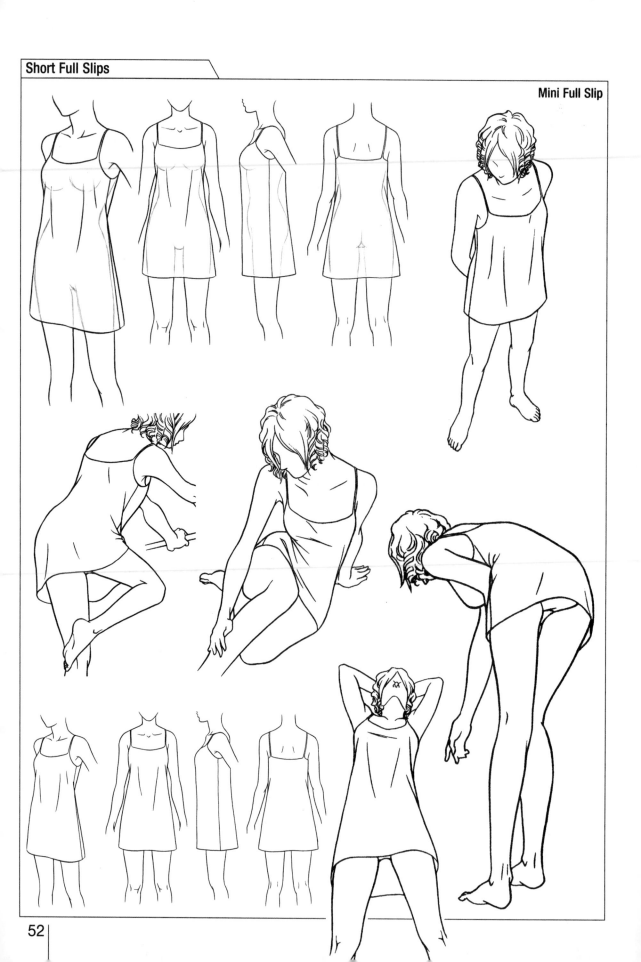

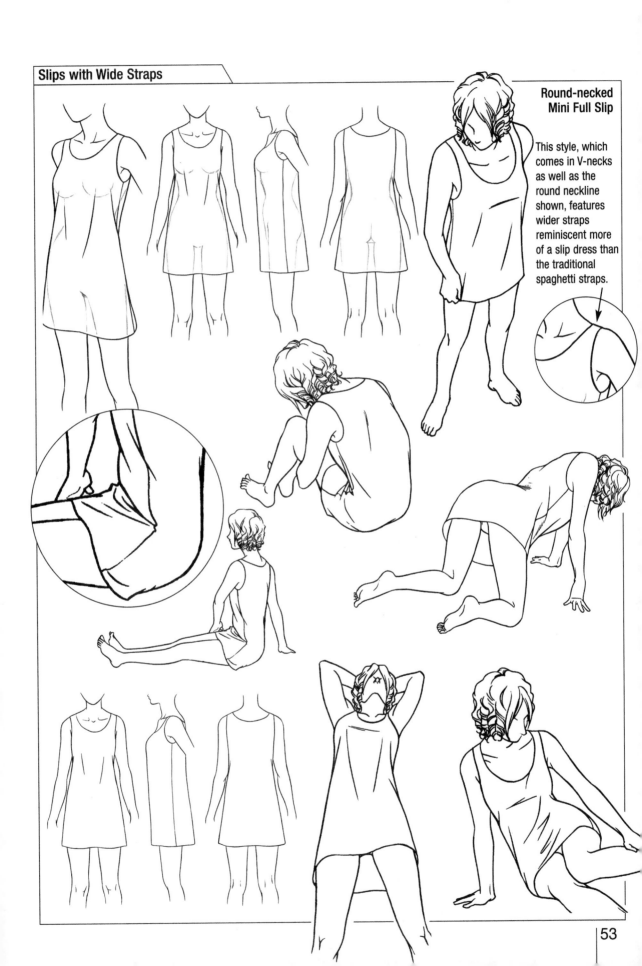

Round-necked Mini Full Slip

This style, which comes in V-necks as well as the round neckline shown, features wider straps reminiscent more of a slip dress than the traditional spaghetti straps.

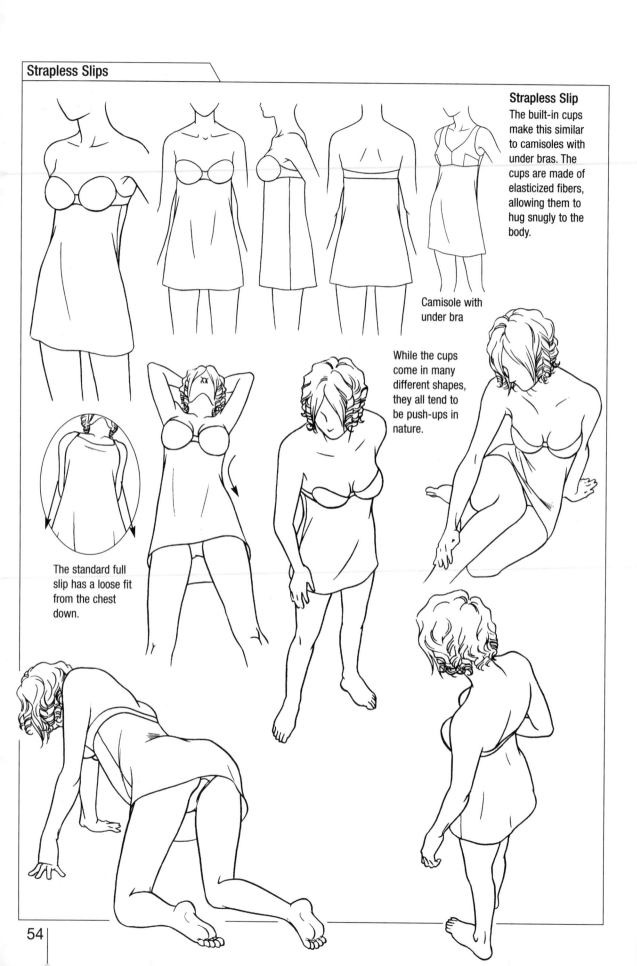

Strapless Slip
The built-in cups make this similar to camisoles with under bras. The cups are made of elasticized fibers, allowing them to hug snugly to the body.

Camisole with under bra

While the cups come in many different shapes, they all tend to be push-ups in nature.

The standard full slip has a loose fit from the chest down.

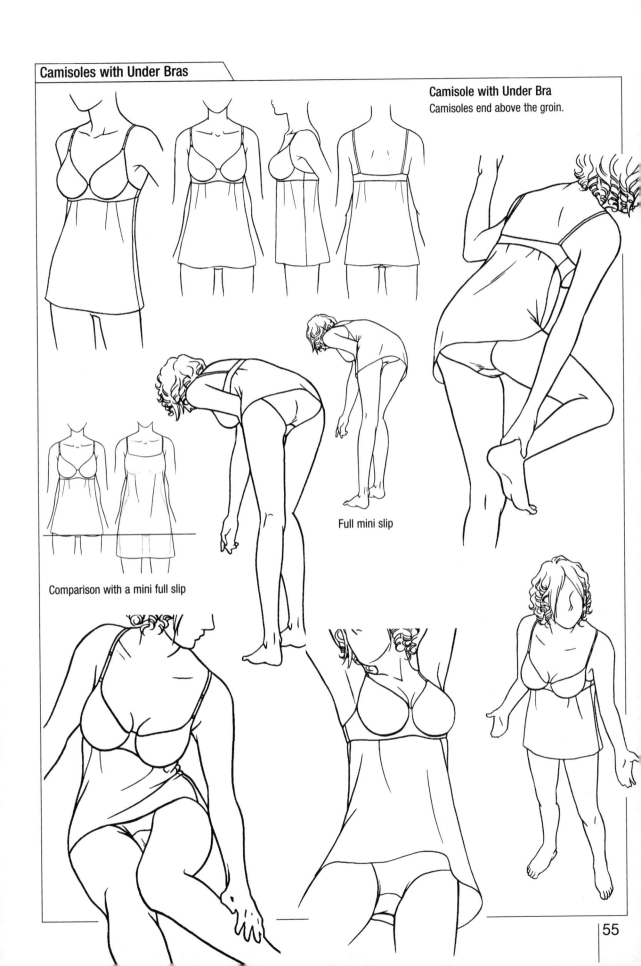

Camisoles with Under Bras

Camisole with Under Bra
Camisoles end above the groin.

Full mini slip

Comparison with a mini full slip

55

V-neckline Camisole

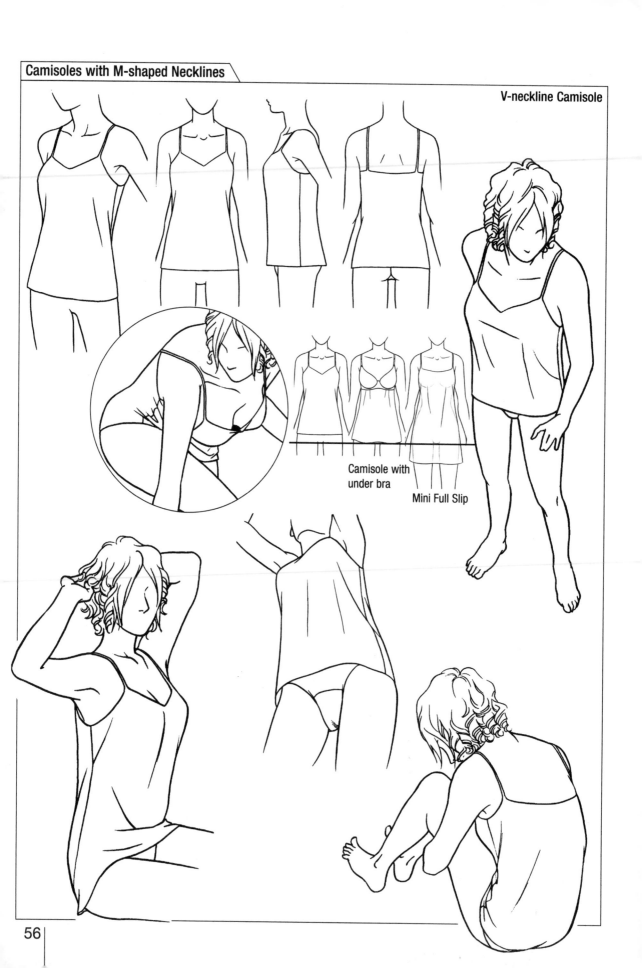

Camisole with
under bra

Mini Full Slip

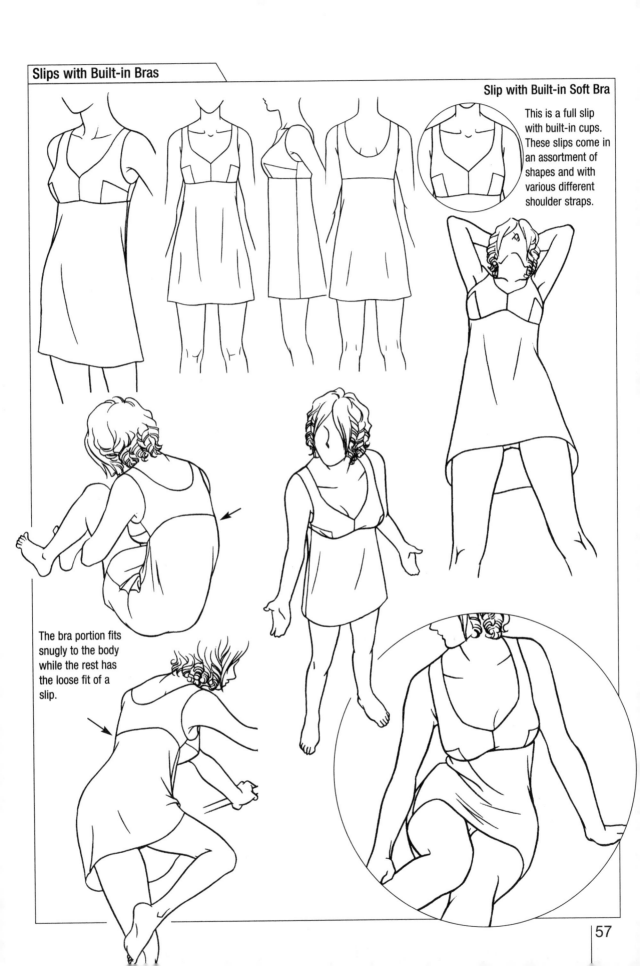

Slips with Built-in Bras

This is a full slip with built-in cups. These slips come in an assortment of shapes and with various different shoulder straps.

The bra portion fits snugly to the body while the rest has the loose fit of a slip.

Short, Fitted Slips

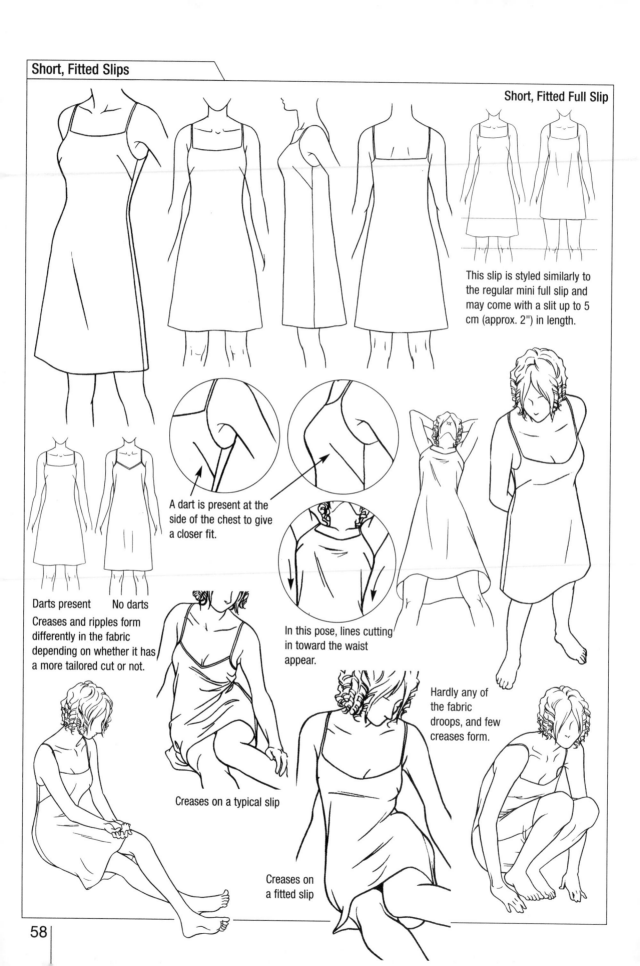

Short, Fitted Full Slip

This slip is styled similarly to the regular mini full slip and may come with a slit up to 5 cm (approx. 2") in length.

A dart is present at the side of the chest to give a closer fit.

Darts present No darts

Creases and ripples form differently in the fabric depending on whether it has a more tailored cut or not.

In this pose, lines cutting in toward the waist appear.

Hardly any of the fabric droops, and few creases form.

Creases on a typical slip

Creases on a fitted slip

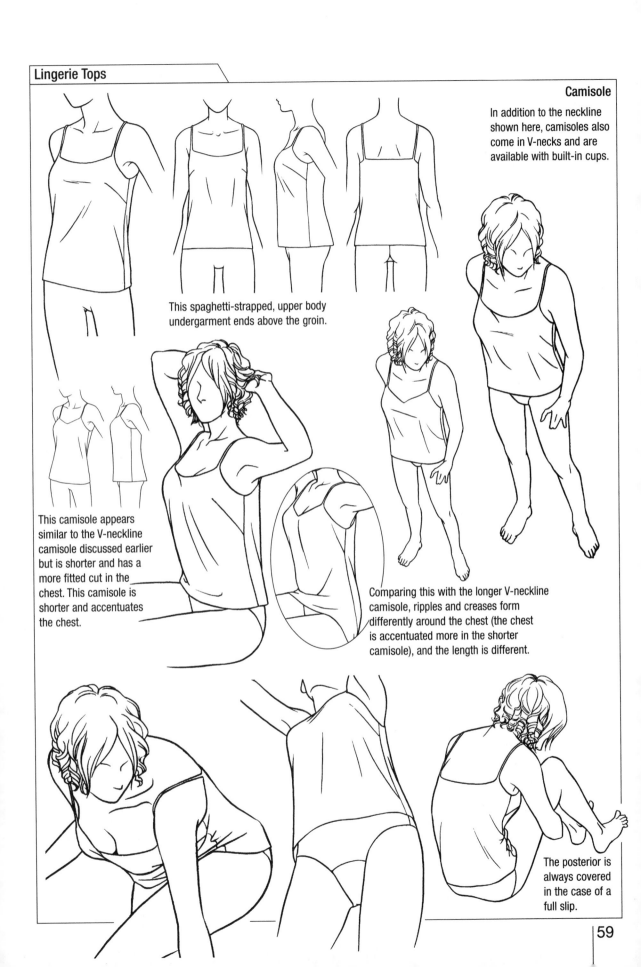

Camisole

In addition to the neckline shown here, camisoles also come in V-necks and are available with built-in cups.

This spaghetti-strapped, upper body undergarment ends above the groin.

This camisole appears similar to the V-neckline camisole discussed earlier but is shorter and has a more fitted cut in the chest. This camisole is shorter and accentuates the chest.

Comparing this with the longer V-neckline camisole, ripples and creases form differently around the chest (the chest is accentuated more in the shorter camisole), and the length is different.

The posterior is always covered in the case of a full slip.

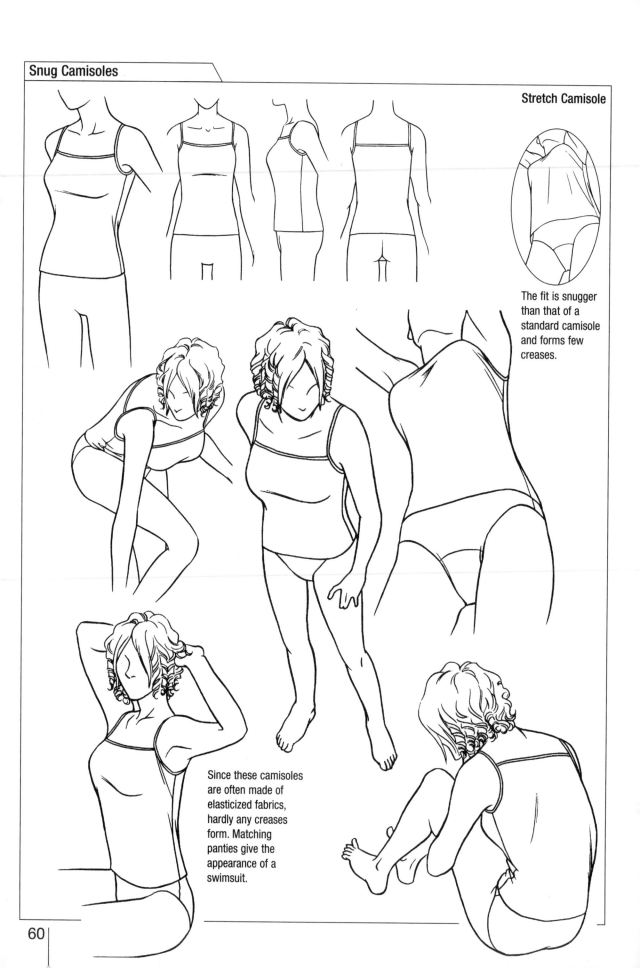

Stretch Camisole

The fit is snugger than that of a standard camisole and forms few creases.

Since these camisoles are often made of elasticized fabrics, hardly any creases form. Matching panties give the appearance of a swimsuit.

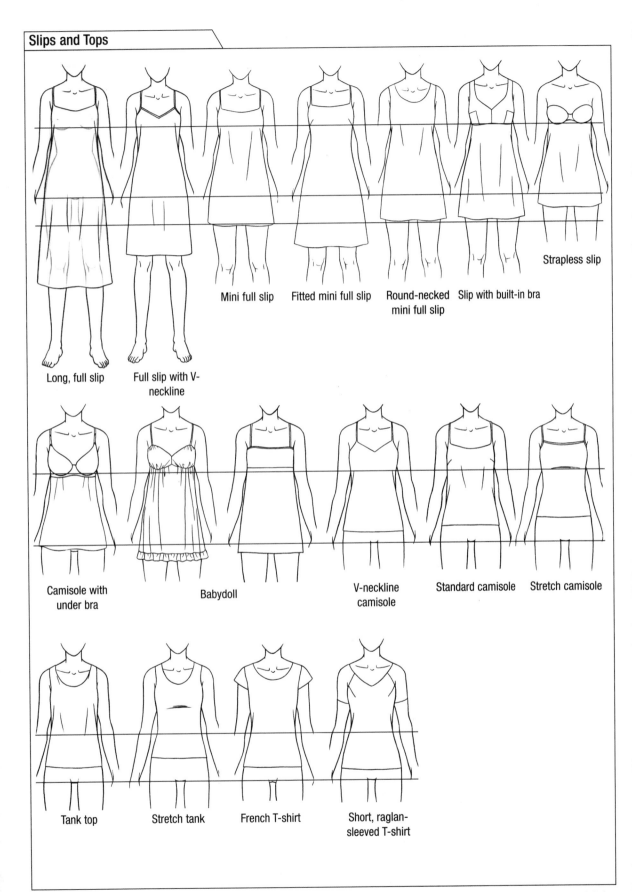

Mini full slip

Fitted mini full slip

Round-necked mini full slip

Slip with built-in bra

Strapless slip

Long, full slip

Full slip with V-neckline

Camisole with under bra

Babydoll

V-neckline camisole

Standard camisole

Stretch camisole

Tank top

Stretch tank

French T-shirt

Short, raglan-sleeved T-shirt

Lace Decorating Slip Fronts and Chests

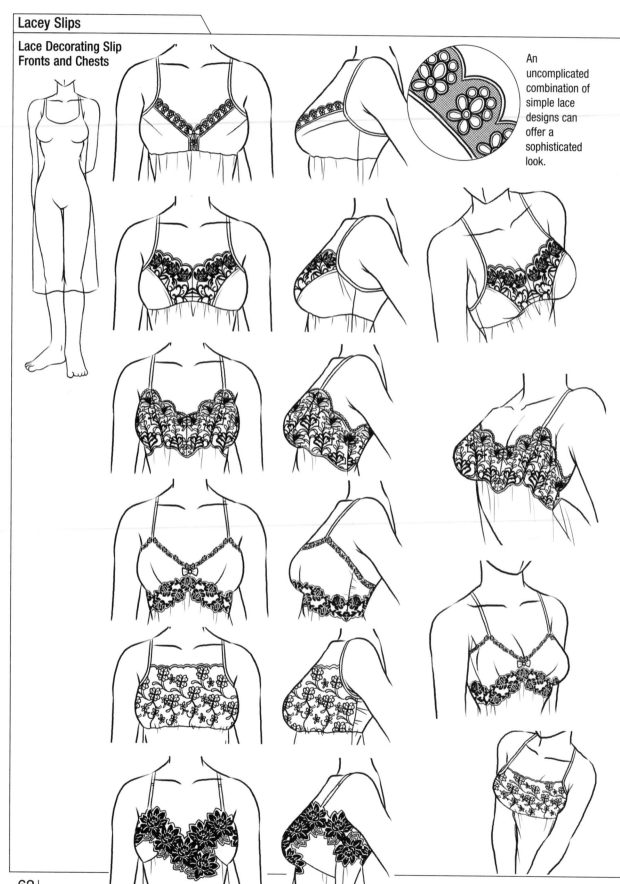

An uncomplicated combination of simple lace designs can offer a sophisticated look.

Effects of Different Lace Patterns

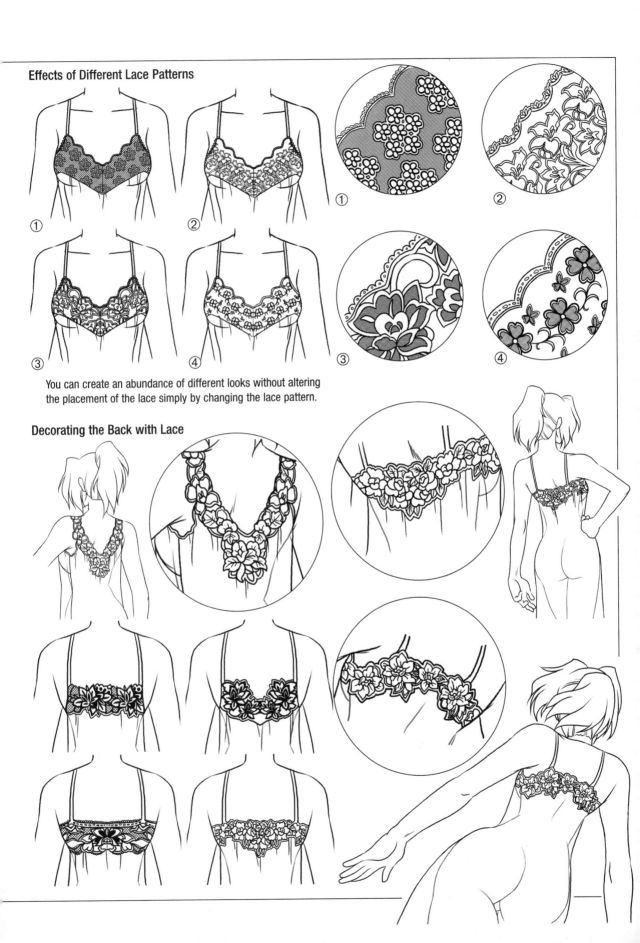

You can create an abundance of different looks without altering the placement of the lace simply by changing the lace pattern.

Decorating the Back with Lace

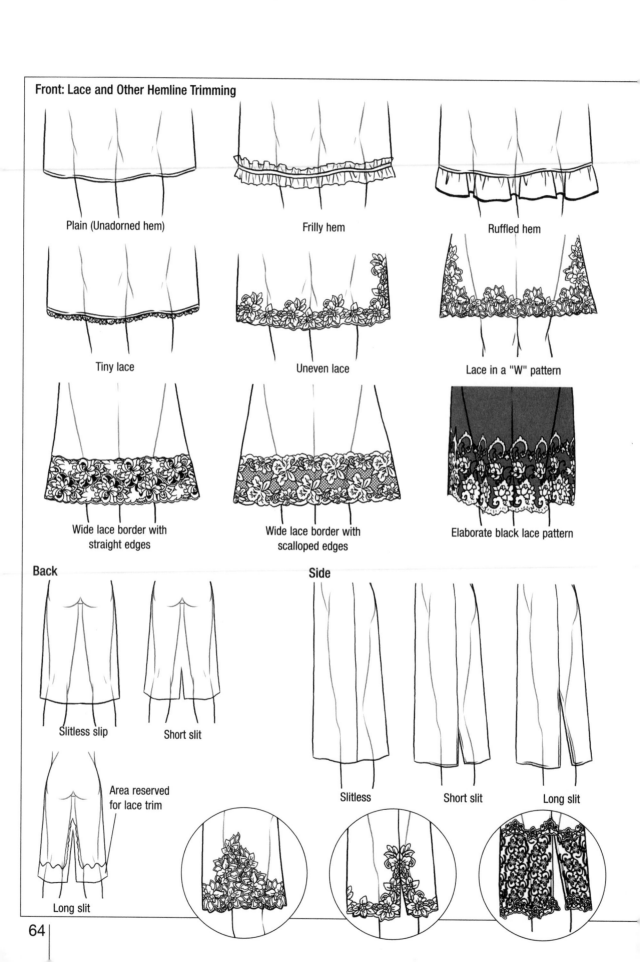

Front: Lace and Other Hemline Trimming

Plain (Unadorned hem)

Frilly hem

Ruffled hem

Tiny lace

Uneven lace

Lace in a "W" pattern

Wide lace border with straight edges

Wide lace border with scalloped edges

Elaborate black lace pattern

Back

Slitless slip

Short slit

Area reserved for lace trim

Long slit

Side

Slitless

Short slit

Long slit

Lace Trim with Connecting Front Swath

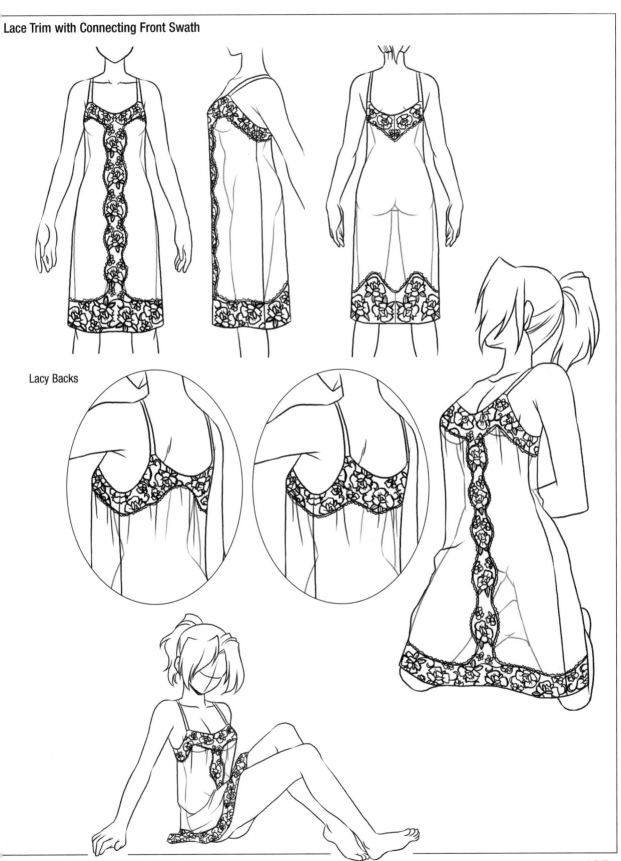

Lacy Backs

Tops

This section is dedicated to what would be known in the men's department as "undershirts." They fit closely to the body yet are never tight, regardless of the body type.

Tank Tops

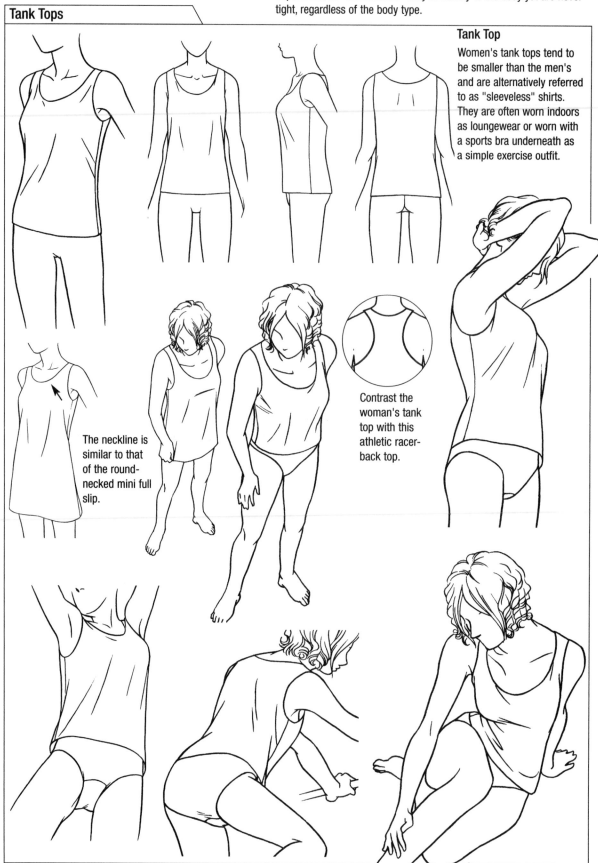

Tank Top

Women's tank tops tend to be smaller than the men's and are alternatively referred to as "sleeveless" shirts. They are often worn indoors as loungewear or worn with a sports bra underneath as a simple exercise outfit.

The neckline is similar to that of the round-necked mini full slip.

Contrast the woman's tank top with this athletic racer-back top.

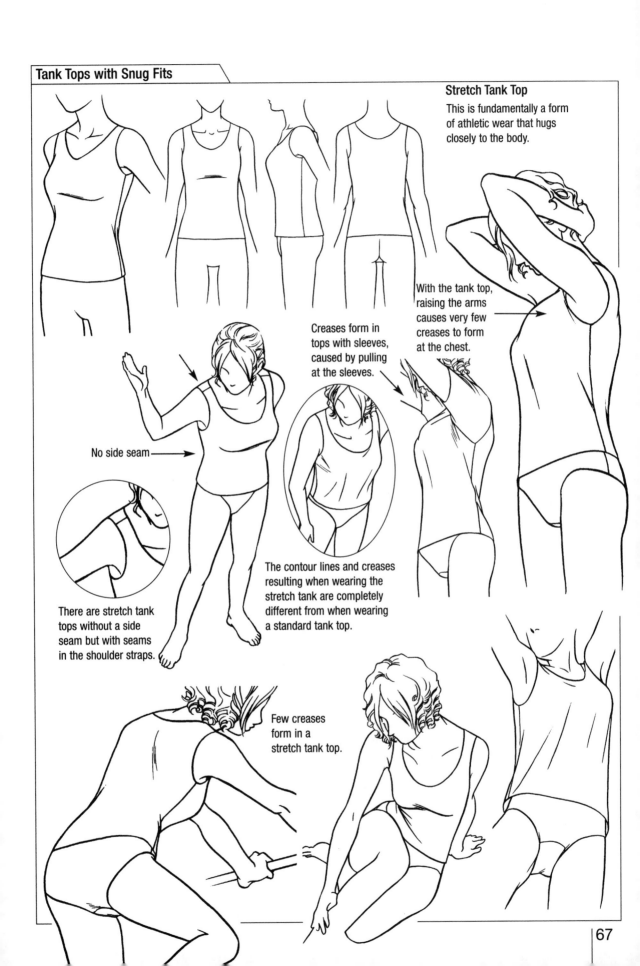

Stretch Tank Top

This is fundamentally a form of athletic wear that hugs closely to the body.

With the tank top, raising the arms causes very few creases to form at the chest.

Creases form in tops with sleeves, caused by pulling at the sleeves.

No side seam

There are stretch tank tops without a side seam but with seams in the shoulder straps.

The contour lines and creases resulting when wearing the stretch tank are completely different from when wearing a standard tank top.

Few creases form in a stretch tank top.

Sleeved Tops

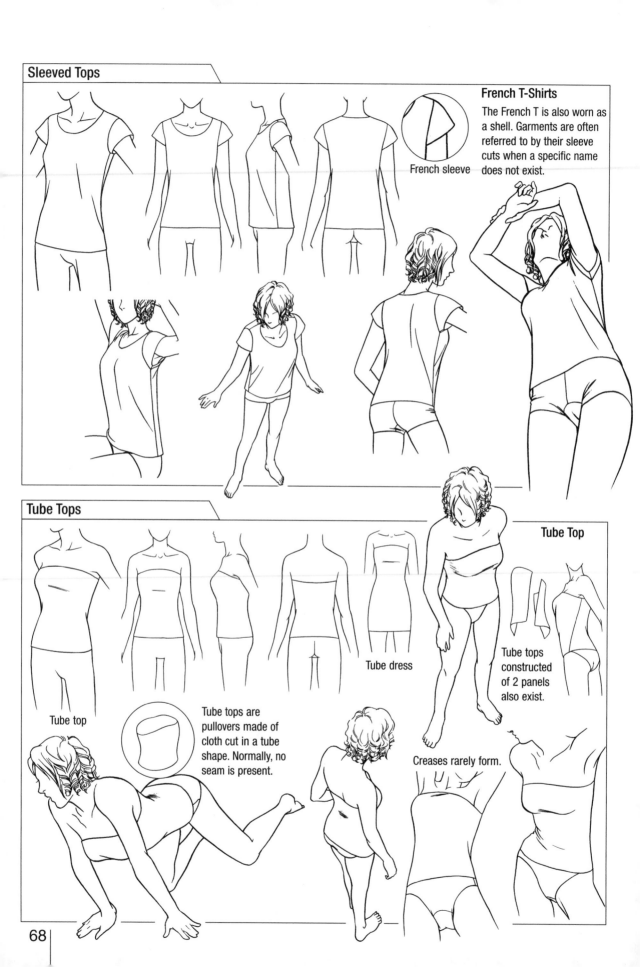

French T-Shirts

The French T is also worn as a shell. Garments are often referred to by their sleeve cuts when a specific name does not exist.

French sleeve

Tube Tops

Tube dress

Tube Top

Tube tops constructed of 2 panels also exist.

Tube top

Tube tops are pullovers made of cloth cut in a tube shape. Normally, no seam is present.

Creases rarely form.

Short Tops That Cover the Shoulders and Chest

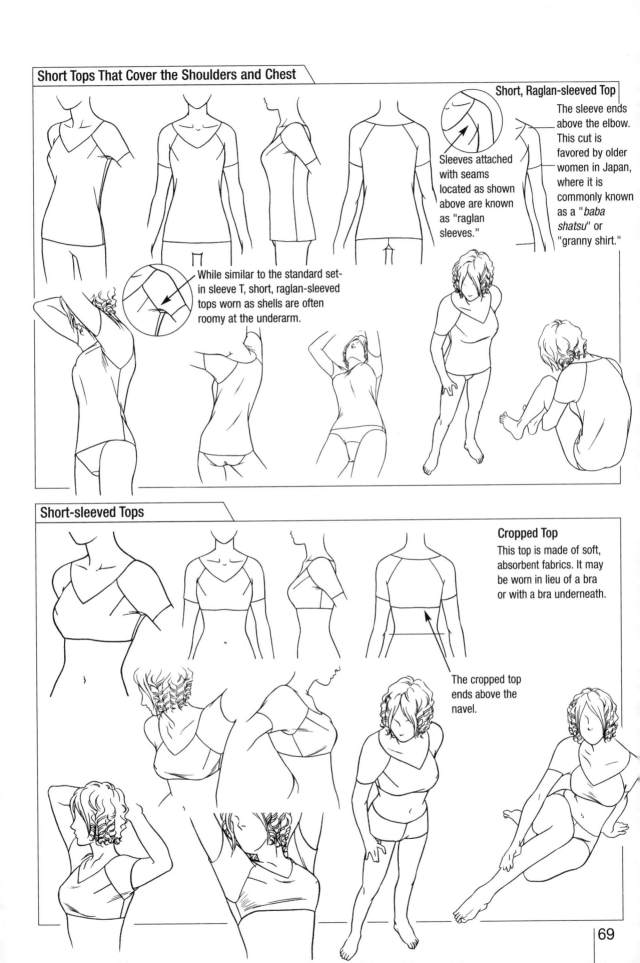

Short, Raglan-sleeved Top

The sleeve ends above the elbow. This cut is favored by older women in Japan, where it is commonly known as a "*baba shatsu*" or "granny shirt."

Sleeves attached with seams located as shown above are known as "raglan sleeves."

While similar to the standard set-in sleeve T, short, raglan-sleeved tops worn as shells are often roomy at the underarm.

Short-sleeved Tops

Cropped Top

This top is made of soft, absorbent fabrics. It may be worn in lieu of a bra or with a bra underneath.

The cropped top ends above the navel.

Babydoll (Empire Waist)

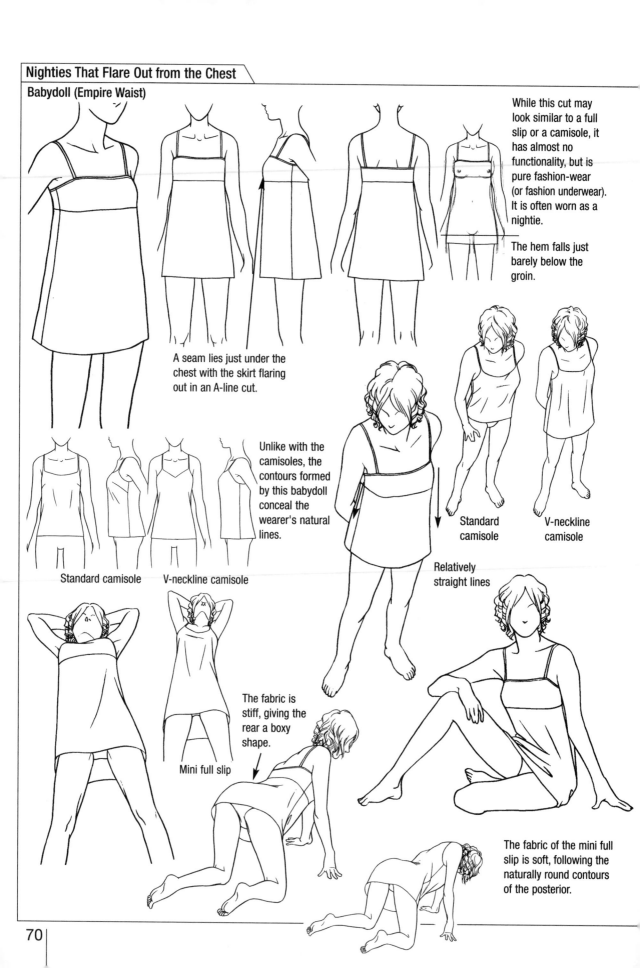

While this cut may look similar to a full slip or a camisole, it has almost no functionality, but is pure fashion-wear (or fashion underwear). It is often worn as a nightie.

The hem falls just barely below the groin.

A seam lies just under the chest with the skirt flaring out in an A-line cut.

Unlike with the camisoles, the contours formed by this babydoll conceal the wearer's natural lines.

Standard camisole

V-neckline camisole

Standard camisole

V-neckline camisole

Relatively straight lines

The fabric is stiff, giving the rear a boxy shape.

Mini full slip

The fabric of the mini full slip is soft, following the naturally round contours of the posterior.

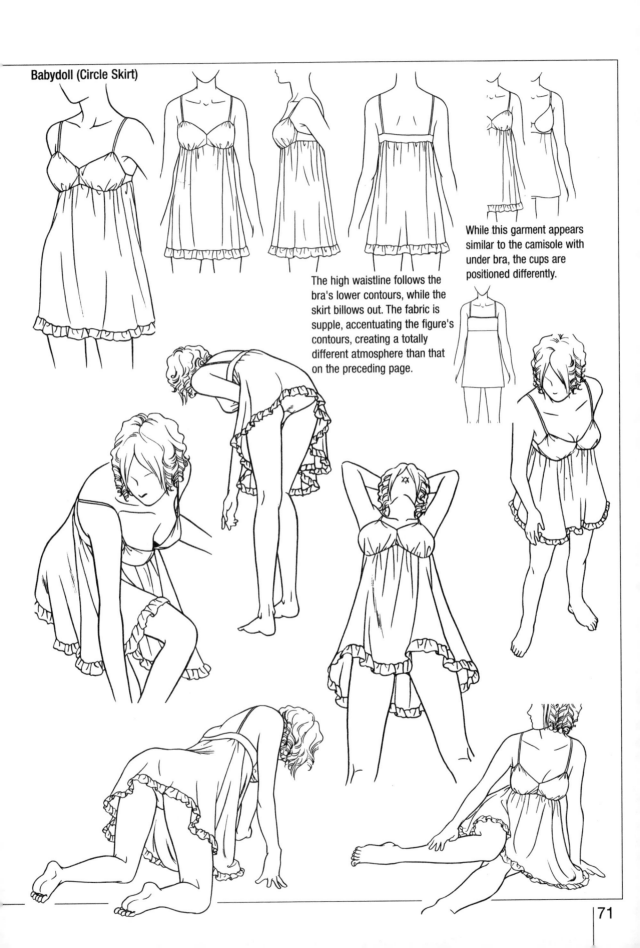

Babydoll (Circle Skirt)

The high waistline follows the bra's lower contours, while the skirt billows out. The fabric is supple, accentuating the figure's contours, creating a totally different atmosphere than that on the preceding page.

While this garment appears similar to the camisole with under bra, the cups are positioned differently.

Bottoms

The following pages present undergarments a little roomier than the tiny or snugly fitting panties discussed previously. On this page, we introduce women's boxers and other loose-fitting bottoms that contrast with the half-slips (discussed later), designed specifically to be worn underneath outer clothing.

Ladies' Boxers

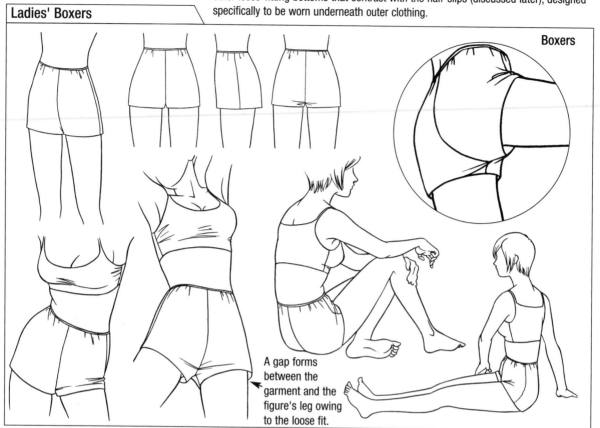

Boxers

A gap forms between the garment and the figure's leg owing to the loose fit.

Long Boxers

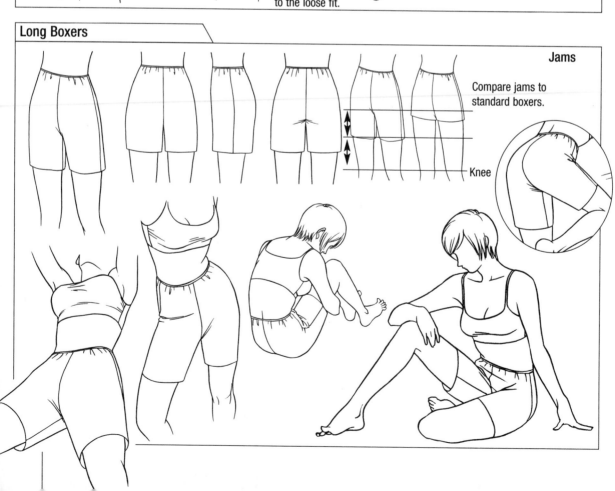

Jams

Compare jams to standard boxers.

Knee

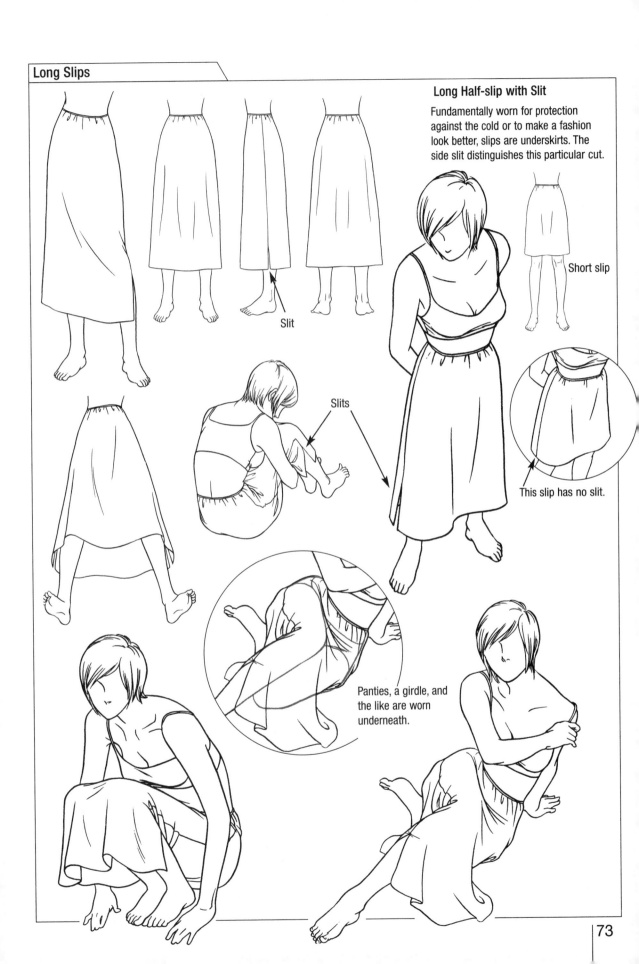

Long Half-slip with Slit

Fundamentally worn for protection against the cold or to make a fashion look better, slips are underskirts. The side slit distinguishes this particular cut.

Short slip

Slit

Slits

This slip has no slit.

Panties, a girdle, and the like are worn underneath.

Billowy Undies

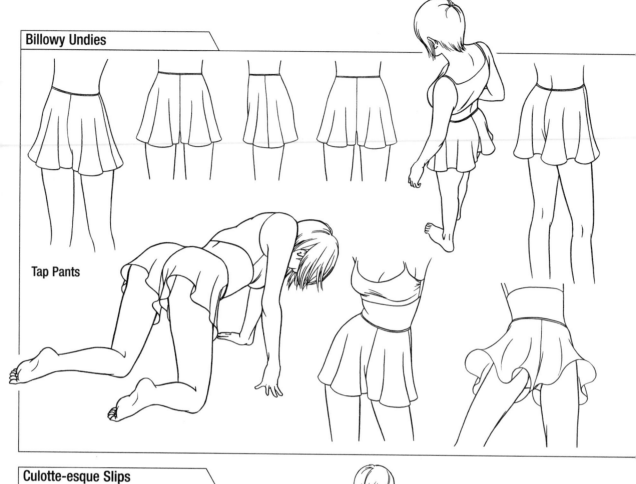

Tap Pants

Culotte-esque Slips

Split Slip

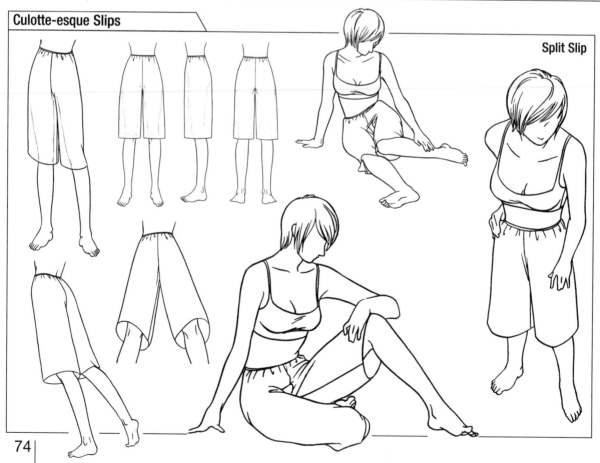

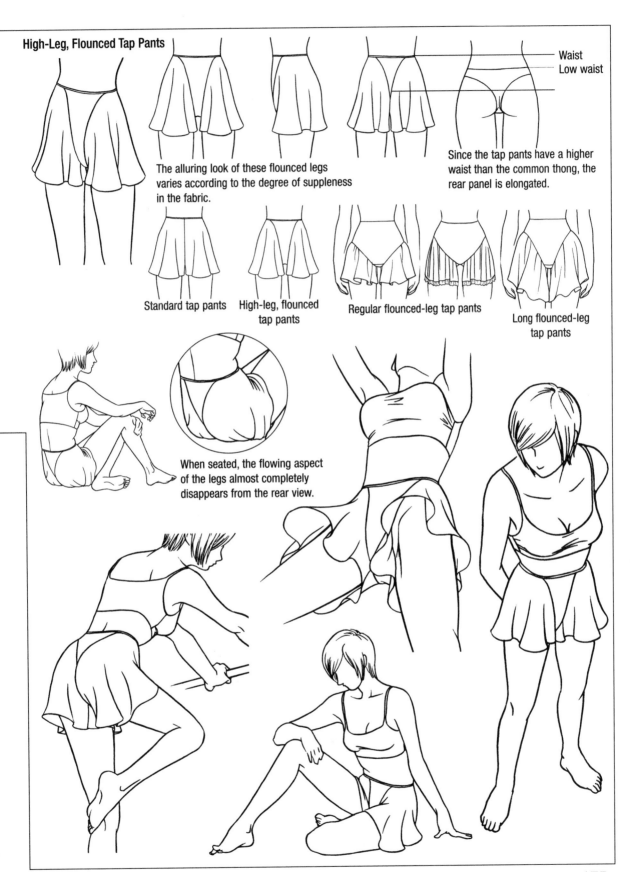

High-Leg, Flounced Tap Pants

The alluring look of these flounced legs varies according to the degree of suppleness in the fabric.

Waist
Low waist

Since the tap pants have a higher waist than the common thong, the rear panel is elongated.

Standard tap pants

High-leg, flounced tap pants

Regular flounced-leg tap pants

Long flounced-leg tap pants

When seated, the flowing aspect of the legs almost completely disappears from the rear view.

Tap Pants, Half-slips, and Petticoats

The garments on the following pages are worn underneath skirts. Some are "half-slips" or slips from the waist down. They are made of silky fabrics and improve the appearance of the outer garment over that when worn without the slip and facilitate movement. Full skirts that billow outward like an umbrella often are actually hiding underneath petticoats, which serve to augment the outer shape of the skirt. The term "underskirt" refers to petticoats, slips, and the like.

Short Tap Pants

Tap Pants (Dolphin-Short Cut)

Unlike boxers, the dolphin-short cut has an overall roundness. Moreover, boxers are often made of heavyweight, knit fabrics, while these tap pants are usually made of thin, diaphanous materials.

Boxers

Seen from the same angle, the tap pants have a softer fit.

Boxers

Narrow-legged Split Skirts

Narrow-legged Split Skirt

Very few creases form.

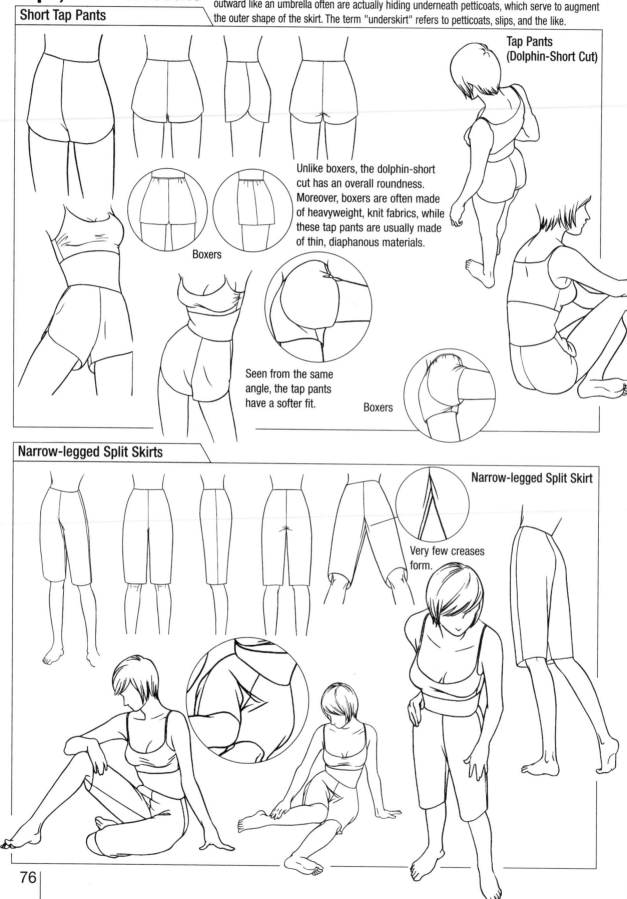

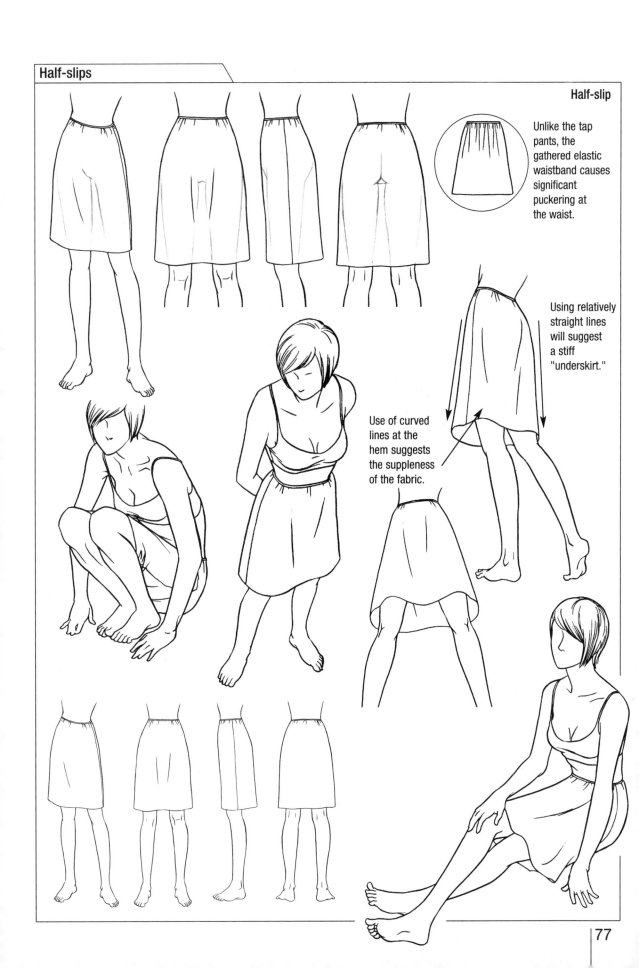

Half-slip

Unlike the tap pants, the gathered elastic waistband causes significant puckering at the waist.

Using relatively straight lines will suggest a stiff "underskirt."

Use of curved lines at the hem suggests the suppleness of the fabric.

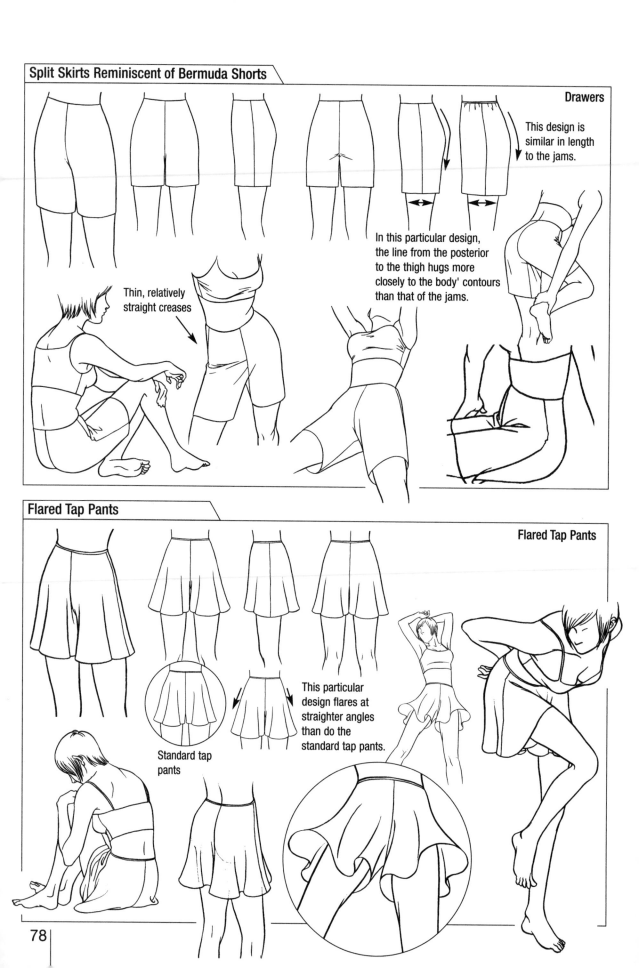

Split Skirts Reminiscent of Bermuda Shorts

Drawers

This design is similar in length to the jams.

In this particular design, the line from the posterior to the thigh hugs more closely to the body' contours than that of the jams.

Thin, relatively straight creases

Flared Tap Pants

Flared Tap Pants

Standard tap pants

This particular design flares at straighter angles than do the standard tap pants.

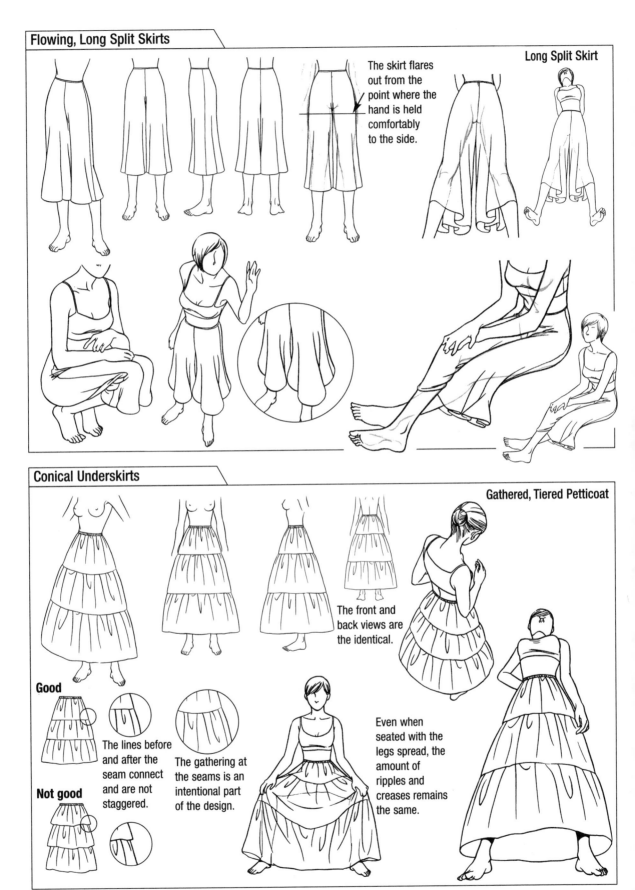

Flowing, Long Split Skirts

The skirt flares out from the point where the hand is held comfortably to the side.

Long Split Skirt

Conical Underskirts

Gathered, Tiered Petticoat

The front and back views are the identical.

Good

The lines before and after the seam connect and are not staggered.

Not good

The gathering at the seams is an intentional part of the design.

Even when seated with the legs spread, the amount of ripples and creases remains the same.

When to Wear Slips, Tap Pants, Etc.

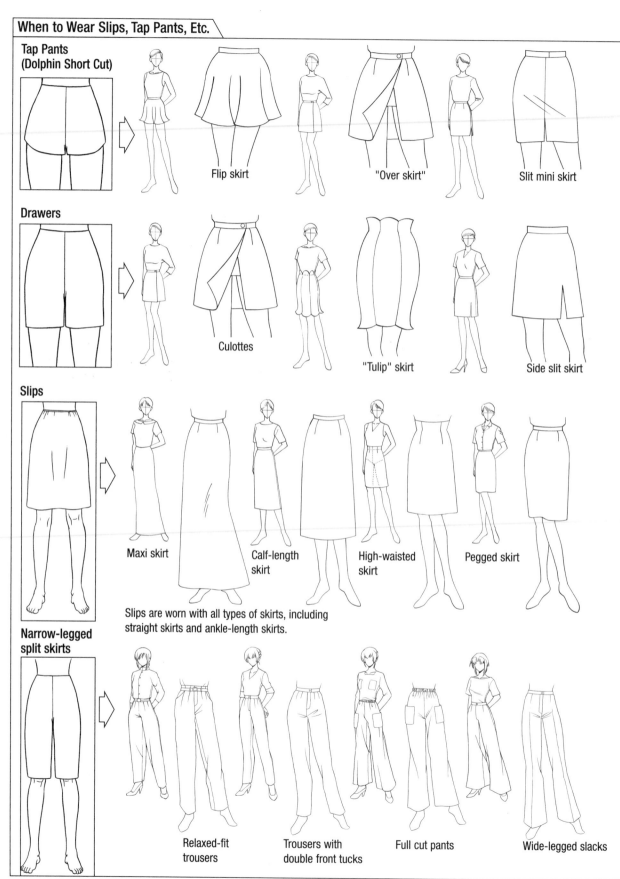

Tap Pants
(Dolphin Short Cut)

Flip skirt

"Over skirt"

Slit mini skirt

Drawers

Culottes

"Tulip" skirt

Side slit skirt

Slips

Maxi skirt

Calf-length skirt

High-waisted skirt

Pegged skirt

Slips are worn with all types of skirts, including straight skirts and ankle-length skirts.

Narrow-legged split skirts

Relaxed-fit trousers

Trousers with double front tucks

Full cut pants

Wide-legged slacks

80

*Slips, tap pants, etc. are in general worn with dressier clothes or those made of thin fabrics. They are not considered necessary with jeans or casual dress.

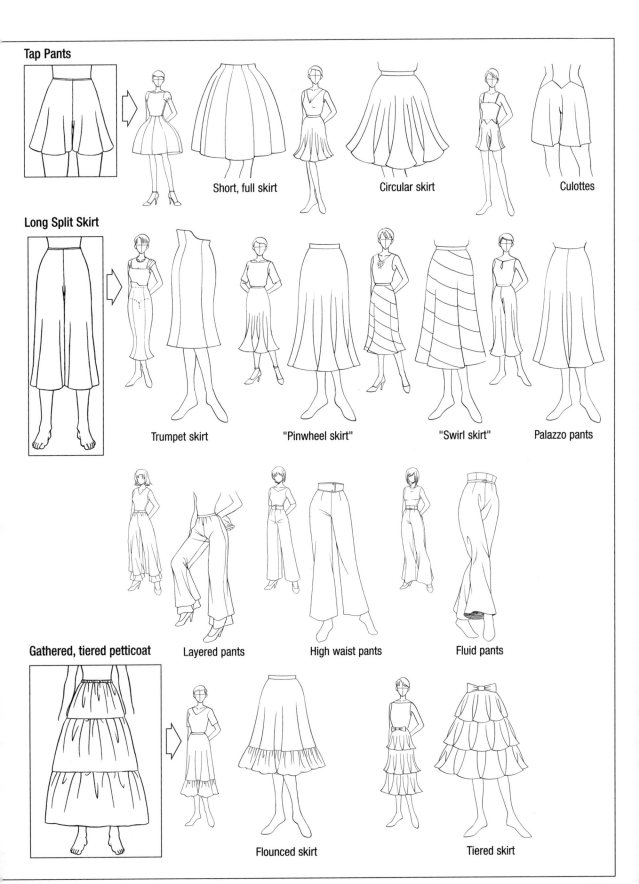

Tap Pants

Short, full skirt

Circular skirt

Culottes

Long Split Skirt

Trumpet skirt

"Pinwheel skirt"

"Swirl skirt"

Palazzo pants

Layered pants

High waist pants

Fluid pants

Gathered, tiered petticoat

Flounced skirt

Tiered skirt

Control and Support

Brassieres and girdles were developed to enhance a woman's figure. These sculpt a woman's figure into a more ideal form by providing strong support to those parts lacking firmness. These garments provide support for the breasts, hips, waist, thighs, and the whole figure.

Control Briefs

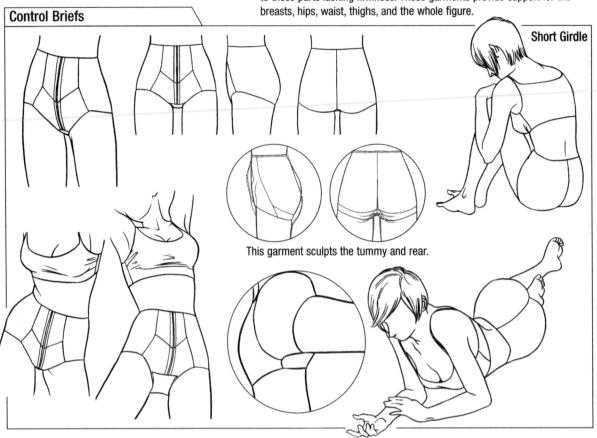

Short Girdle

This garment sculpts the tummy and rear.

Long, Mid-Thigh Girdles

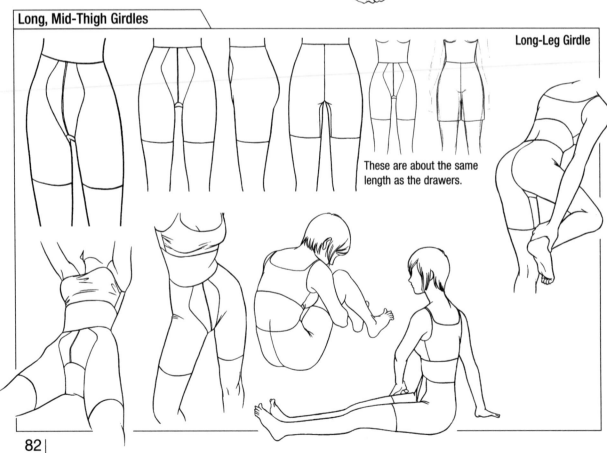

Long-Leg Girdle

These are about the same length as the drawers.

More Long-Leg Girdles

Girdles with Side Zippers

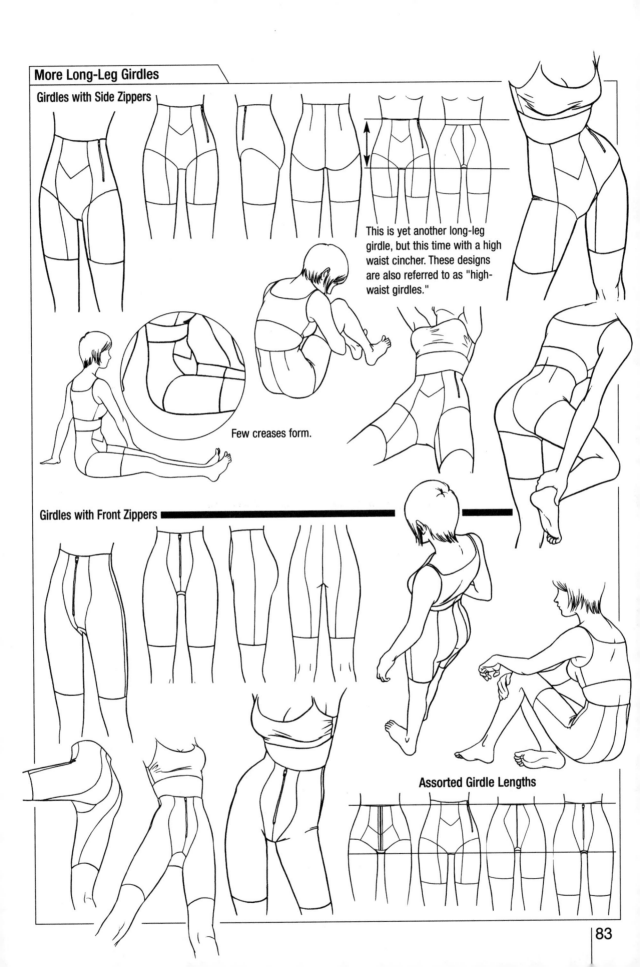

This is yet another long-leg girdle, but this time with a high waist cincher. These designs are also referred to as "high-waist girdles."

Few creases form.

Girdles with Front Zippers

Assorted Girdle Lengths

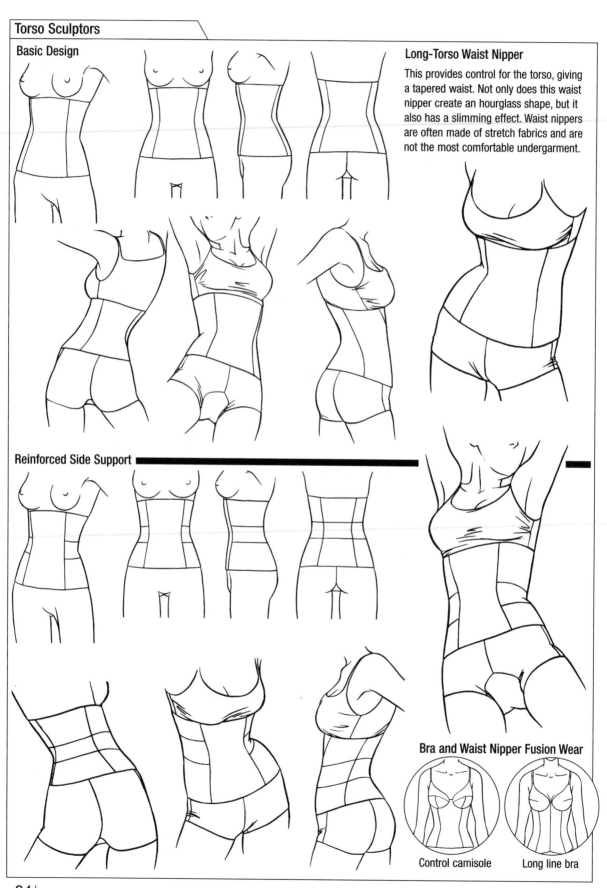

Torso Sculptors

Basic Design

Long-Torso Waist Nipper

This provides control for the torso, giving a tapered waist. Not only does this waist nipper create an hourglass shape, but it also has a slimming effect. Waist nippers are often made of stretch fabrics and are not the most comfortable undergarment.

Reinforced Side Support

Bra and Waist Nipper Fusion Wear

Control camisole

Long line bra

Corsets: Support from the Chest to the Waist

Tube Top-style Corset

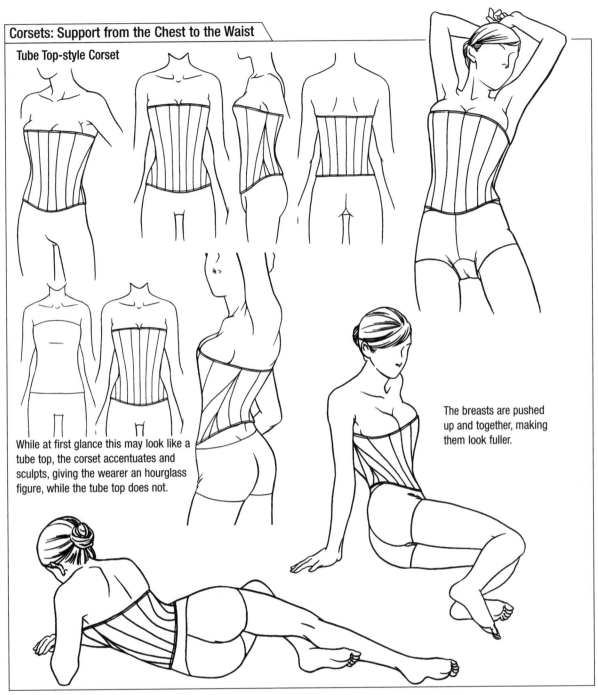

While at first glance this may look like a tube top, the corset accentuates and sculpts, giving the wearer an hourglass figure, while the tube top does not.

The breasts are pushed up and together, making them look fuller.

Waist Cinchers

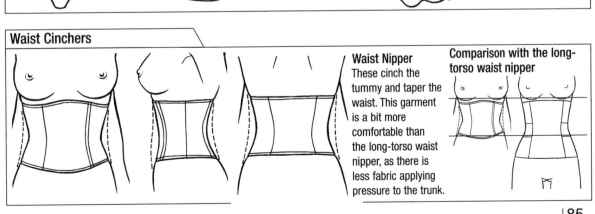

Waist Nipper
These cinch the tummy and taper the waist. This garment is a bit more comfortable than the long-torso waist nipper, as there is less fabric applying pressure to the trunk.

Comparison with the long-torso waist nipper

Under Bust Corset: Corsets Extending from the Hips to under the Breasts

Serving a similar function to the waist nipper, the corset is another support garment covering the torso from the chest to the hips.

The corset covers approximately the same area of the body as the long-torso waist nipper.

The corset is often made of highly elasticized fabric, providing a snug fit and allowing few creases to form.

Short Under Bust Corsets

Waist Nipper Corset

The lower half of the corset is often V-shaped.

This version of a corset is extremely similar to the waist nipper, but with a difference in length.

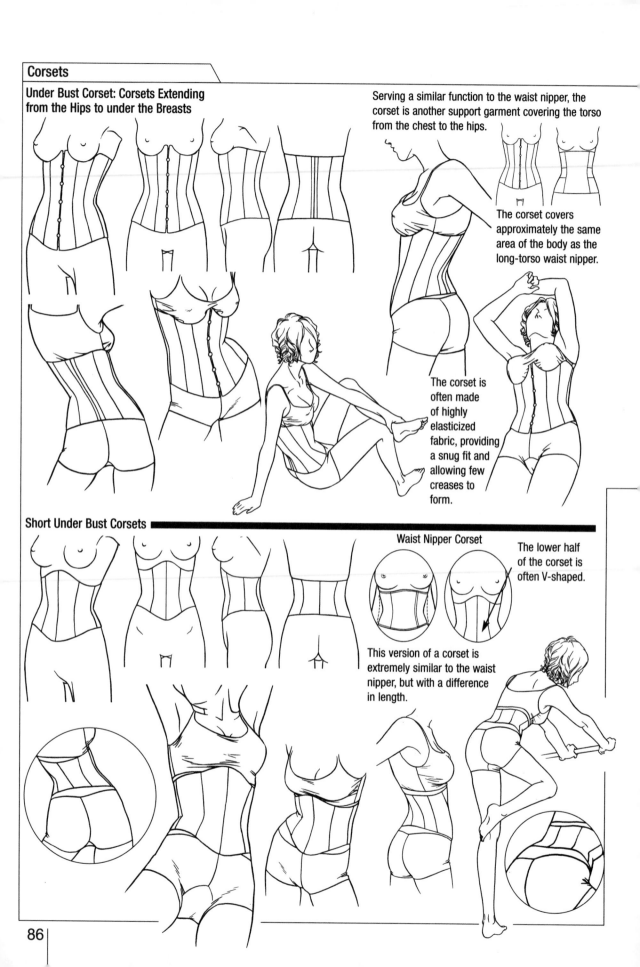

Corsets with Bra Cups

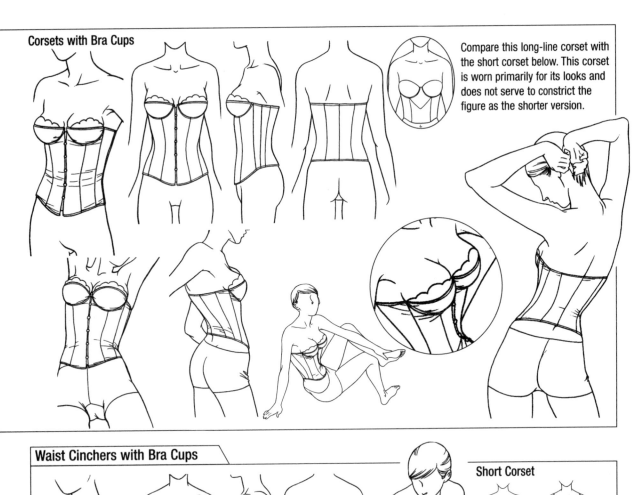

Compare this long-line corset with the short corset below. This corset is worn primarily for its looks and does not serve to constrict the figure as the shorter version.

Waist Cinchers with Bra Cups

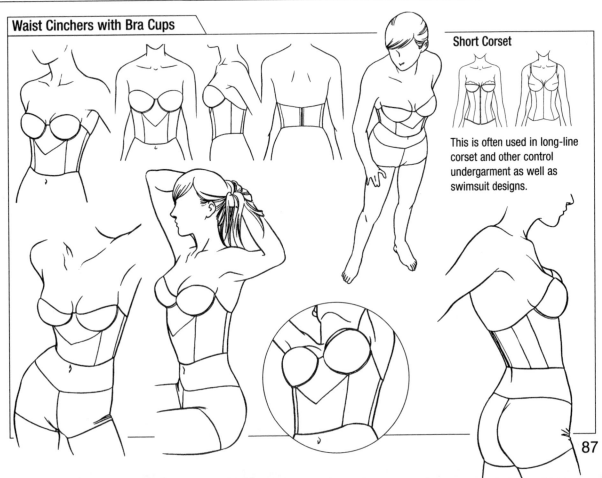

Short Corset

This is often used in long-line corset and other control undergarment as well as swimsuit designs.

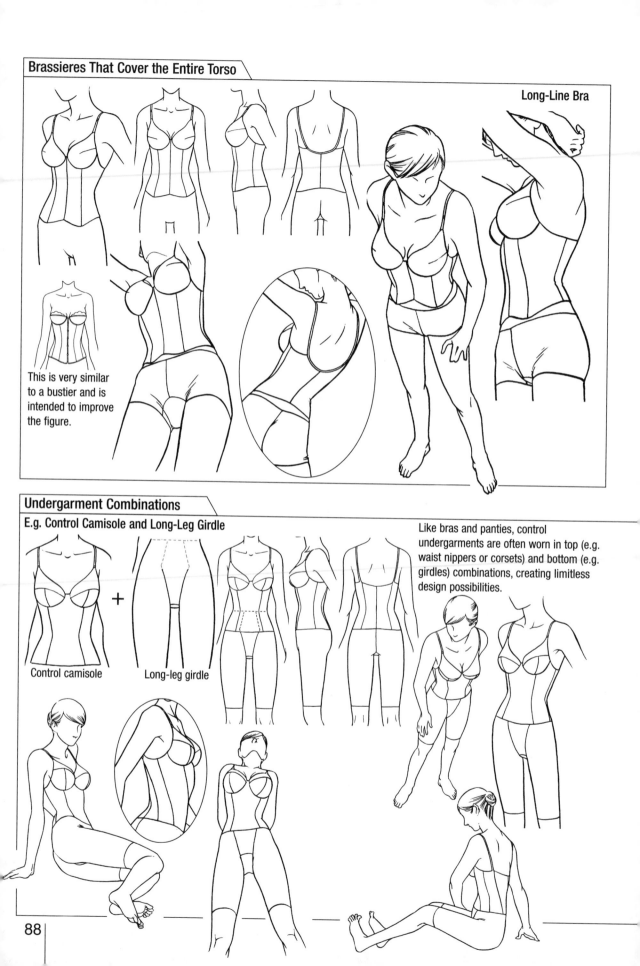

Brassieres That Cover the Entire Torso

Long-Line Bra

This is very similar to a bustier and is intended to improve the figure.

Undergarment Combinations

E.g. Control Camisole and Long-Leg Girdle

Control camisole

Long-leg girdle

Like bras and panties, control undergarments are often worn in top (e.g. waist nippers or corsets) and bottom (e.g. girdles) combinations, creating limitless design possibilities.

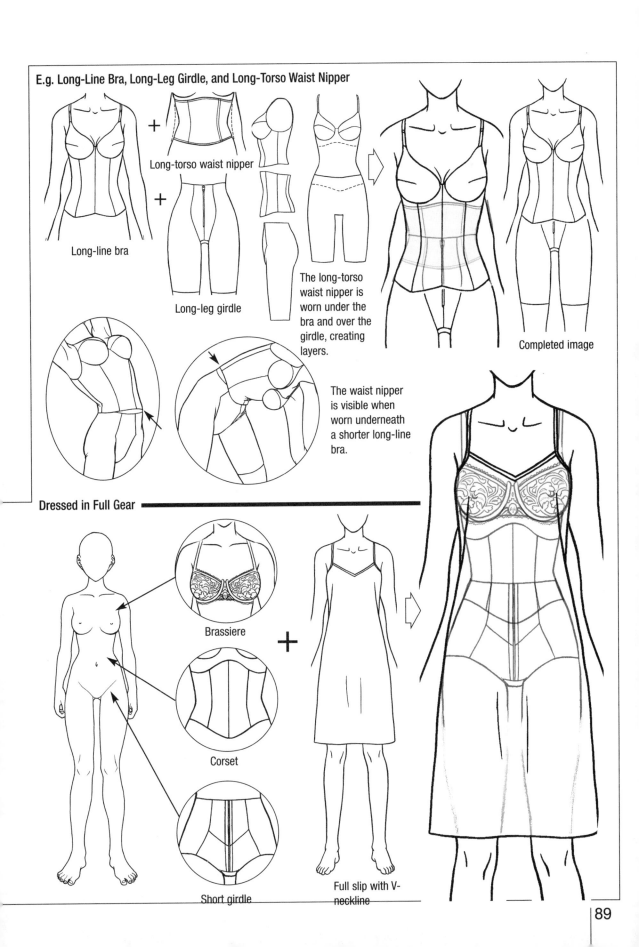

E.g. Long-Line Bra, Long-Leg Girdle, and Long-Torso Waist Nipper

Long-line bra

+

Long-torso waist nipper

+

Long-leg girdle

The long-torso waist nipper is worn under the bra and over the girdle, creating layers.

The waist nipper is visible when worn underneath a shorter long-line bra.

Completed image

Dressed in Full Gear

Brassiere

+

Corset

Short girdle

Full slip with V-neckline

Swimsuit-Like Control Undergarments

Body Briefers

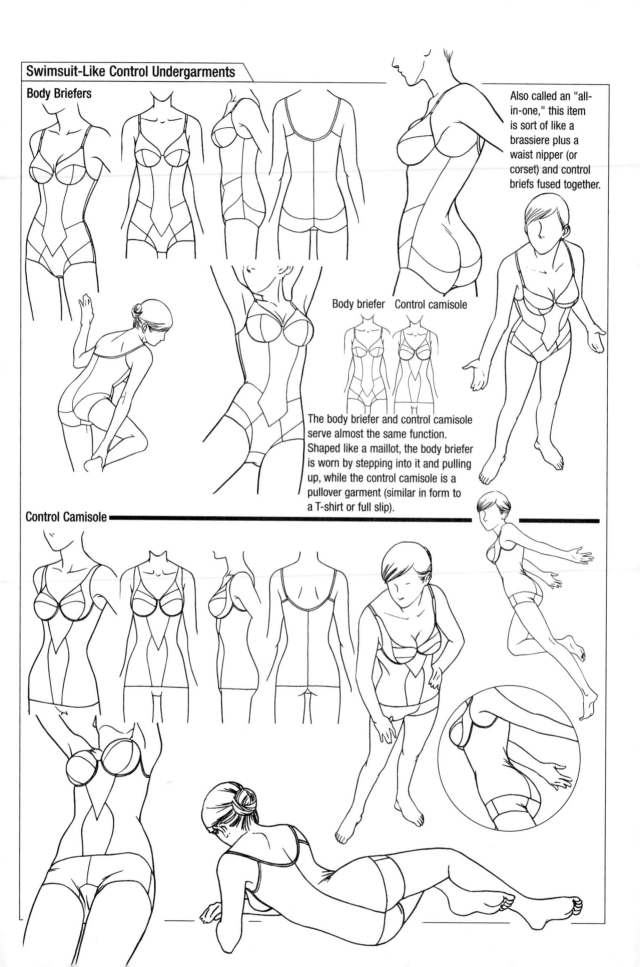

Also called an "all-in-one," this item is sort of like a brassiere plus a waist nipper (or corset) and control briefs fused together.

Body briefer Control camisole

The body briefer and control camisole serve almost the same function. Shaped like a maillot, the body briefer is worn by stepping into it and pulling up, while the control camisole is a pullover garment (similar in form to a T-shirt or full slip).

Control Camisole

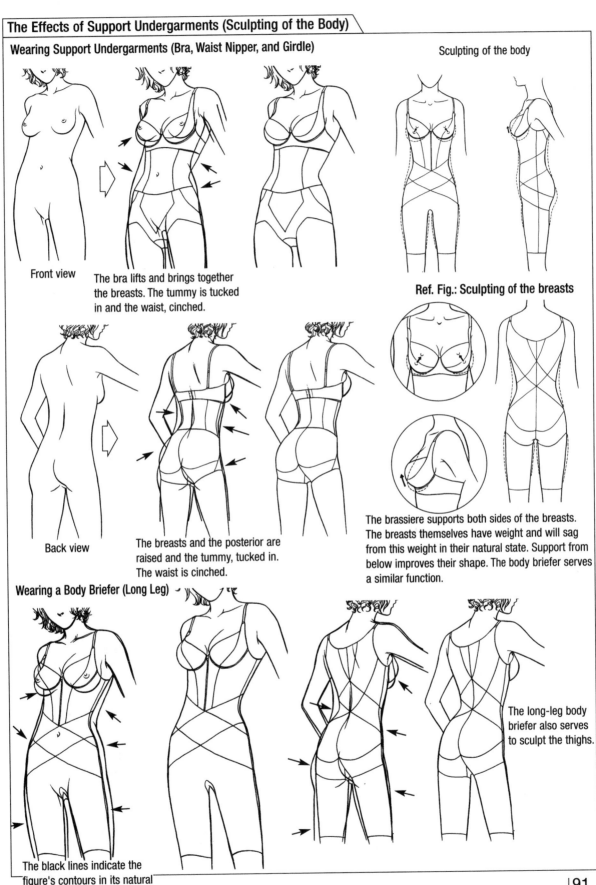

The Effects of Support Undergarments (Sculpting of the Body)

Wearing Support Undergarments (Bra, Waist Nipper, and Girdle)

Sculpting of the body

Front view

The bra lifts and brings together the breasts. The tummy is tucked in and the waist, cinched.

Ref. Fig.: Sculpting of the breasts

Back view

The breasts and the posterior are raised and the tummy, tucked in. The waist is cinched.

The brassiere supports both sides of the breasts. The breasts themselves have weight and will sag from this weight in their natural state. Support from below improves their shape. The body briefer serves a similar function.

Wearing a Body Briefer (Long Leg)

The long-leg body briefer also serves to sculpt the thighs.

The black lines indicate the figure's contours in its natural (nude) state.

91

The Figure with and without Support Undergarments

Without

With

The key differences in the with and without figures are (1) the chest, (2) the abdomen, (3) the waist, and (4) the hips. The same effects result whether wearing a body briefer or a bra, panties, and waist nipper combo.

Without

With

The chest is shapeless.

The waist does not taper.

The abdomen protrudes.

The posterior droops.

Here, the waist hardly tapers, resulting in rather straight up-and-down lines. The lack of the bra allows the nipples to show through.

In this figure, the chest contours are clean, and the curves of the waist and hips result in a pleasing hourglass form.

Here, the divisions of the chest and figure contours are clearly delineated, and the posterior is raised.

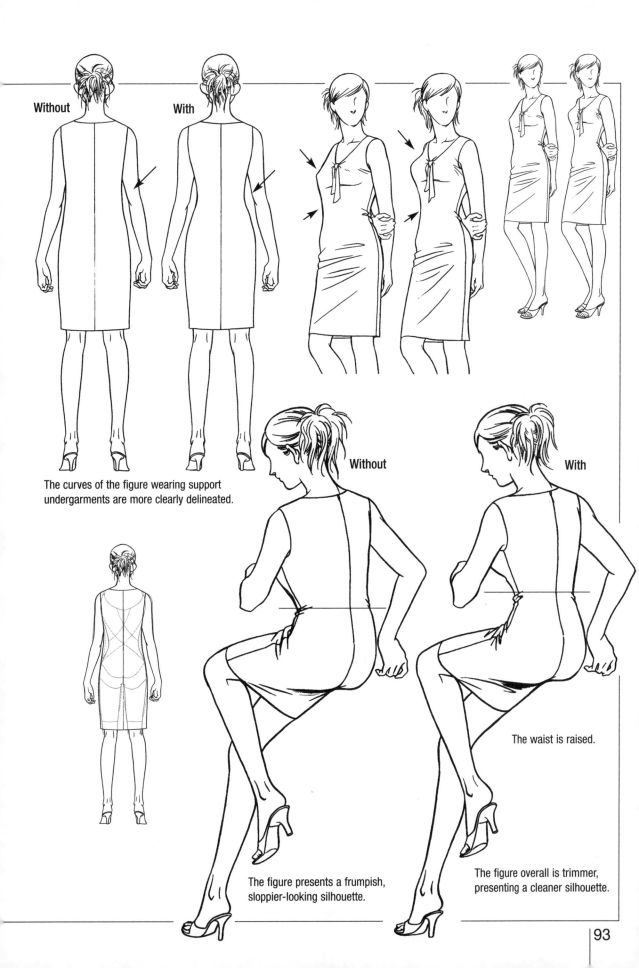

Without

With

The curves of the figure wearing support undergarments are more clearly delineated.

Without

With

The waist is raised.

The figure presents a frumpish, sloppier-looking silhouette.

The figure overall is trimmer, presenting a cleaner silhouette.

Breast Enhancement Items

Unpadded Bra

With average-sized breasts, an unpadded bra will not create much cleavage.

Natural swell of the breasts

Pad Inserts

The pads are about palm-size.

Side

Top

Small Pads

The breasts rise according to the pad size.

This creates the illusion of a relatively natural-looking "large cup size."

Large Pads

The breasts are made so full that they begin to spill out of the bra.

Now, the chest takes on that *manga*-esque bowl shape.

Tape

This technique is often used with swimsuits. It forces down the nipples and pushes the breasts together, creating the illusion of increased volume.

Here, the breasts become unnaturally accentuated, rendering them misshapen and distorted.

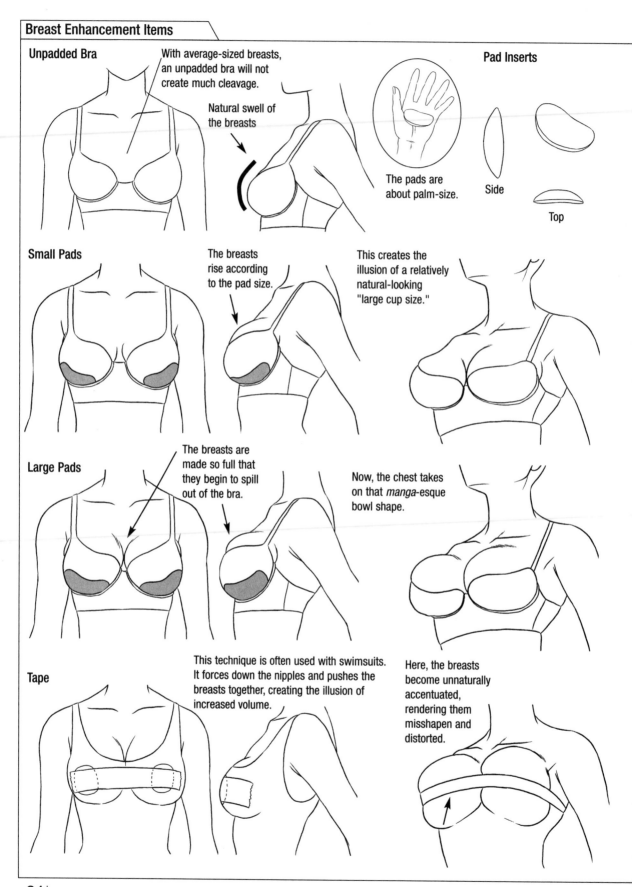

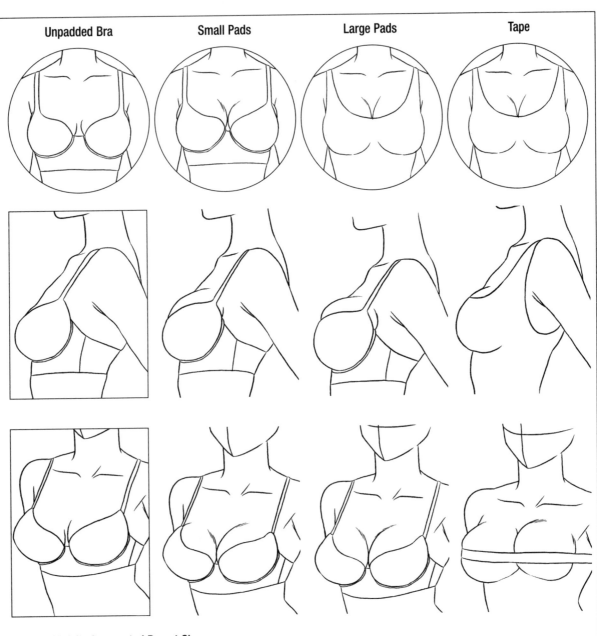

Unpadded Bra	Small Pads	Large Pads	Tape

More Artificially Augmented Breast Shapes

Shapes resulting from
the bra worn

Globular breasts resulting from
a body stocking

Stockings

While today, stockings are made of thin, sheer fabric, they were originally a covering for the foot ending about mid-thigh, distinguished from the sock, which would end about knee-level. Recently, such length distinctions have become blurred.

Thigh-High Stockings

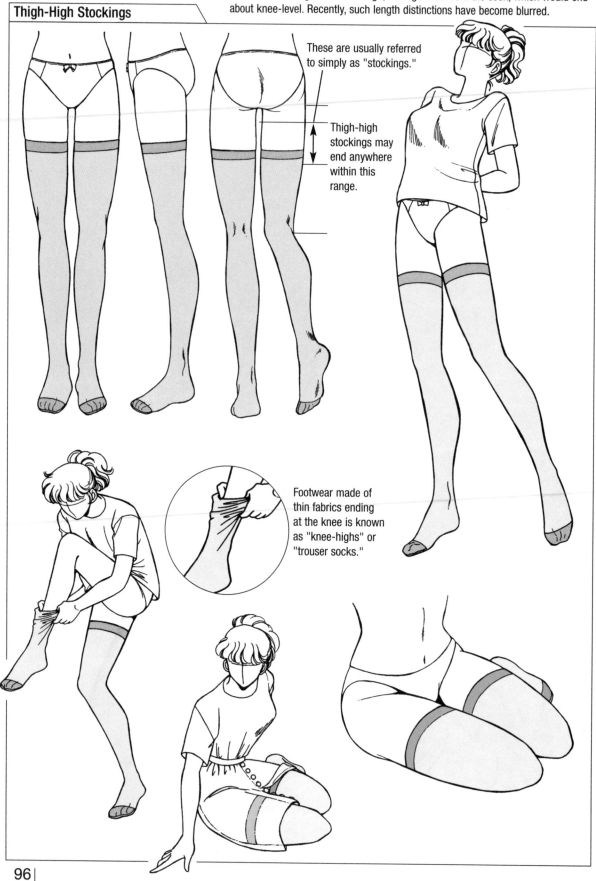

These are usually referred to simply as "stockings."

Thigh-high stockings may end anywhere within this range.

Footwear made of thin fabrics ending at the knee is known as "knee-highs" or "trouser socks."

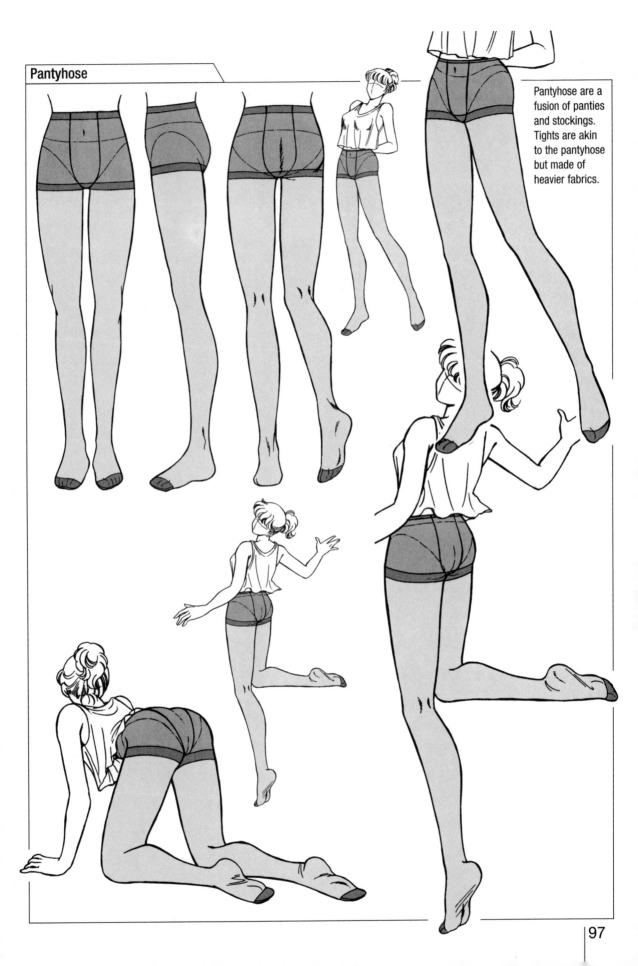

Pantyhose

Pantyhose are a fusion of panties and stockings. Tights are akin to the pantyhose but made of heavier fabrics.

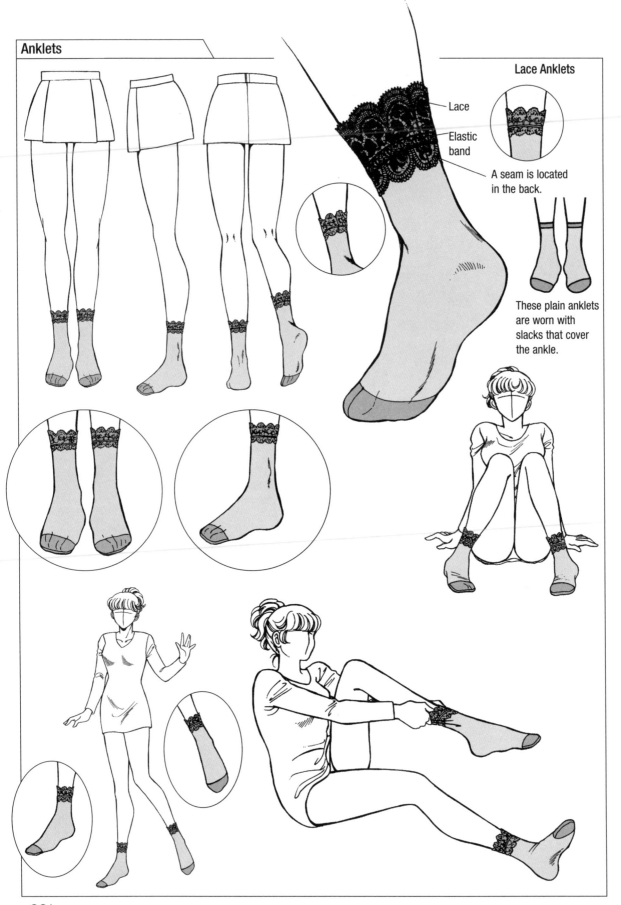

Anklets

Lace Anklets

Lace

Elastic band

A seam is located in the back.

These plain anklets are worn with slacks that cover the ankle.

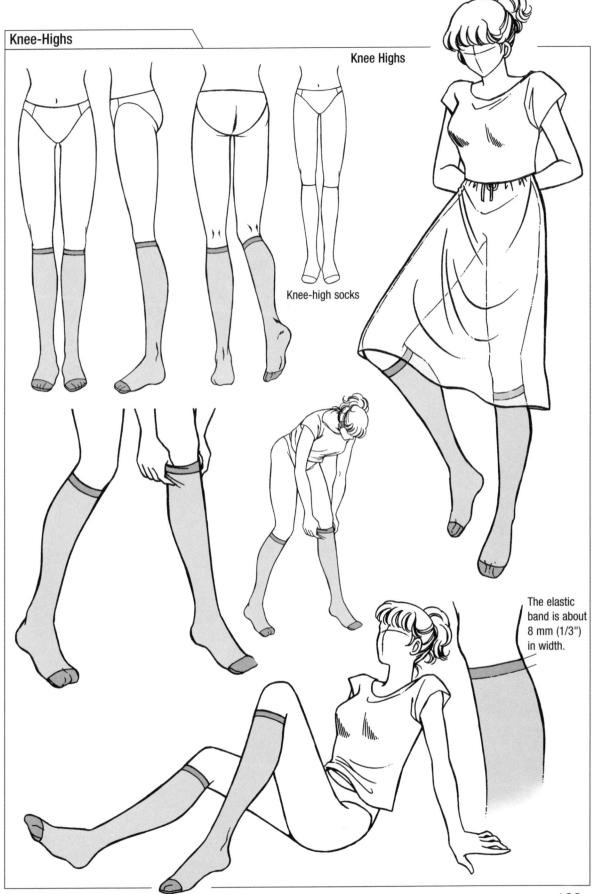

Knee-Highs

Knee Highs

Knee-high socks

The elastic band is about 8 mm (1/3") in width.

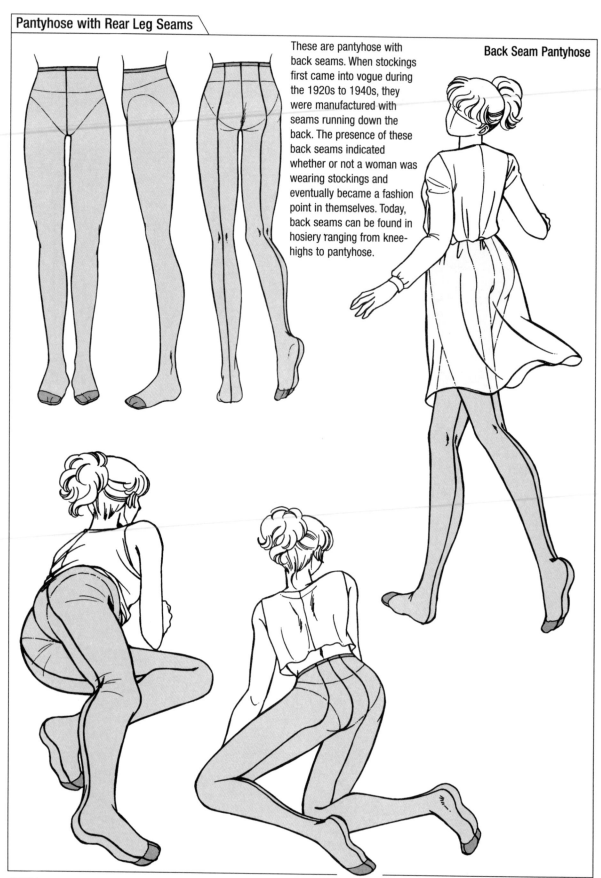

Back Seam Pantyhose

These are pantyhose with back seams. When stockings first came into vogue during the 1920s to 1940s, they were manufactured with seams running down the back. The presence of these back seams indicated whether or not a woman was wearing stockings and eventually became a fashion point in themselves. Today, back seams can be found in hosiery ranging from knee-highs to pantyhose.

Drawing Stockings and Socks

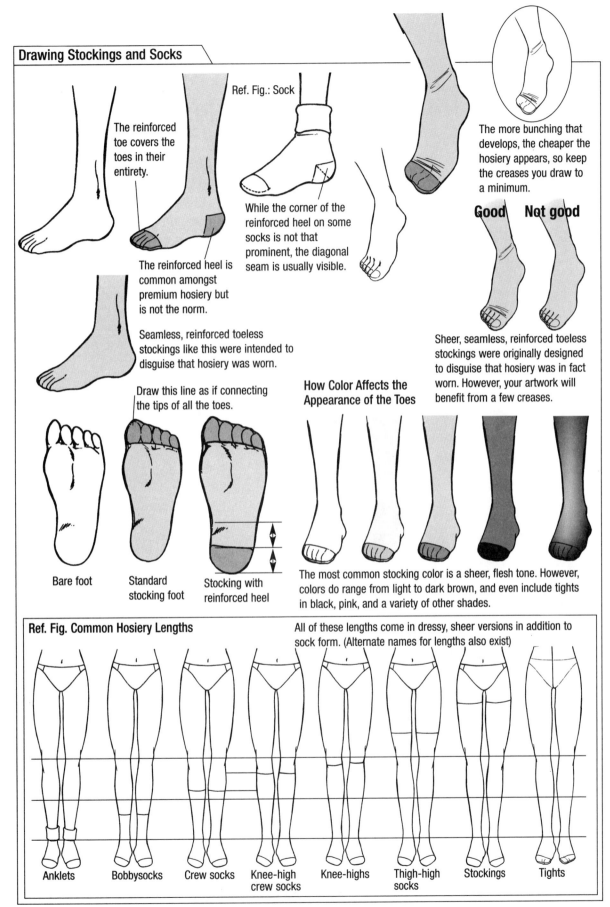

The reinforced toe covers the toes in their entirety.

The reinforced heel is common amongst premium hosiery but is not the norm.

Seamless, reinforced toeless stockings like this were intended to disguise that hosiery was worn.

Ref. Fig.: Sock

While the corner of the reinforced heel on some socks is not that prominent, the diagonal seam is usually visible.

The more bunching that develops, the cheaper the hosiery appears, so keep the creases you draw to a minimum.

Good Not good

Sheer, seamless, reinforced toeless stockings were originally designed to disguise that hosiery was in fact worn. However, your artwork will benefit from a few creases.

Draw this line as if connecting the tips of all the toes.

How Color Affects the Appearance of the Toes

Bare foot

Standard stocking foot

Stocking with reinforced heel

The most common stocking color is a sheer, flesh tone. However, colors do range from light to dark brown, and even include tights in black, pink, and a variety of other shades.

Ref. Fig. Common Hosiery Lengths

All of these lengths come in dressy, sheer versions in addition to sock form. (Alternate names for lengths also exist)

| Anklets | Bobbysocks | Crew socks | Knee-high crew socks | Knee-highs | Thigh-high socks | Stockings | Tights |

*Anklets, bobbysocks, and knee-highs may be worn folded over (once or twice).

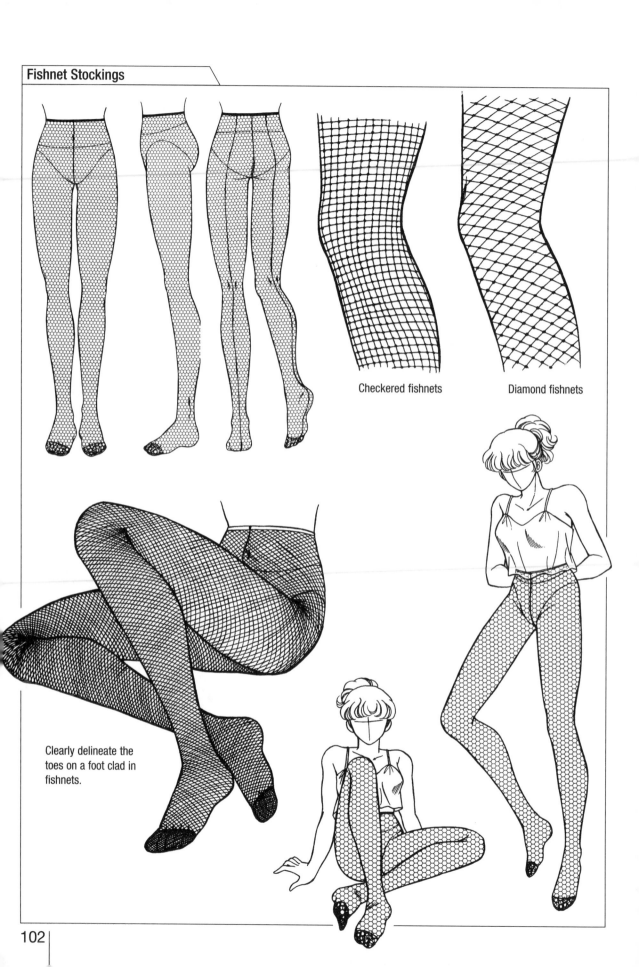

Fishnet Stockings

Checkered fishnets

Diamond fishnets

Clearly delineate the toes on a foot clad in fishnets.

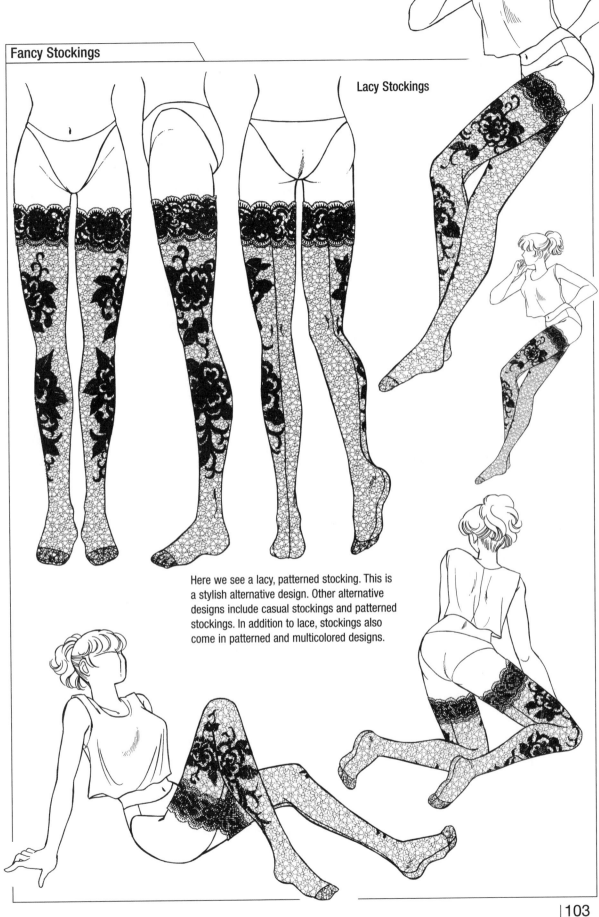

Fancy Stockings

Lacy Stockings

Here we see a lacy, patterned stocking. This is a stylish alternative design. Other alternative designs include casual stockings and patterned stockings. In addition to lace, stockings also come in patterned and multicolored designs.

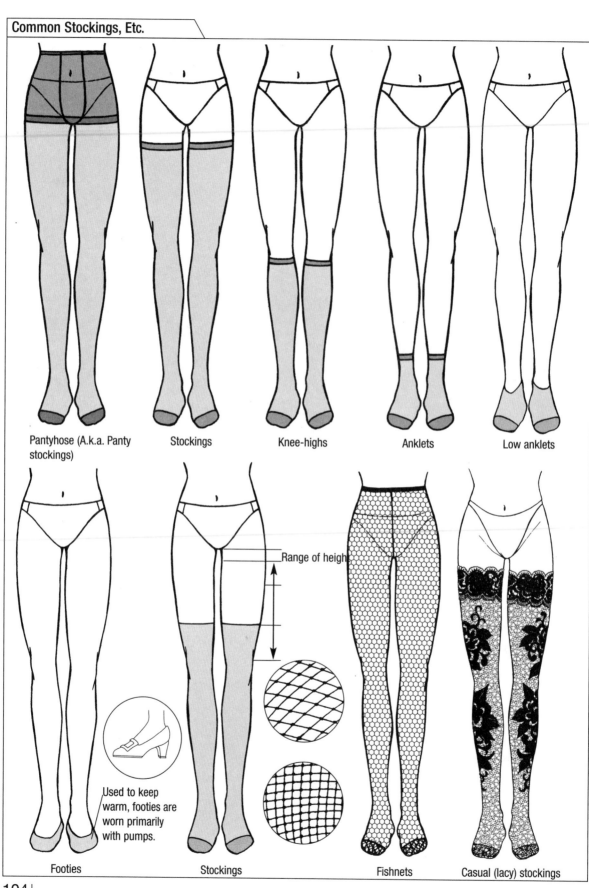

Pantyhose (A.k.a. Panty stockings)

Stockings

Knee-highs

Anklets

Low anklets

Footies

Used to keep warm, footies are worn primarily with pumps.

Stockings

Range of height

Fishnets

Casual (lacy) stockings

Garter Belts

Garters are suspended straps attached to stockings or socks to prevent them from falling down. A garter belt is a band worn at the waist to which 2 to 4 garters attach.

The Components of a Garter Belt

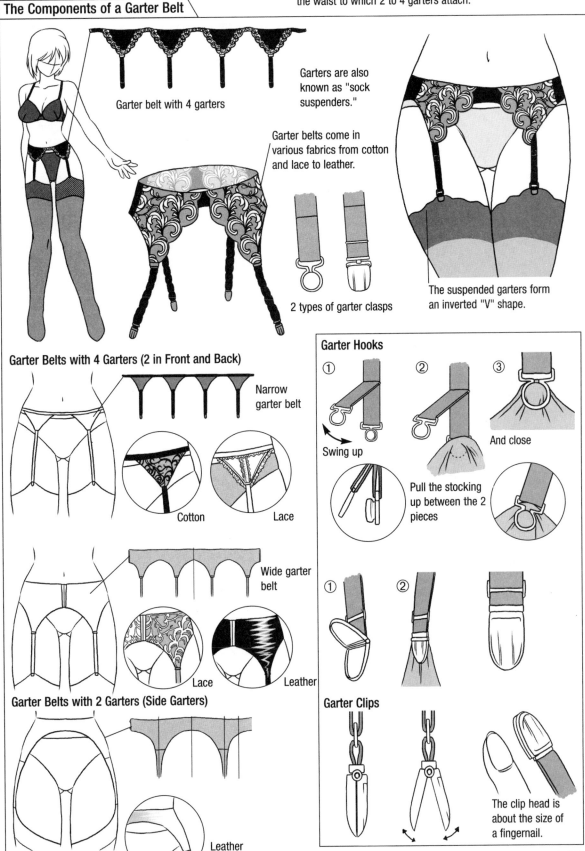

Garter belt with 4 garters

Garters are also known as "sock suspenders."

Garter belts come in various fabrics from cotton and lace to leather.

2 types of garter clasps

The suspended garters form an inverted "V" shape.

Garter Belts with 4 Garters (2 in Front and Back)

Narrow garter belt

Cotton

Lace

Wide garter belt

Lace

Leather

Garter Belts with 2 Garters (Side Garters)

Leather

Garter Hooks

① Swing up

② Pull the stocking up between the 2 pieces

③ And close

①

②

Garter Clips

The clip head is about the size of a fingernail.

Comparison between Garter Belts with 4 and 2 Garters

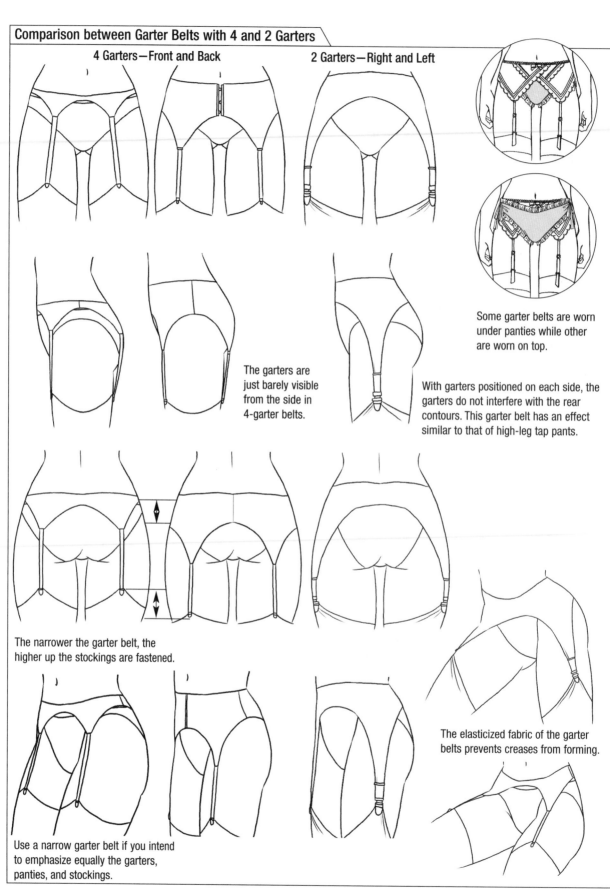

4 Garters—Front and Back

2 Garters—Right and Left

The garters are just barely visible from the side in 4-garter belts.

Some garter belts are worn under panties while other are worn on top.

With garters positioned on each side, the garters do not interfere with the rear contours. This garter belt has an effect similar to that of high-leg tap pants.

The narrower the garter belt, the higher up the stockings are fastened.

The elasticized fabric of the garter belts prevents creases from forming.

Use a narrow garter belt if you intend to emphasize equally the garters, panties, and stockings.

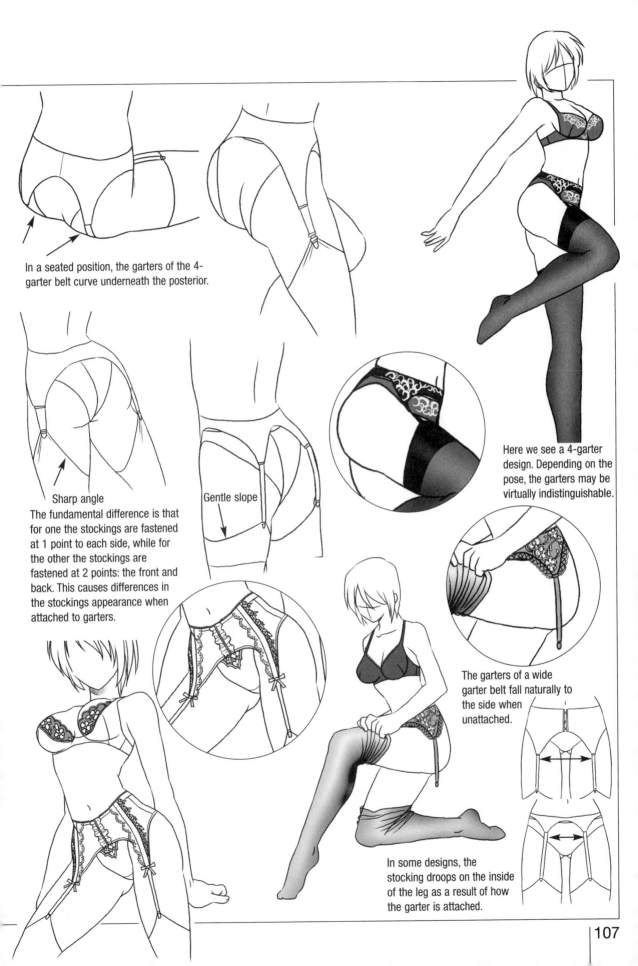

In a seated position, the garters of the 4-garter belt curve underneath the posterior.

Sharp angle

The fundamental difference is that for one the stockings are fastened at 1 point to each side, while for the other the stockings are fastened at 2 points: the front and back. This causes differences in the stockings appearance when attached to garters.

Gentle slope

Here we see a 4-garter design. Depending on the pose, the garters may be virtually indistinguishable.

The garters of a wide garter belt fall naturally to the side when unattached.

In some designs, the stocking droops on the inside of the leg as a result of how the garter is attached.

Bustiers

This is a stylish undergarment whose design was inspired by the corset. The bustier was already in existence in the early 1800s and came into vogue in the mid 20th c. after World War II. It later gained popularity and, along with the camisole, became worn as simple, casual clothing for exterior wear.

Lacy, Frilly Bustiers with Wide Straps

Bustiers often come with detachable shoulder straps. Bustiers with permanent straps are candidate casual wear.

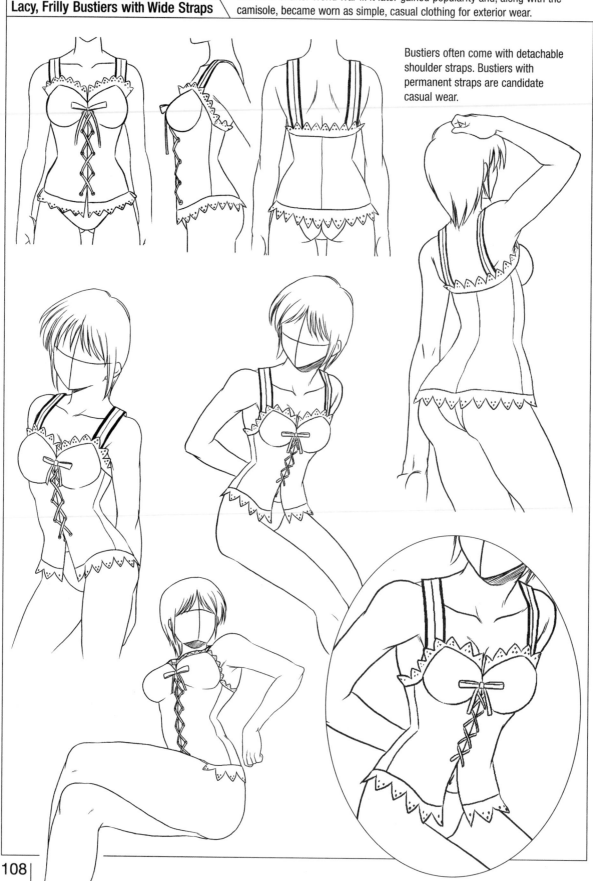

Corsets

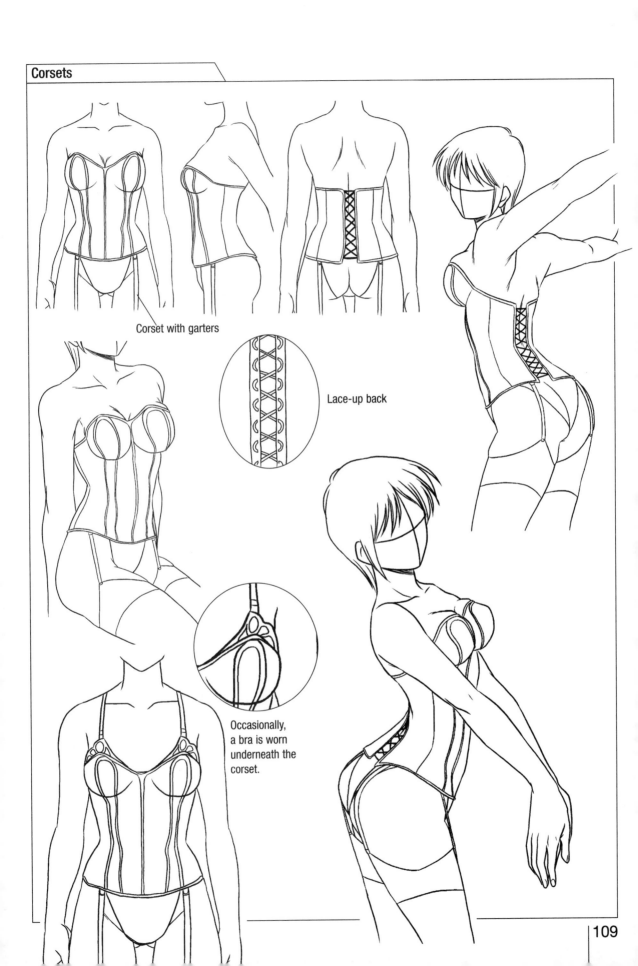

Corset with garters

Lace-up back

Occasionally, a bra is worn underneath the corset.

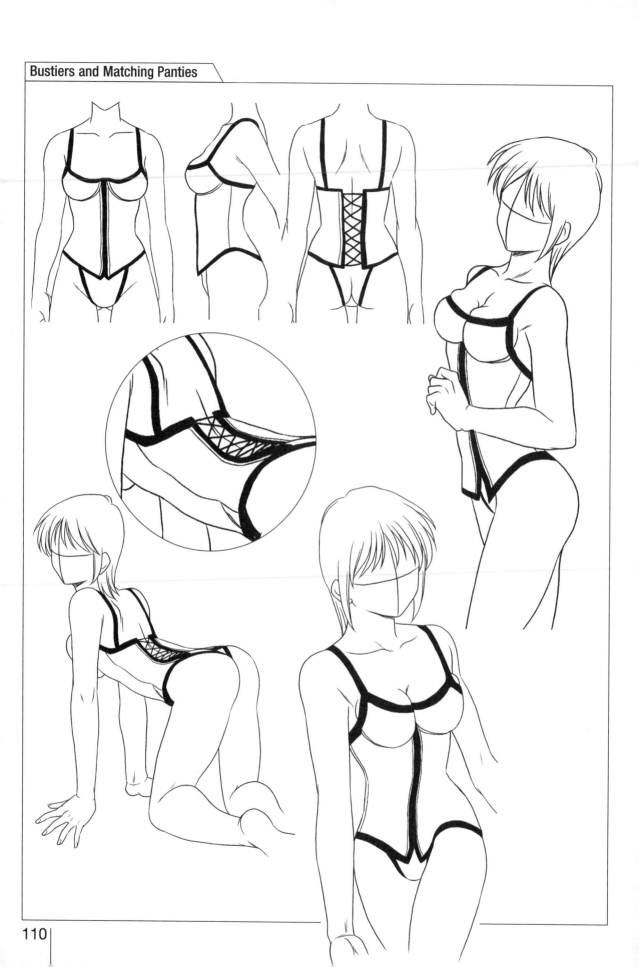

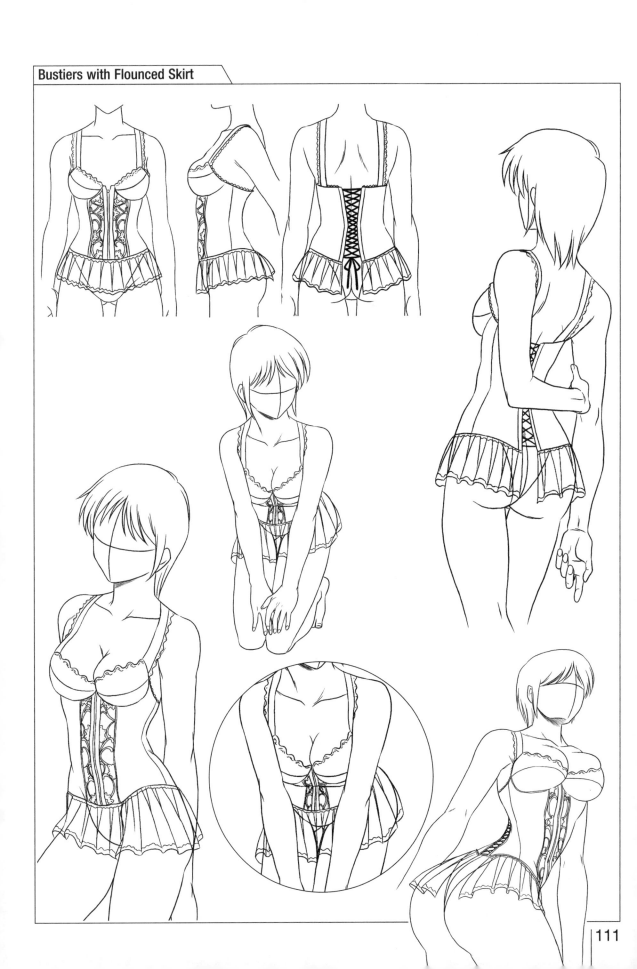

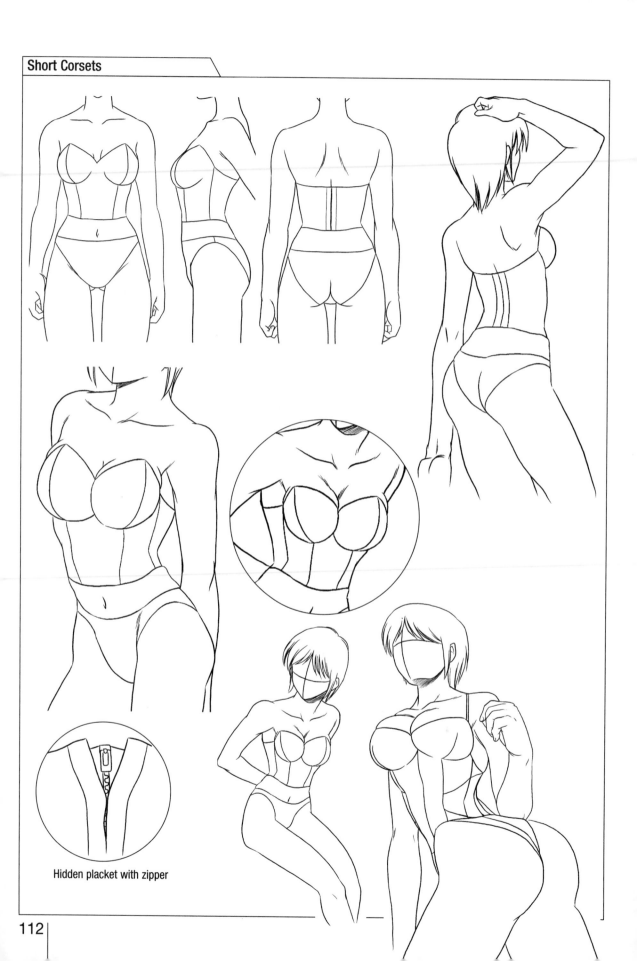

Hidden placket with zipper

Body-Briefer-like Control Camisoles

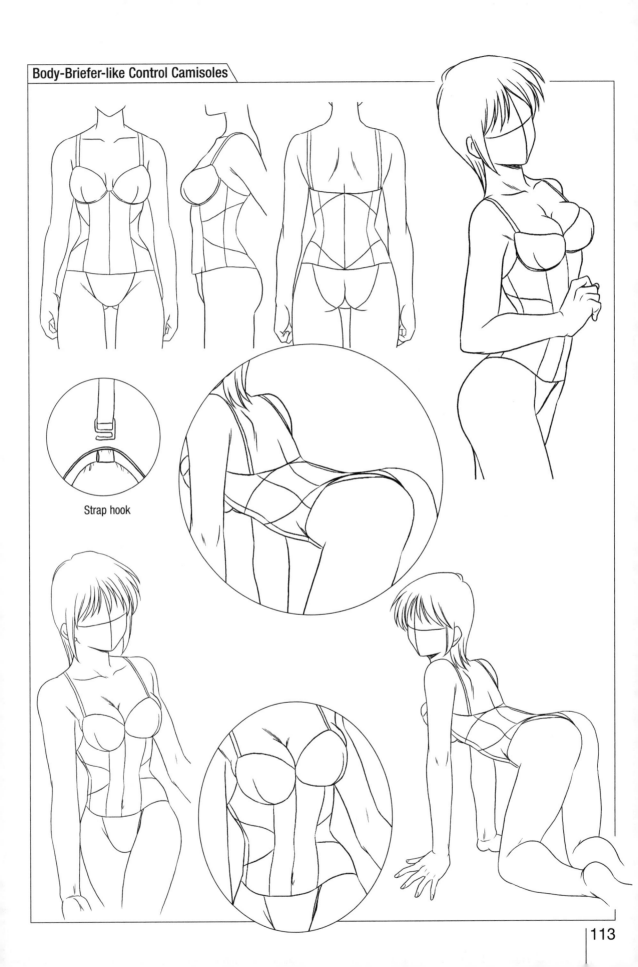

Strap hook

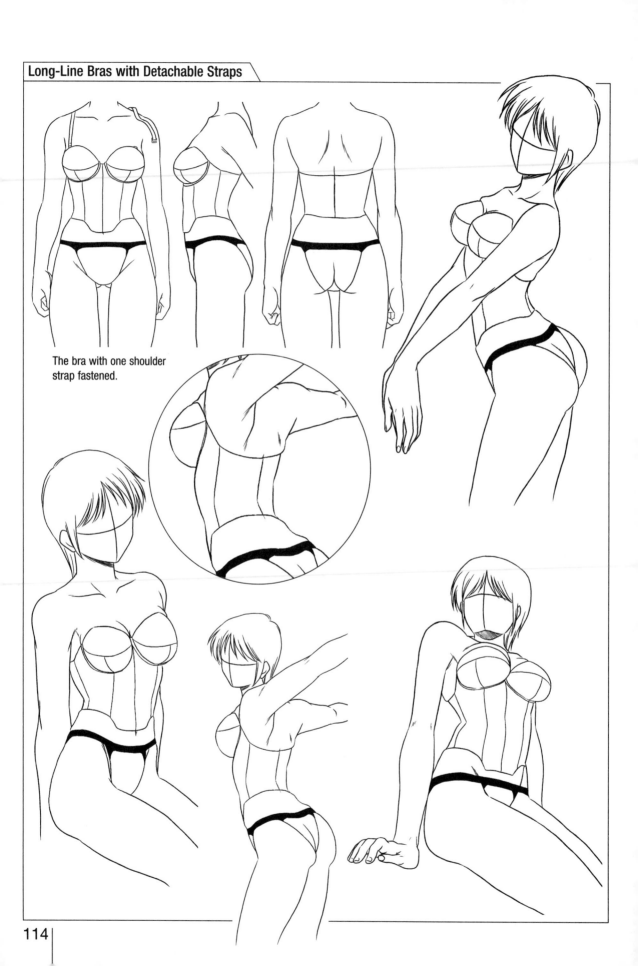

The bra with one shoulder
strap fastened.

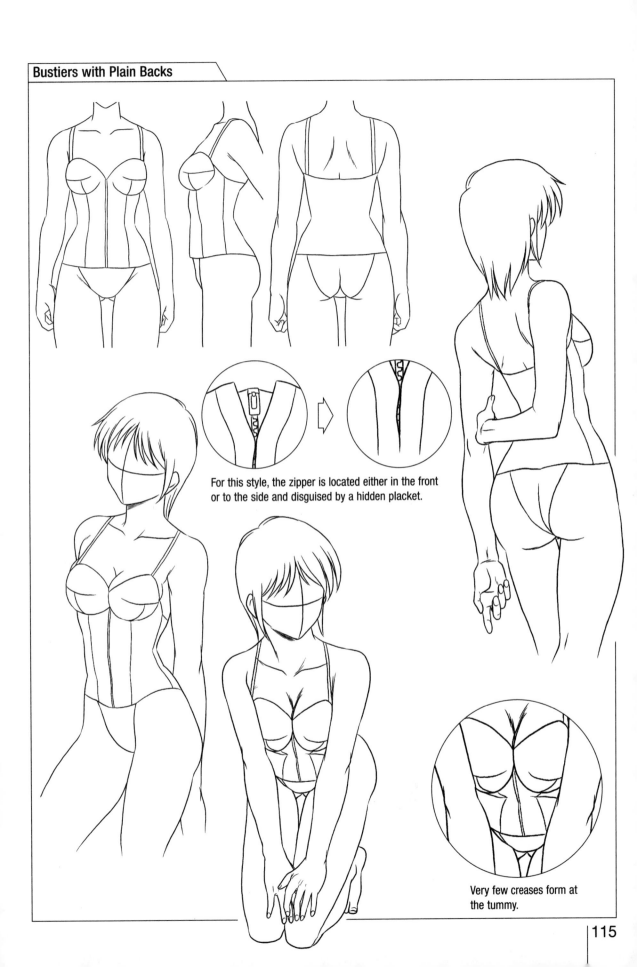

For this style, the zipper is located either in the front or to the side and disguised by a hidden placket.

Very few creases form at the tummy.

Coordinating Tops and Bottoms

Try to achieve a pleasing balance when coordinating bras and panties and other tops (e.g. camisoles, etc.) and bottoms (e.g. slips and tap pants). Think of matching designs of similar shapes or similar colors as different from a "bra-and-panty set."

Matching up Bras and Panties

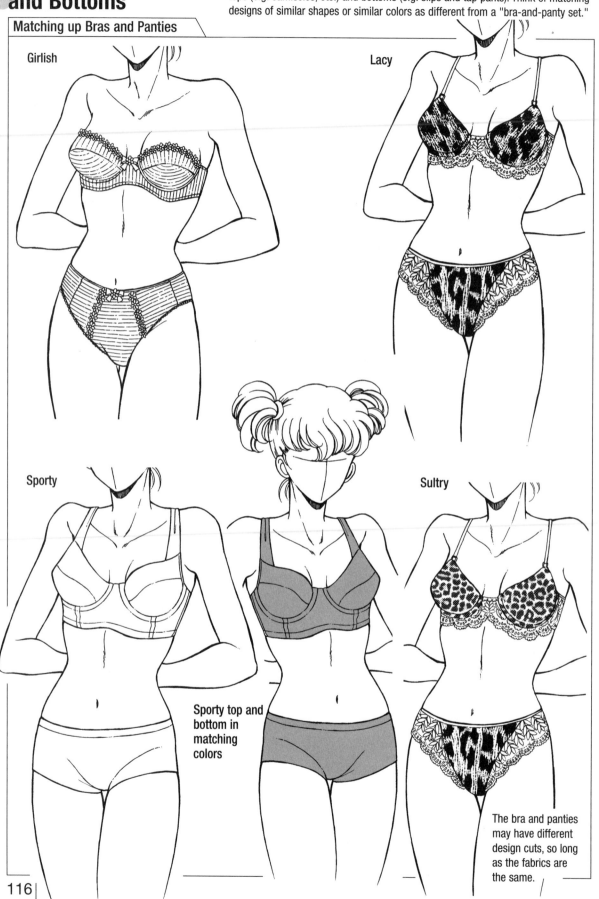

Girlish

Lacy

Sporty

Sporty top and bottom in matching colors

Sultry

The bra and panties may have different design cuts, so long as the fabrics are the same.

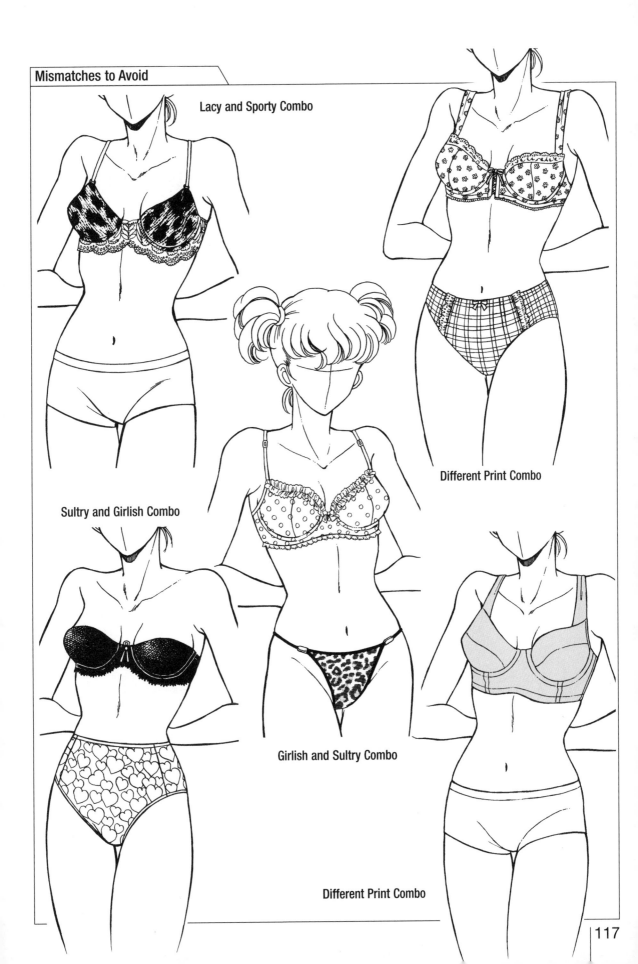

Lacy and Sporty Combo

Different Print Combo

Sultry and Girlish Combo

Girlish and Sultry Combo

Different Print Combo

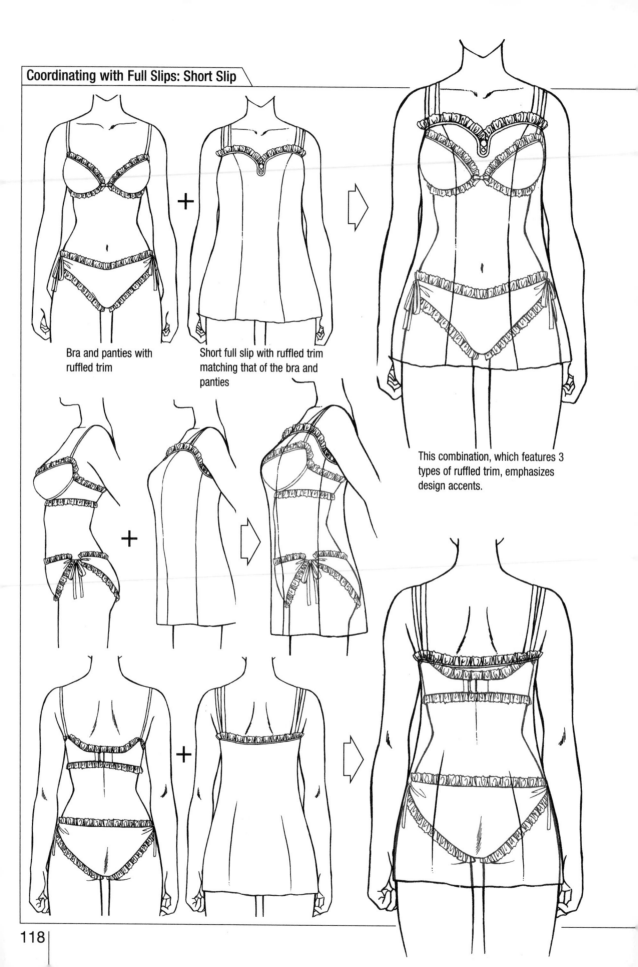

Bra and panties with ruffled trim

Short full slip with ruffled trim matching that of the bra and panties

This combination, which features 3 types of ruffled trim, emphasizes design accents.

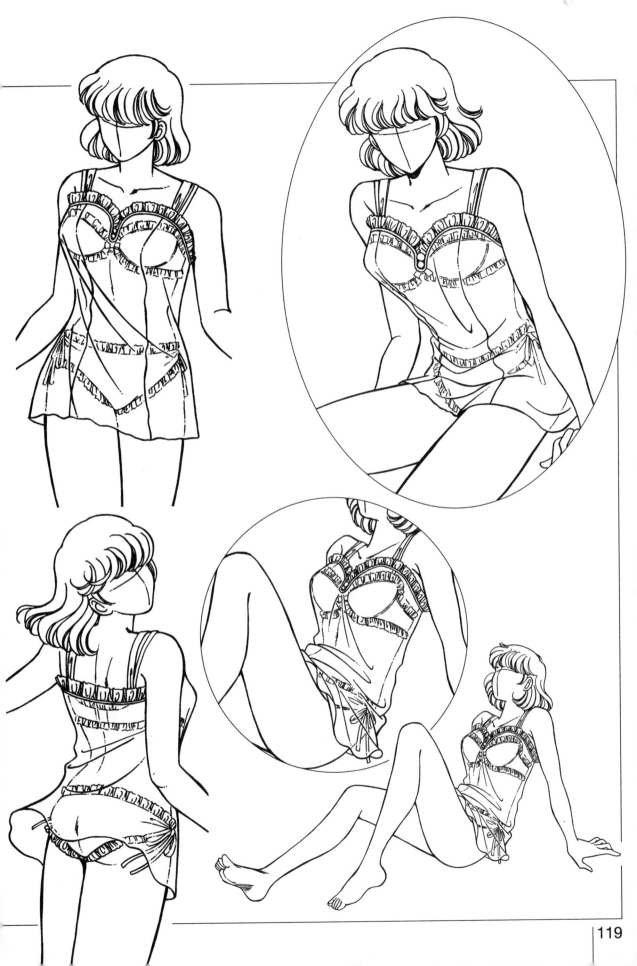

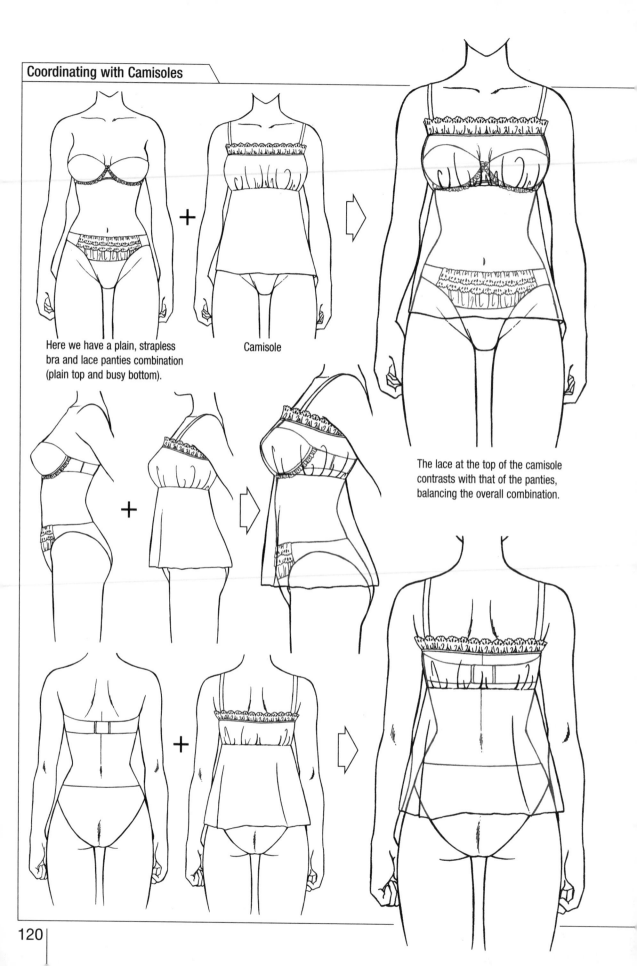

Coordinating with Camisoles

Here we have a plain, strapless bra and lace panties combination (plain top and busy bottom).

Camisole

The lace at the top of the camisole contrasts with that of the panties, balancing the overall combination.

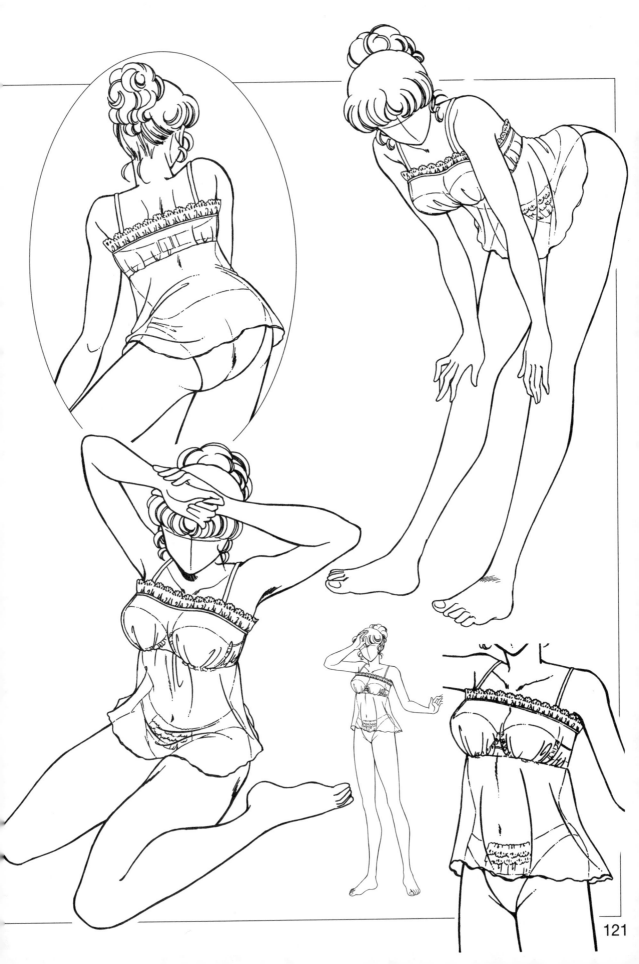

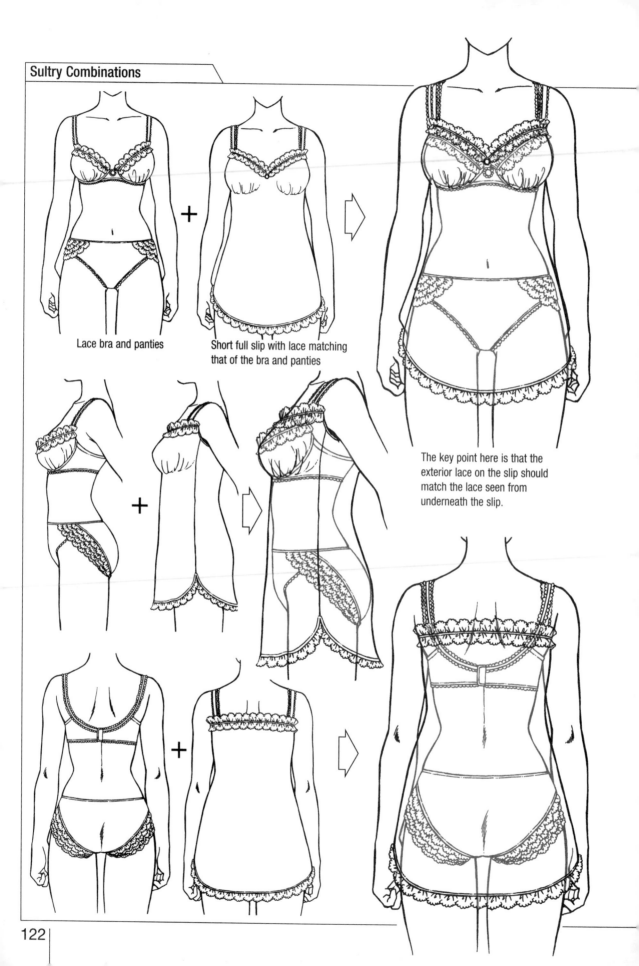

Sultry Combinations

Lace bra and panties

Short full slip with lace matching
that of the bra and panties

The key point here is that the
exterior lace on the slip should
match the lace seen from
underneath the slip.

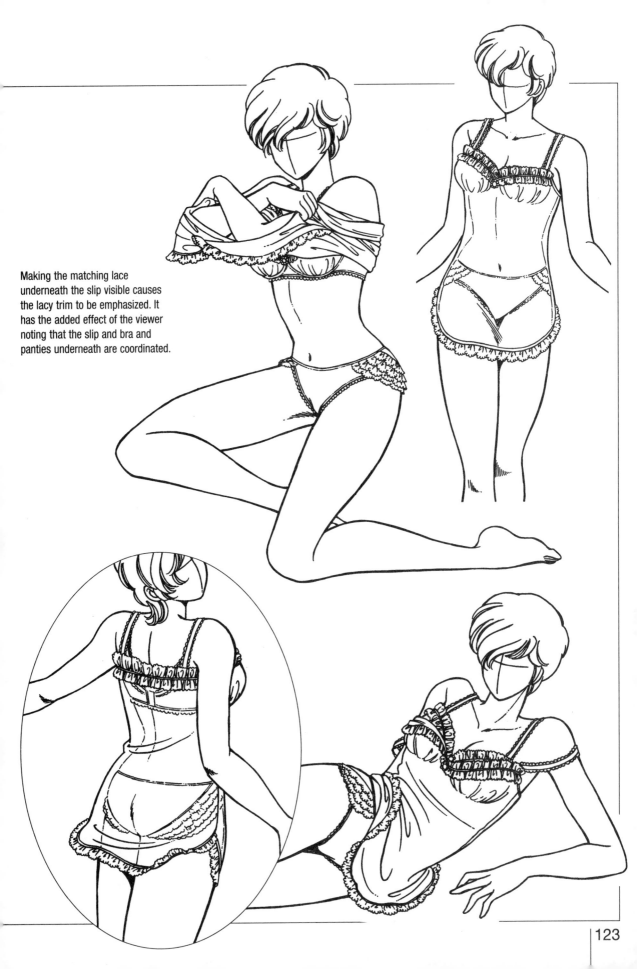

Making the matching lace underneath the slip visible causes the lacy trim to be emphasized. It has the added effect of the viewer noting that the slip and bra and panties underneath are coordinated.

Coordinating Camisoles and Tap Pants I: Flounces and Flow

Camisole

Tap pants

The camisole and tap pants billow outward in similar fashion. For this design, I was trying to match the flow of the top and bottom to present a pretty and charming image.

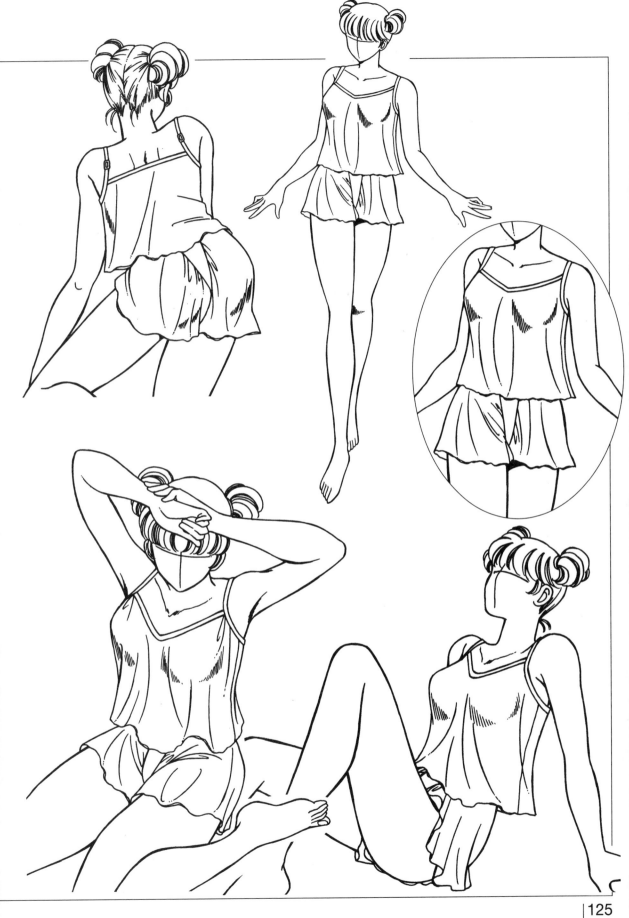

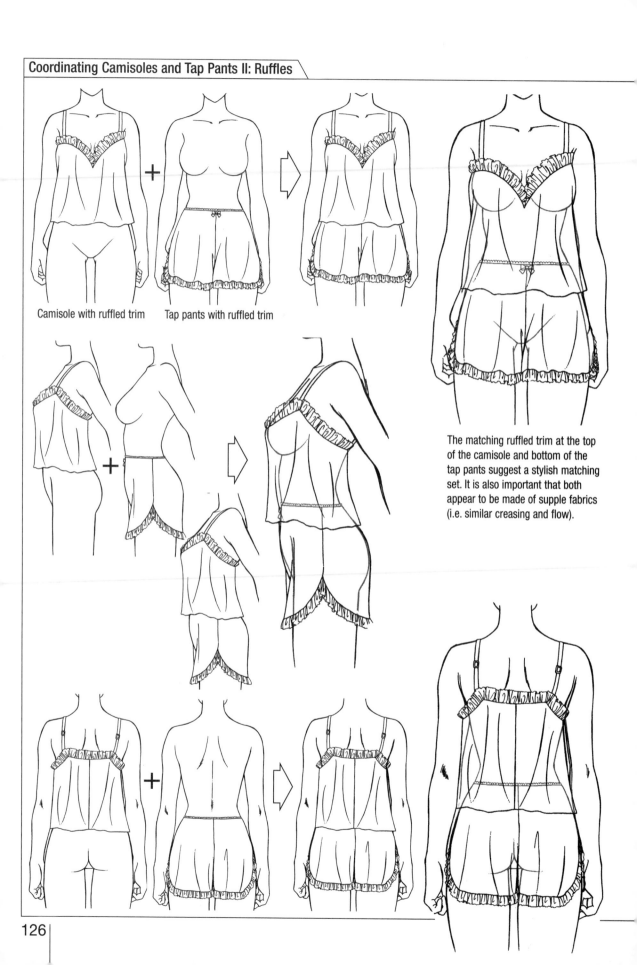

Camisole with ruffled trim Tap pants with ruffled trim

The matching ruffled trim at the top of the camisole and bottom of the tap pants suggest a stylish matching set. It is also important that both appear to be made of supple fabrics (i.e. similar creasing and flow).

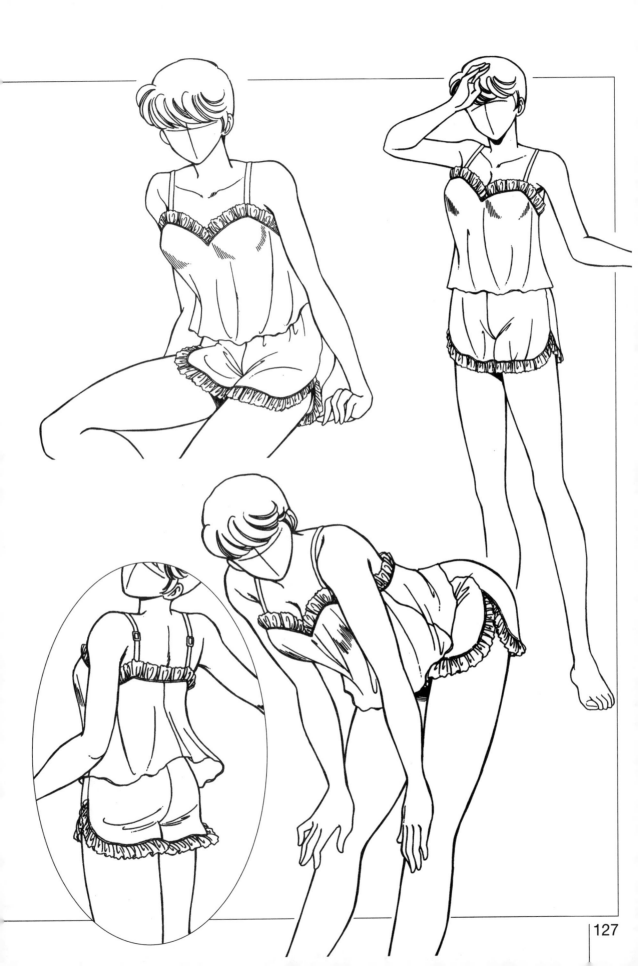

A line camisole

Tap pants

This combination brings out a triangular silhouette by matching the camisole with tap pants that complement its shape.

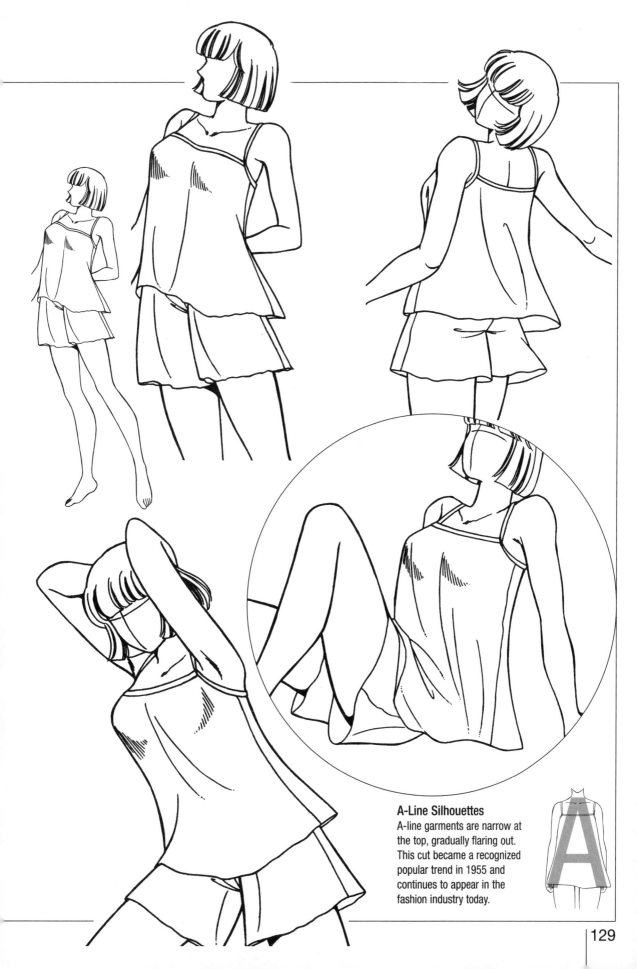

A-Line Silhouettes

A-line garments are narrow at the top, gradually flaring out. This cut became a recognized popular trend in 1955 and continues to appear in the fashion industry today.

V-neckline camisole with
lace trim

Short tap pants

Plain tap pants were
selected in order to bring
focus to the lace at the
camisole's neck.

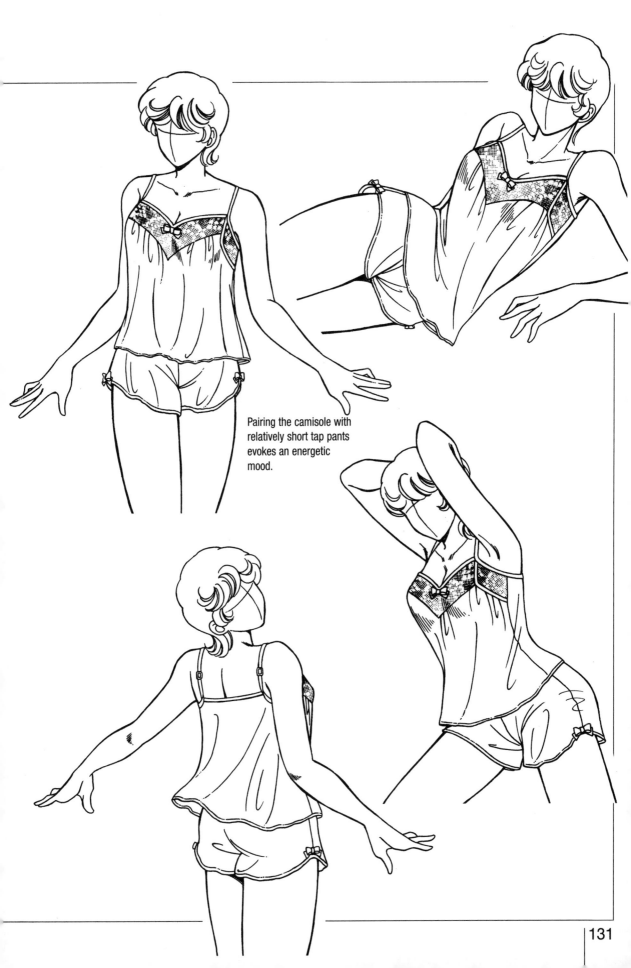

Pairing the camisole with
relatively short tap pants
evokes an energetic
mood.

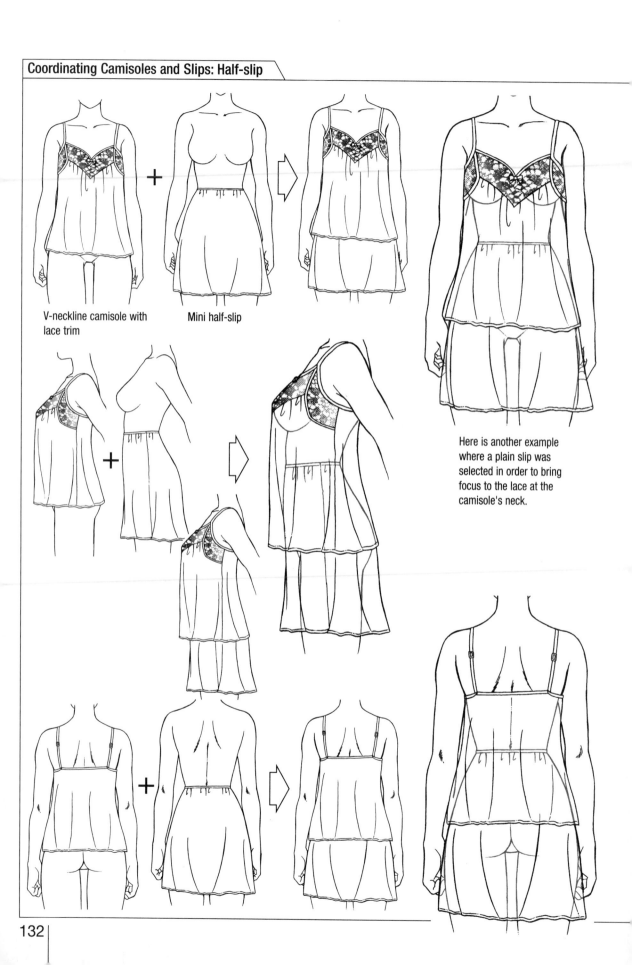

V-neckline camisole with lace trim

Mini half-slip

Here is another example where a plain slip was selected in order to bring focus to the lace at the camisole's neck.

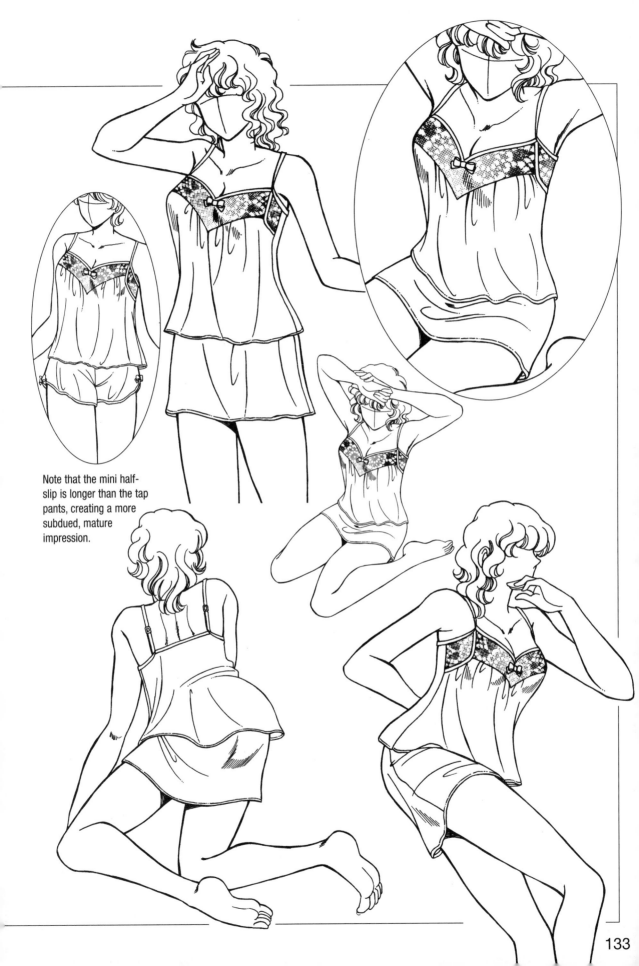

Note that the mini half-slip is longer than the tap pants, creating a more subdued, mature impression.

133

Camisole with flaring
hemline

Tap pants with flared legs

Here, the flaring of the
camisole's hem is echoed
in the tap pants.

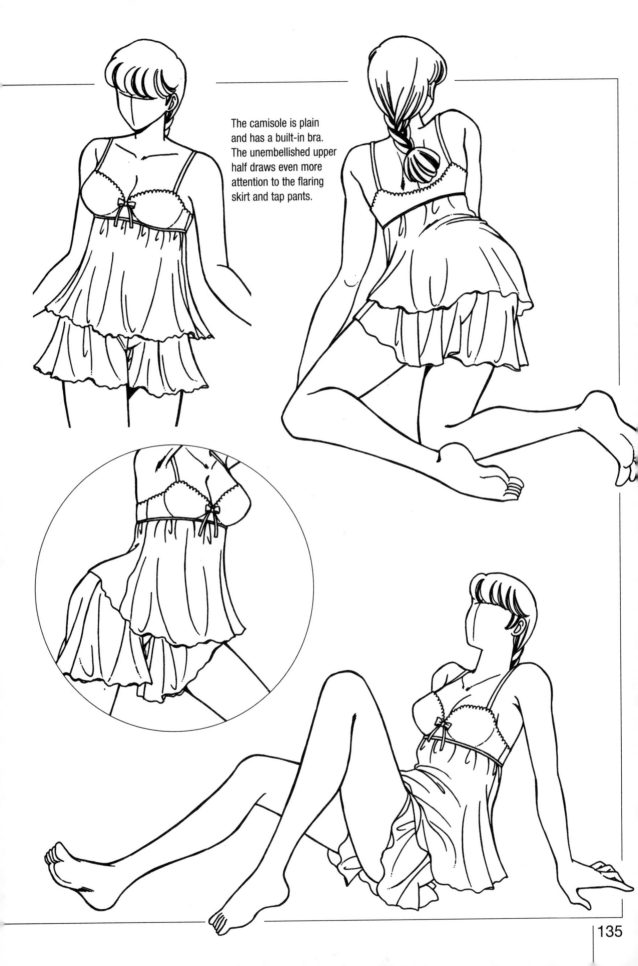

The camisole is plain and has a built-in bra. The unembellished upper half draws even more attention to the flaring skirt and tap pants.

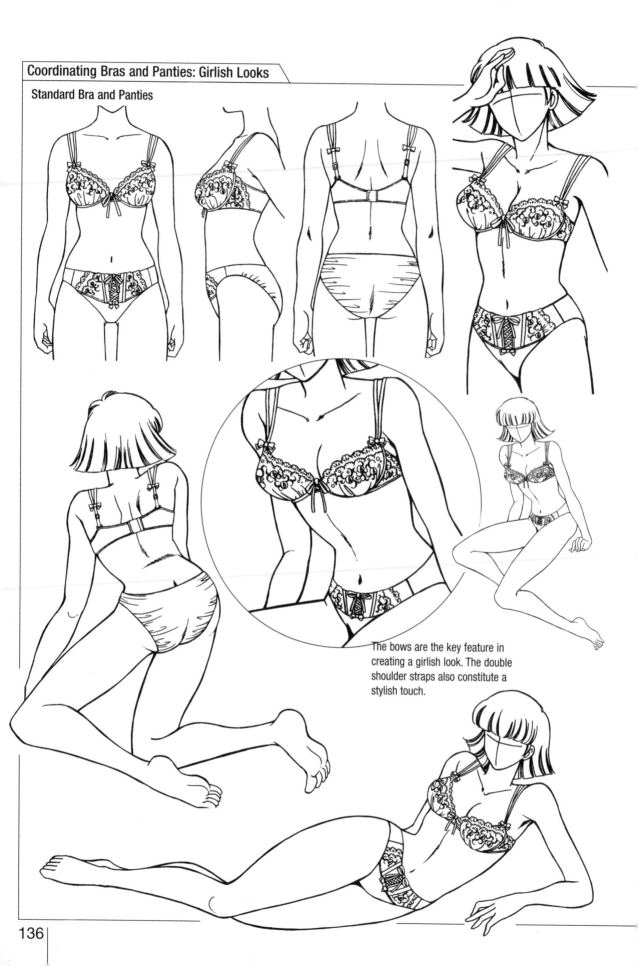

Coordinating Bras and Panties: Girlish Looks

Standard Bra and Panties

The bows are the key feature in creating a girlish look. The double shoulder straps also constitute a stylish touch.

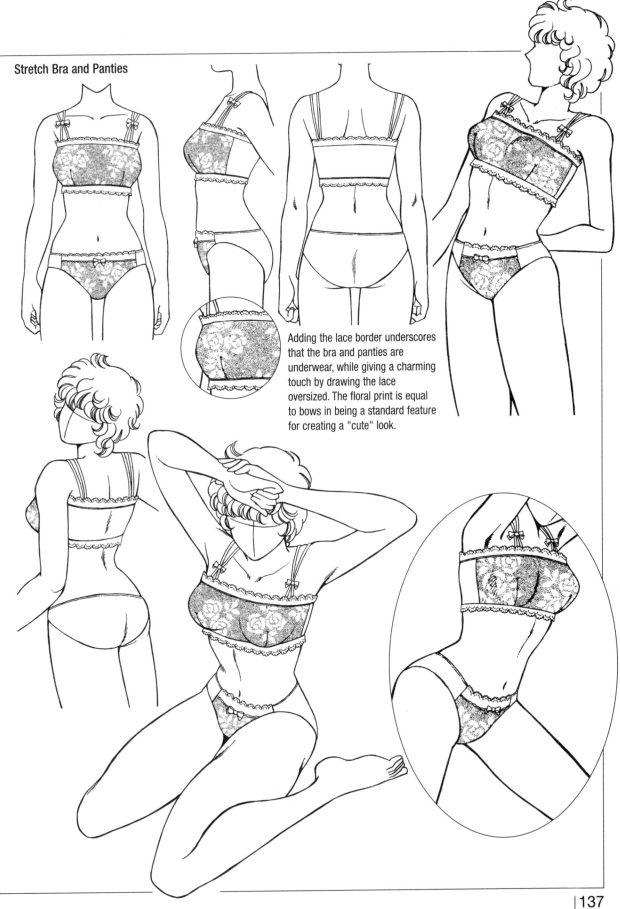

Stretch Bra and Panties

Adding the lace border underscores that the bra and panties are underwear, while giving a charming touch by drawing the lace oversized. The floral print is equal to bows in being a standard feature for creating a "cute" look.

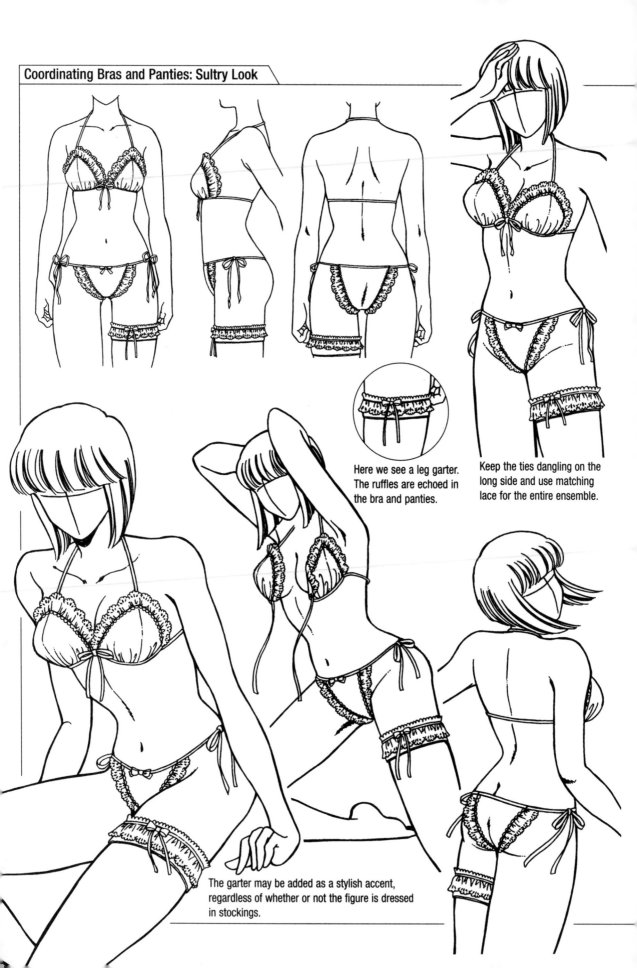

Coordinating Bras and Panties: Sultry Look

Here we see a leg garter. The ruffles are echoed in the bra and panties.

Keep the ties dangling on the long side and use matching lace for the entire ensemble.

The garter may be added as a stylish accent, regardless of whether or not the figure is dressed in stockings.

Choker

Always draw panties on the tiny side to increase skin exposure when going for a "sultry" look.

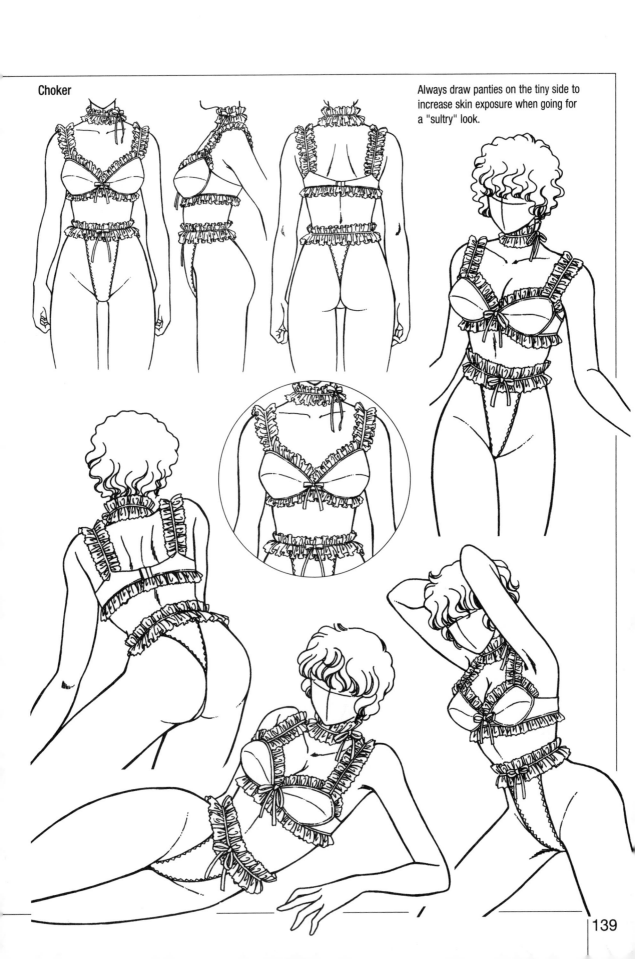

When the entire garment is made of lace, the flow of the cloth is set, and the garment should be drawn as if wrapped around the figure.

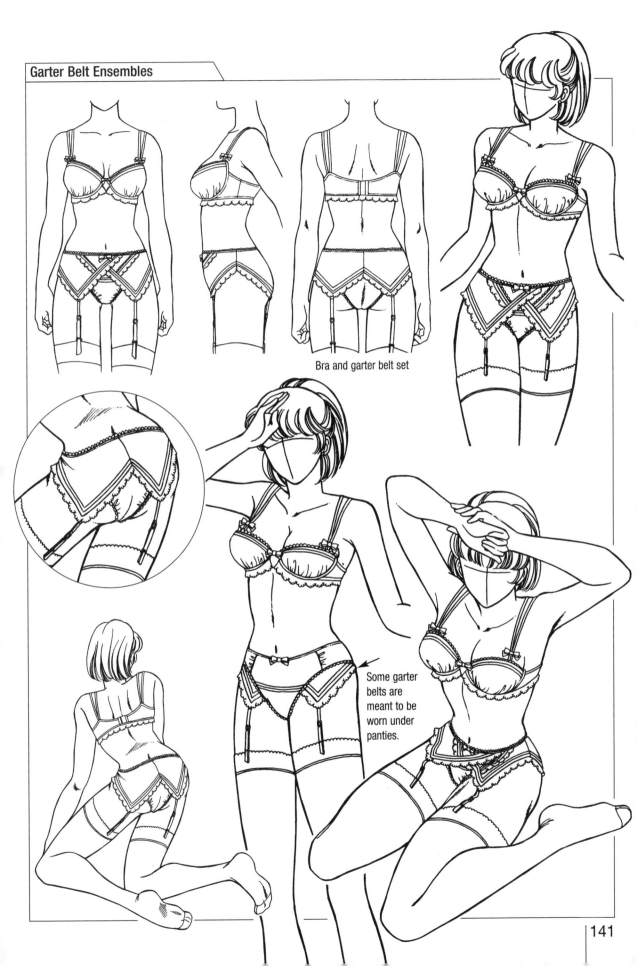

Bra and garter belt set

Some garter belts are meant to be worn under panties.

Sleepwear

Garments worn to sleep are usually loose and roomy rather than form fitting, since they are intended for rest. Sleepwear may be worn directly over the skin without undergarments.

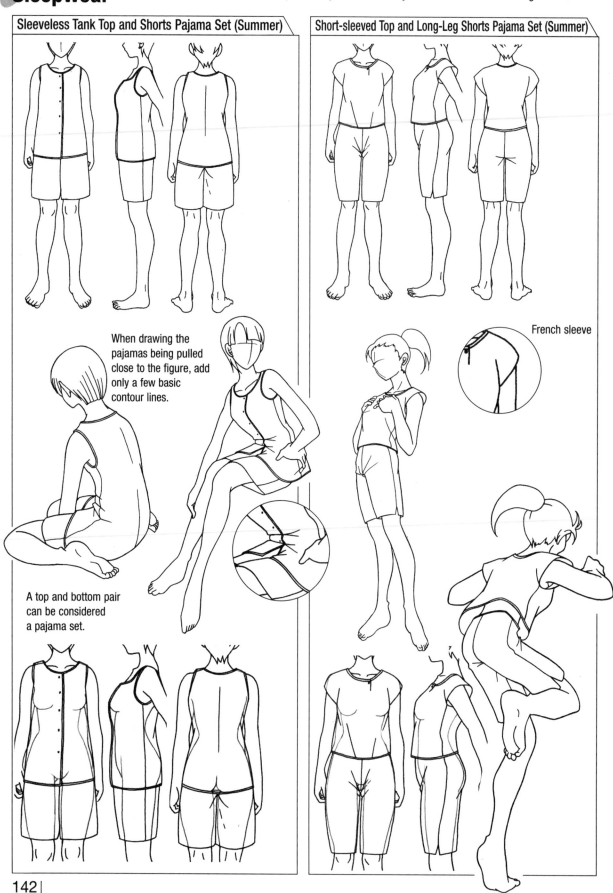

Sleeveless Tank Top and Shorts Pajama Set (Summer)

Short-sleeved Top and Long-Leg Shorts Pajama Set (Summer)

When drawing the pajamas being pulled close to the figure, add only a few basic contour lines.

French sleeve

A top and bottom pair can be considered a pajama set.

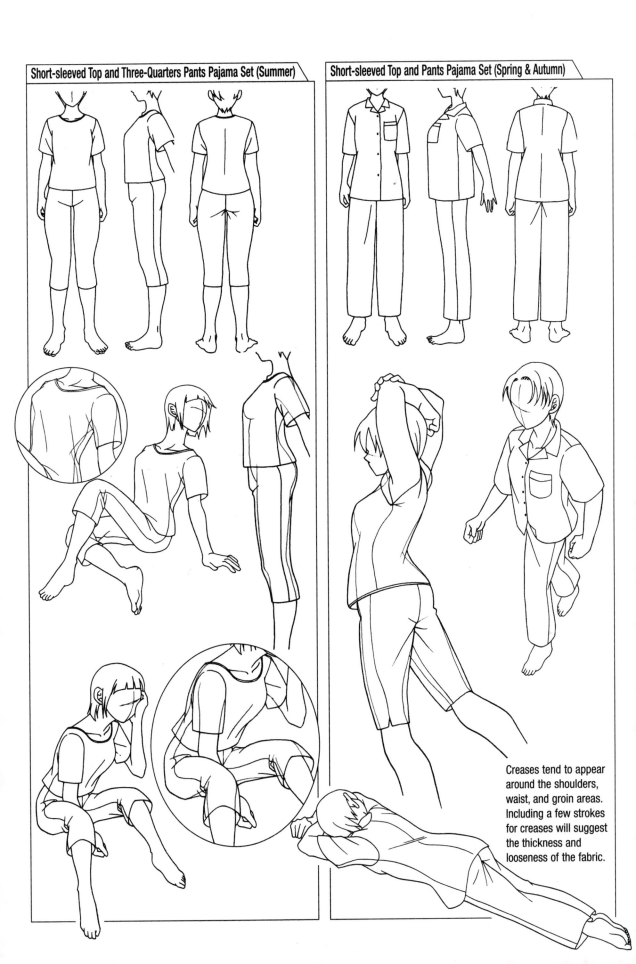

Short-sleeved Top and Three-Quarters Pants Pajama Set (Summer)

Short-sleeved Top and Pants Pajama Set (Spring & Autumn)

Creases tend to appear around the shoulders, waist, and groin areas. Including a few strokes for creases will suggest the thickness and looseness of the fabric.

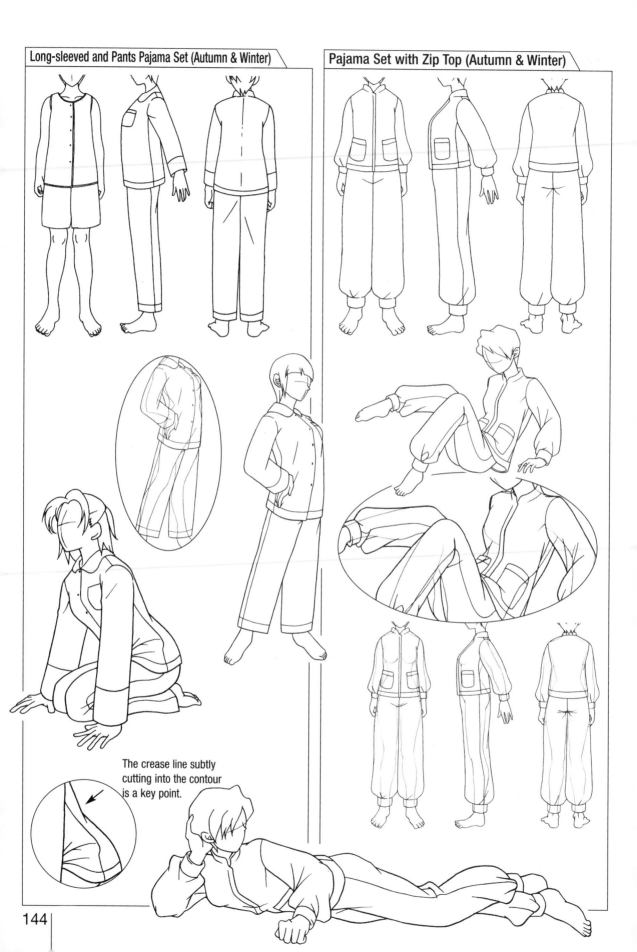

Long-sleeved and Pants Pajama Set (Autumn & Winter)

Pajama Set with Zip Top (Autumn & Winter)

The crease line subtly cutting into the contour is a key point.

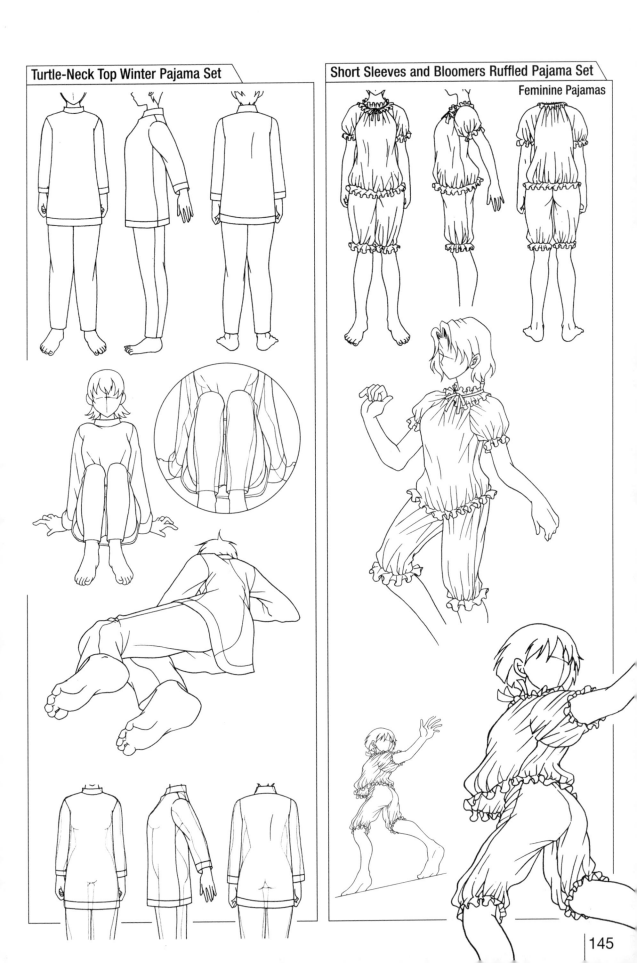

Turtle-Neck Top Winter Pajama Set

Short Sleeves and Bloomers Ruffled Pajama Set

Feminine Pajamas

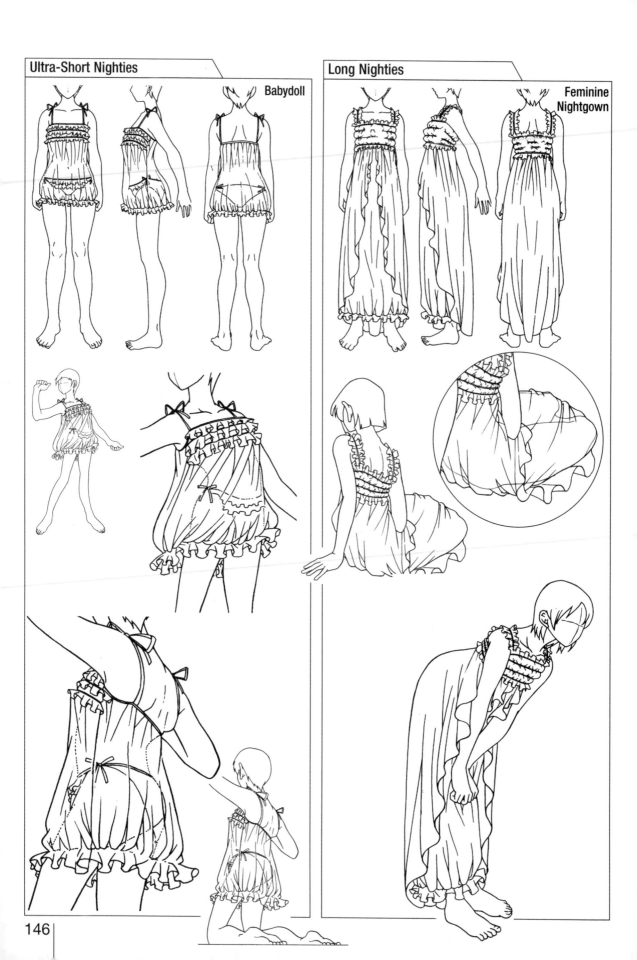

Ultra-Short Nighties

Babydoll

Long Nighties

Feminine Nightgown

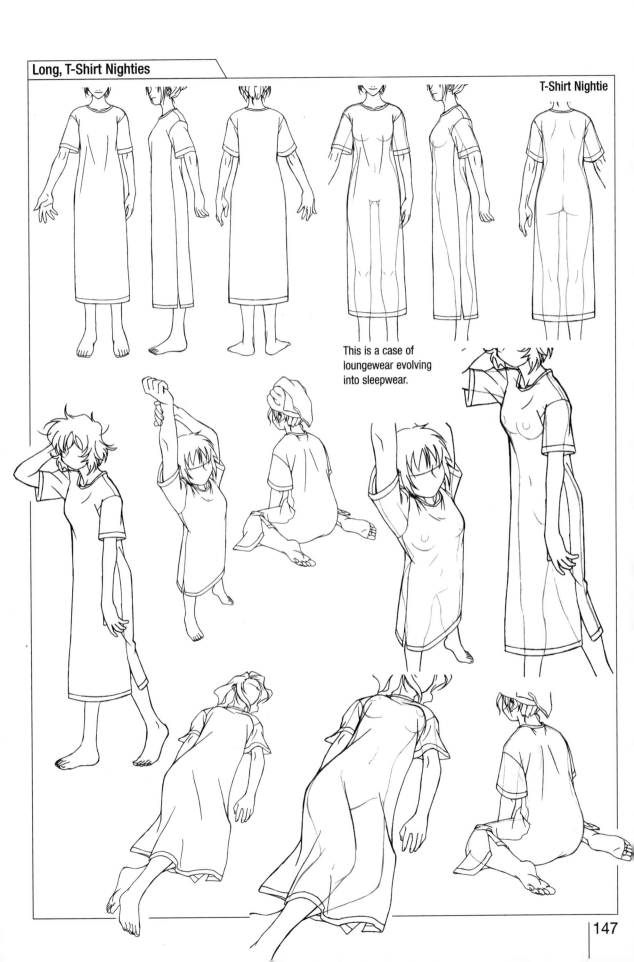

Long, T-Shirt Nighties

T-Shirt Nightie

This is a case of loungewear evolving into sleepwear.

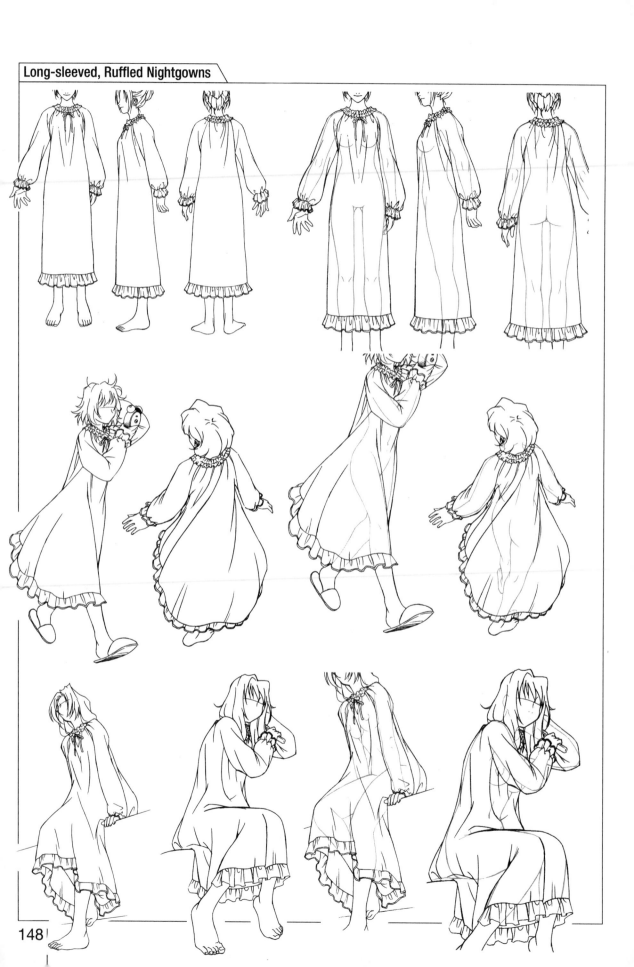

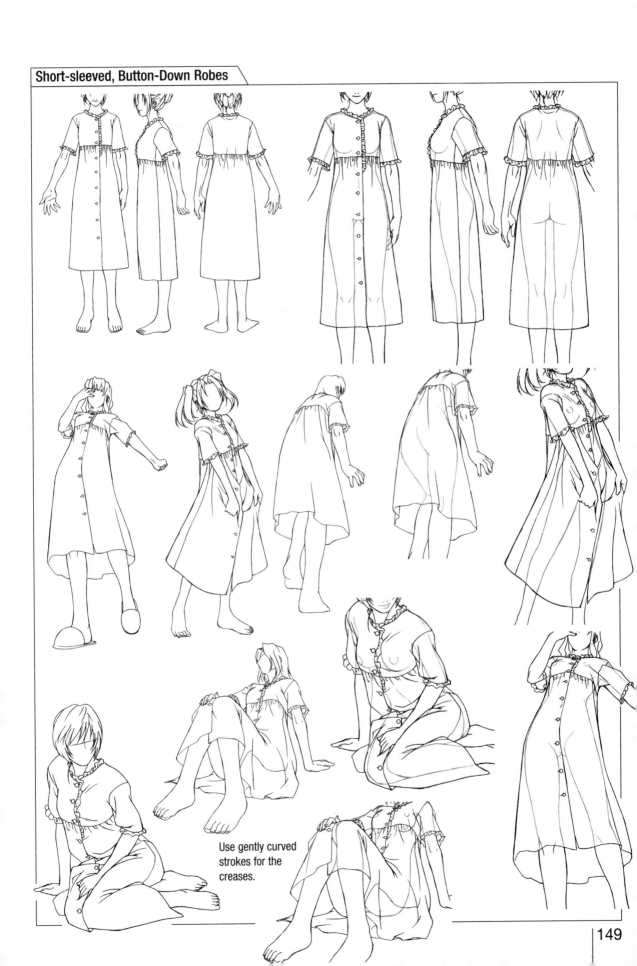

Use gently curved strokes for the creases.

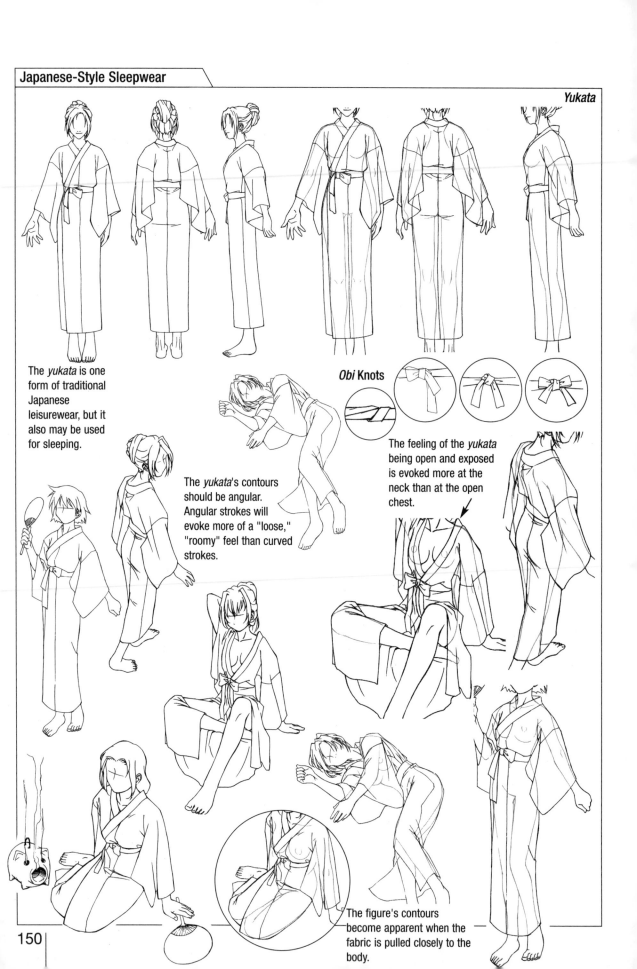

The *yukata* is one form of traditional Japanese leisurewear, but it also may be used for sleeping.

Obi Knots

The *yukata*'s contours should be angular. Angular strokes will evoke more of a "loose," "roomy" feel than curved strokes.

The feeling of the *yukata* being open and exposed is evoked more at the neck than at the open chest.

The figure's contours become apparent when the fabric is pulled closely to the body.

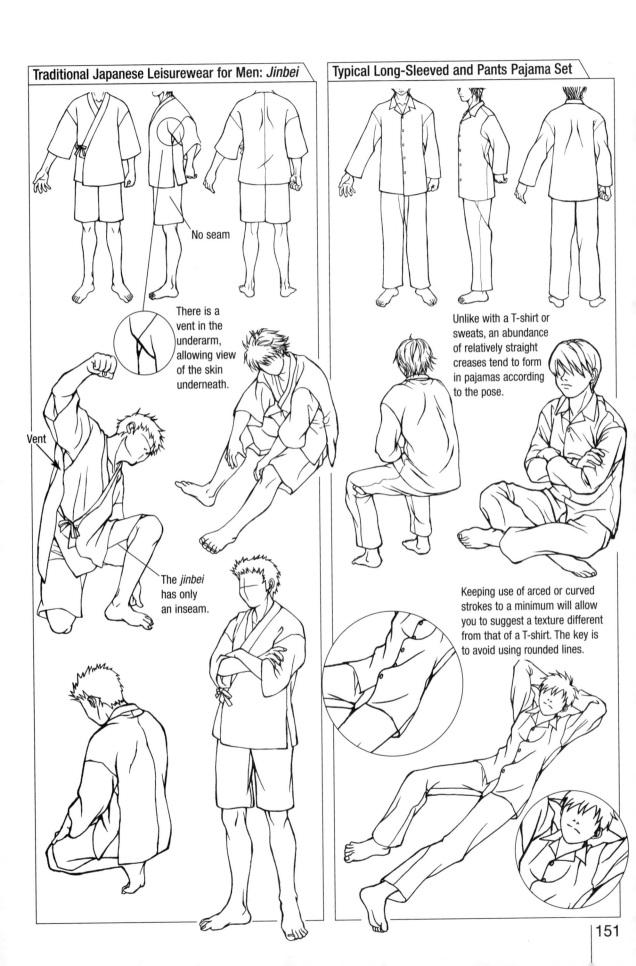

Traditional Japanese Leisurewear for Men: *Jinbei*

No seam

There is a vent in the underarm, allowing view of the skin underneath.

Vent

The *jinbei* has only an inseam.

Typical Long-Sleeved and Pants Pajama Set

Unlike with a T-shirt or sweats, an abundance of relatively straight creases tend to form in pajamas according to the pose.

Keeping use of arced or curved strokes to a minimum will allow you to suggest a texture different from that of a T-shirt. The key is to avoid using rounded lines.

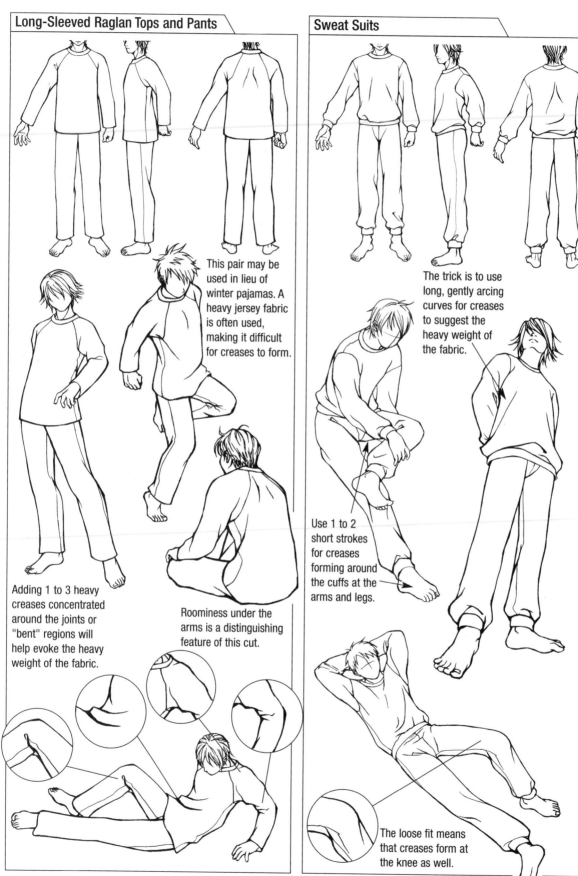

Long-Sleeved Raglan Tops and Pants

This pair may be used in lieu of winter pajamas. A heavy jersey fabric is often used, making it difficult for creases to form.

Adding 1 to 3 heavy creases concentrated around the joints or "bent" regions will help evoke the heavy weight of the fabric.

Roominess under the arms is a distinguishing feature of this cut.

Sweat Suits

The trick is to use long, gently arcing curves for creases to suggest the heavy weight of the fabric.

Use 1 to 2 short strokes for creases forming around the cuffs at the arms and legs.

The loose fit means that creases form at the knee as well.

Tank Top and Shorts Set

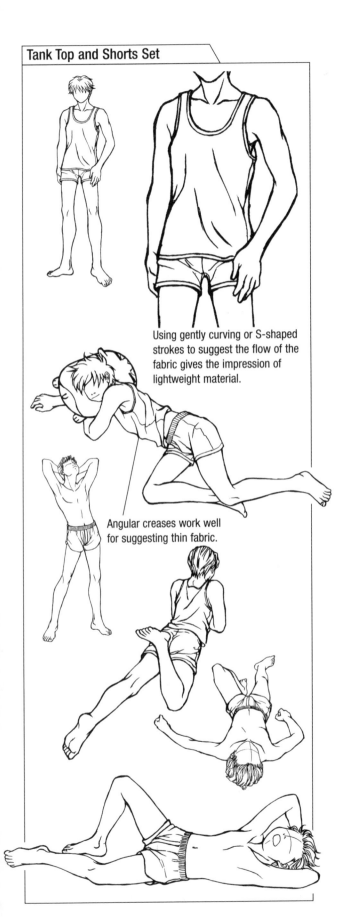

Using gently curving or S-shaped strokes to suggest the flow of the fabric gives the impression of lightweight material.

Angular creases work well for suggesting thin fabric.

T-Shirt Nightie: Creases and Ripples at the Chest

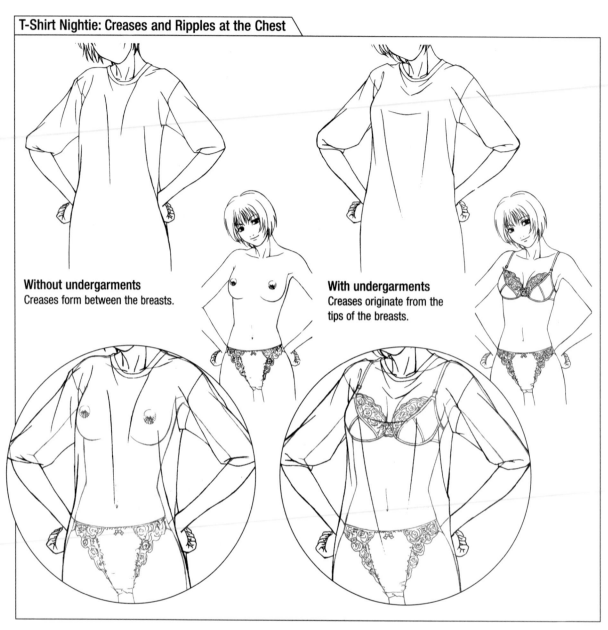

Without undergarments
Creases form between the breasts.

With undergarments
Creases originate from the tips of the breasts.

Sleepwear at a Glance

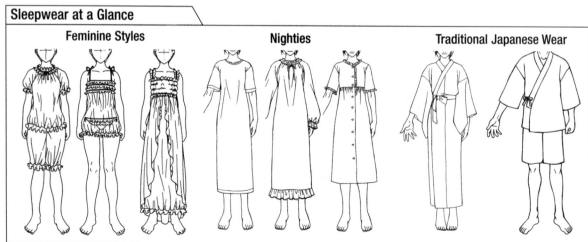

Feminine Styles

Nighties

Traditional Japanese Wear

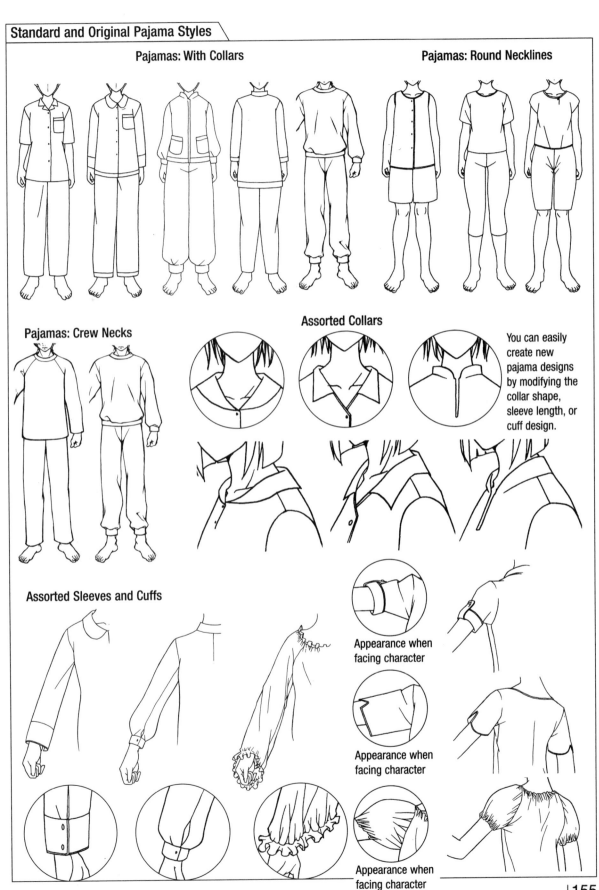

Pajamas: With Collars

Pajamas: Round Necklines

Pajamas: Crew Necks

Assorted Collars

You can easily create new pajama designs by modifying the collar shape, sleeve length, or cuff design.

Assorted Sleeves and Cuffs

Appearance when facing character

Appearance when facing character

Appearance when facing character

Robes

Robes are loose garments that may be worn directly over the skin, on top of sleepwear, as sleepwear, or to the bath.

Robes

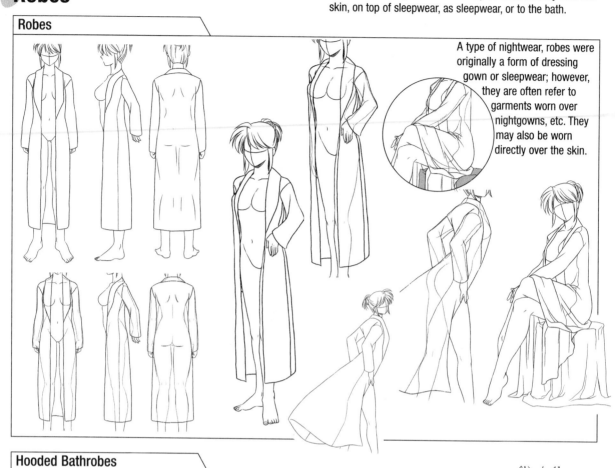

A type of nightwear, robes were originally a form of dressing gown or sleepwear; however, they are often refer to garments worn over nightgowns, etc. They may also be worn directly over the skin.

Hooded Bathrobes

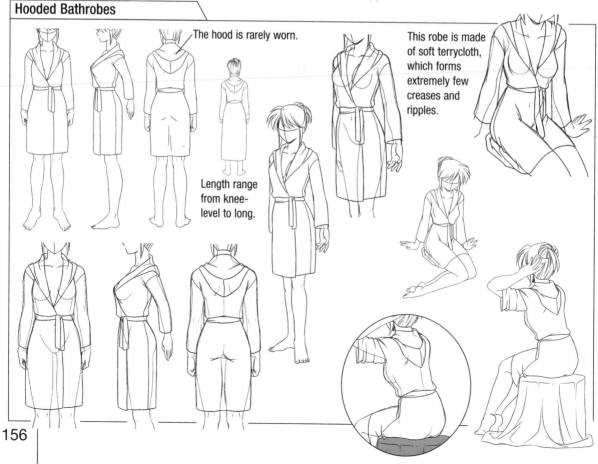

The hood is rarely worn.

Length range from knee-level to long.

This robe is made of soft terrycloth, which forms extremely few creases and ripples.

Long Bathrobes

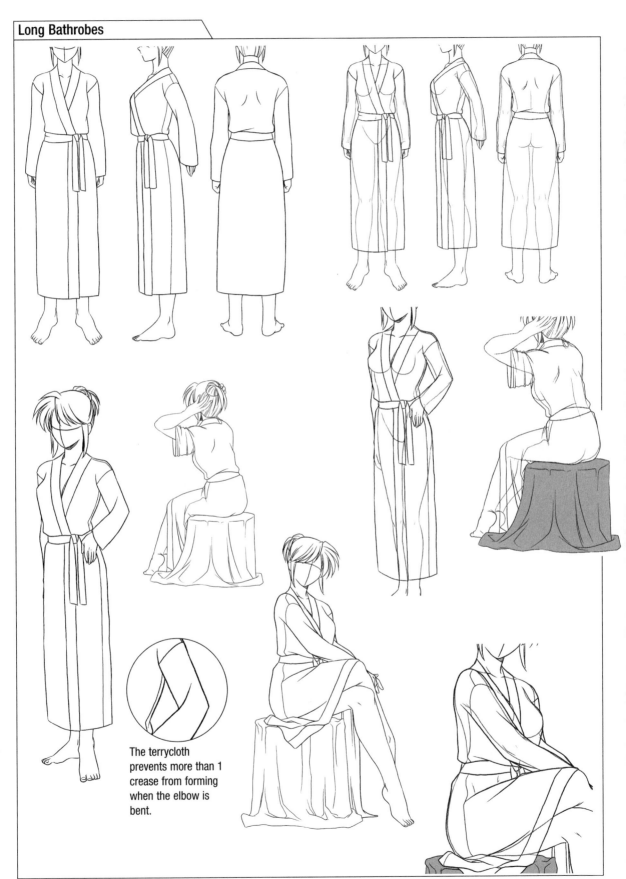

The terrycloth prevents more than 1 crease from forming when the elbow is bent.

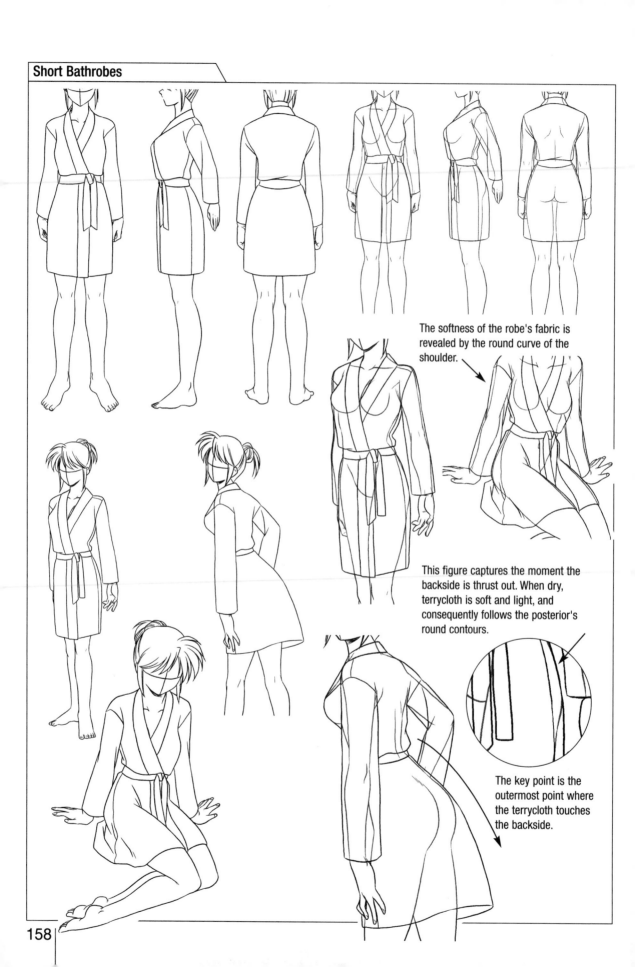

Short Bathrobes

The softness of the robe's fabric is revealed by the round curve of the shoulder.

This figure captures the moment the backside is thrust out. When dry, terrycloth is soft and light, and consequently follows the posterior's round contours.

The key point is the outermost point where the terrycloth touches the backside.

158

Hooded Dressing Gown

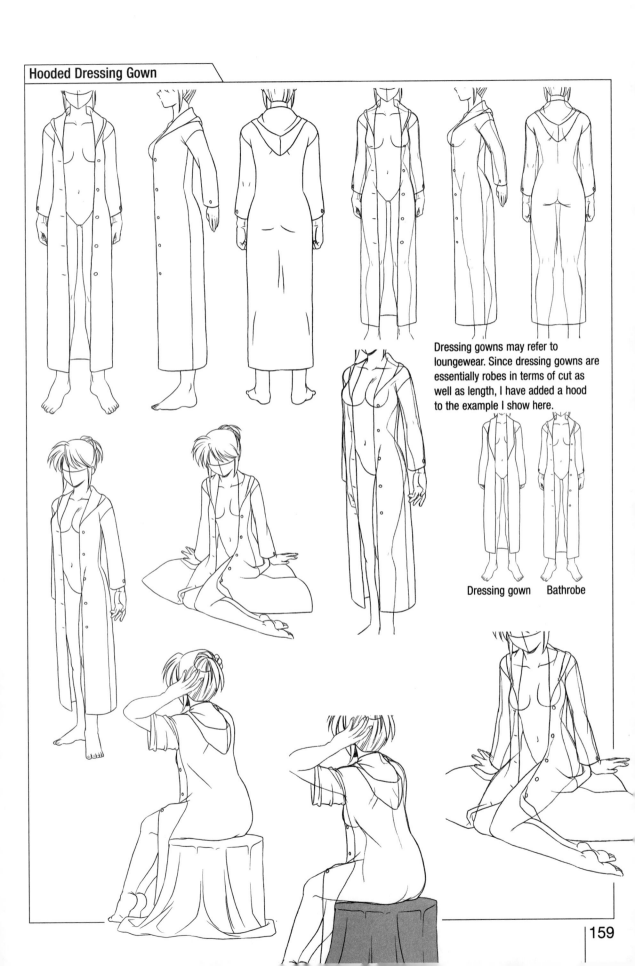

Dressing gowns may refer to loungewear. Since dressing gowns are essentially robes in terms of cut as well as length, I have added a hood to the example I show here.

Dressing gown Bathrobe

Bodysuits, Cat Suits, and Body Stockings

Early body stockings were snugly fitting support wear covering the whole figure from toe to chest. Today, we have versions extending to the neck and others cut like swimsuits. Some of these no longer function as support wear and have evolved into undergarments functioning as casual wear.

Whole Figure Coverage

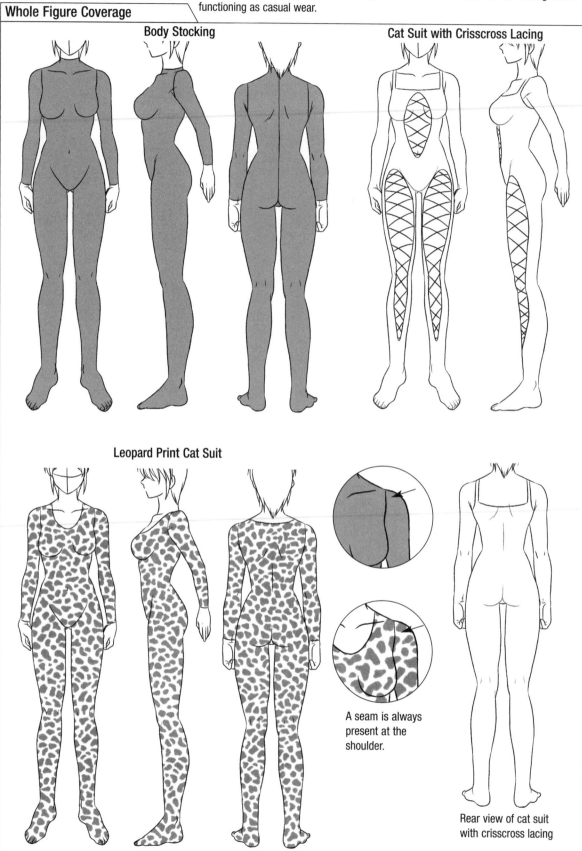

Body Stocking

Cat Suit with Crisscross Lacing

Leopard Print Cat Suit

A seam is always present at the shoulder.

Rear view of cat suit with crisscross lacing

Fishnet

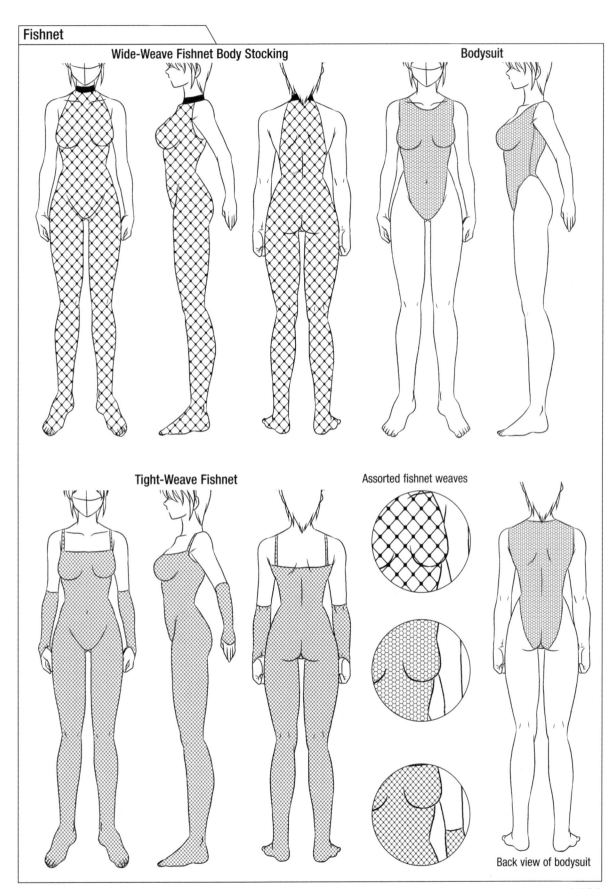

Wide-Weave Fishnet Body Stocking

Bodysuit

Tight-Weave Fishnet

Assorted fishnet weaves

Back view of bodysuit

Men's Undergarments

Standard Tank Top/Undershirt

Racer-Back Tank

Sleeveless, U-Neck Top

Sleeveless, Round-Neck Top

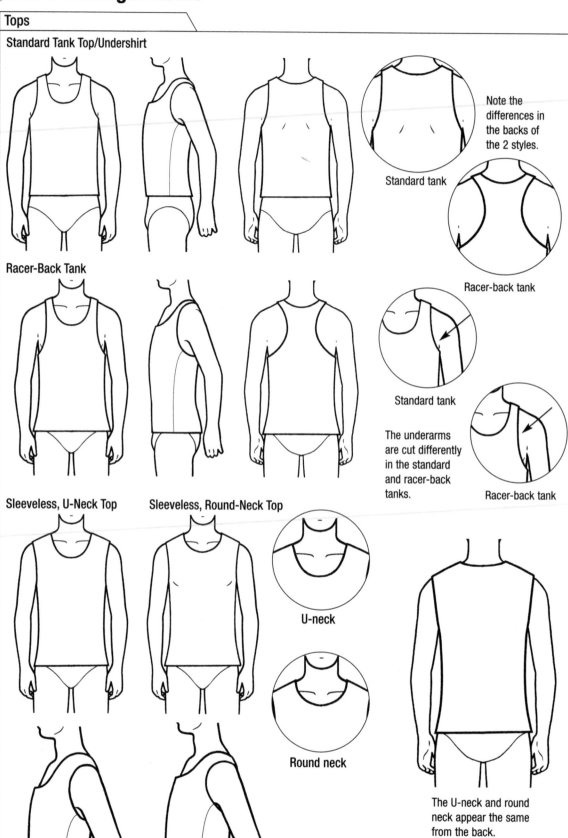

Note the differences in the backs of the 2 styles.

Standard tank

Racer-back tank

Standard tank

The underarms are cut differently in the standard and racer-back tanks.

Racer-back tank

U-neck

Round neck

The U-neck and round neck appear the same from the back.

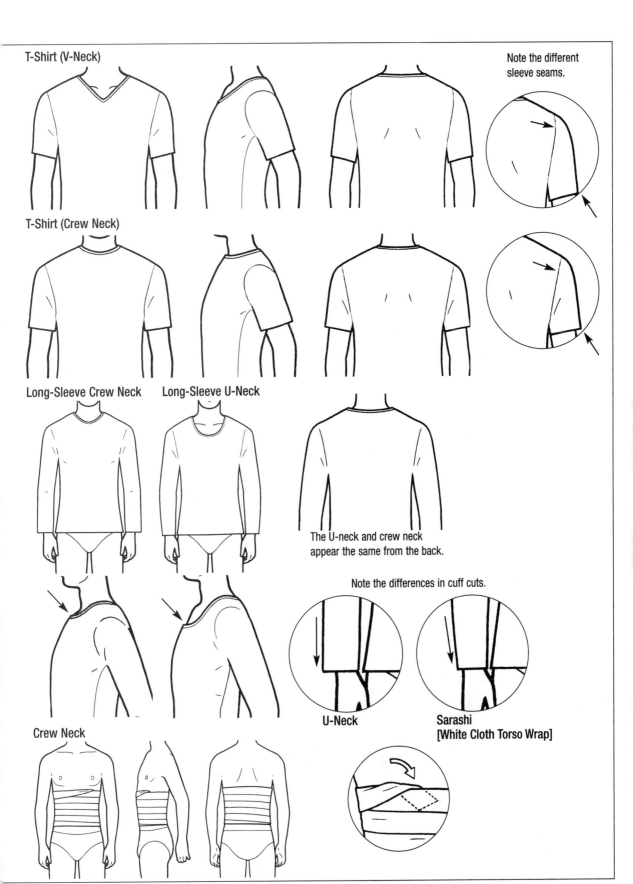

T-Shirt (V-Neck)

Note the different sleeve seams.

T-Shirt (Crew Neck)

Long-Sleeve Crew Neck Long-Sleeve U-Neck

The U-neck and crew neck appear the same from the back.

Note the differences in cuff cuts.

U-Neck

Sarashi
[White Cloth Torso Wrap]

Crew Neck

Bottoms

Briefs (Standard)

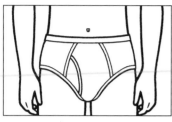

Briefs

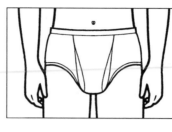

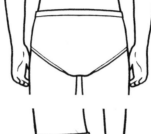

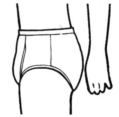

Bikini Briefs

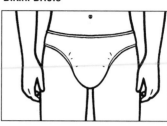

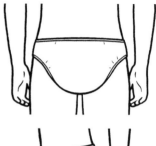

Boxers I

Boxers II

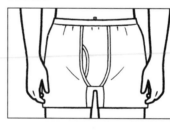

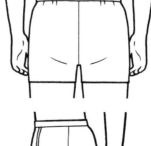

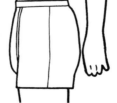

Boxers III

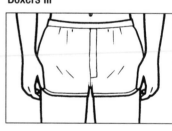

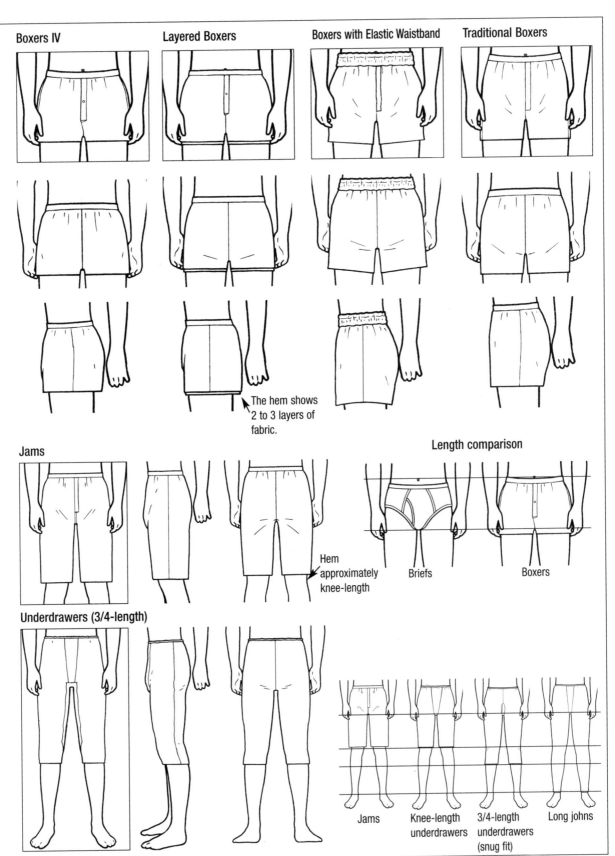

Boxers IV

Layered Boxers

Boxers with Elastic Waistband

Traditional Boxers

The hem shows 2 to 3 layers of fabric.

Jams

Length comparison

Hem approximately knee-length

Briefs

Boxers

Underdrawers (3/4-length)

Jams

Knee-length underdrawers

3/4-length underdrawers (snug fit)

Long johns

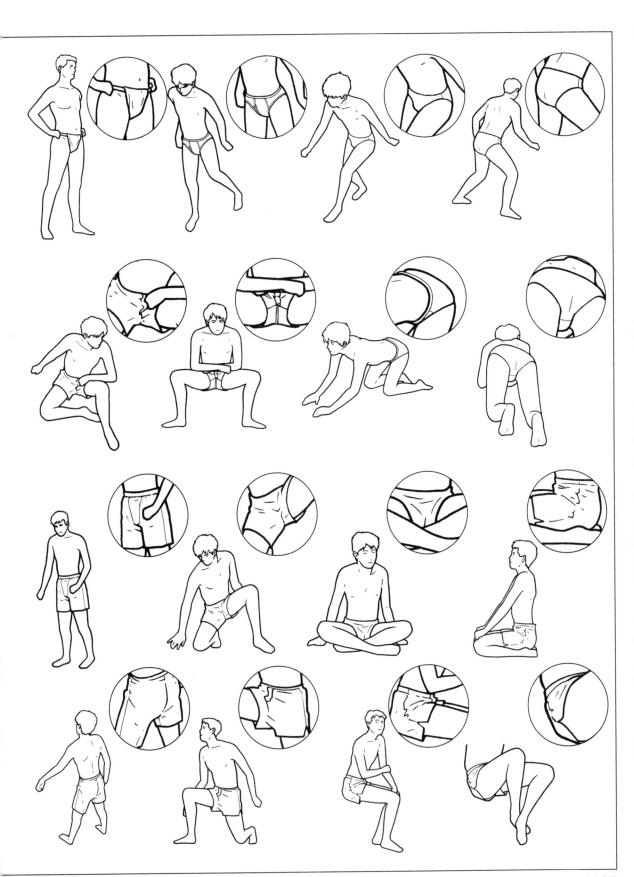

Some historians claim that the *fundoshi* [*loincloth*]'s use in Japan can be traced back to the Warring States Period and that it continued to be used as a boy's undergarment until the 1960s. The *fundoshi* comes in many shapes and sizes, and in Japan, methods of knotting vary from region to region. Moreover, *loincloths* virtually identical to the Japanese *fundoshi* appearing in ancient Egyptian and Aztec paintings suggest that the *loincloth* was universally a primitive undergarment.

Fundoshi [Loincloth]

Etchu Fundoshi

Knotting the Etchu *Fundoshi*

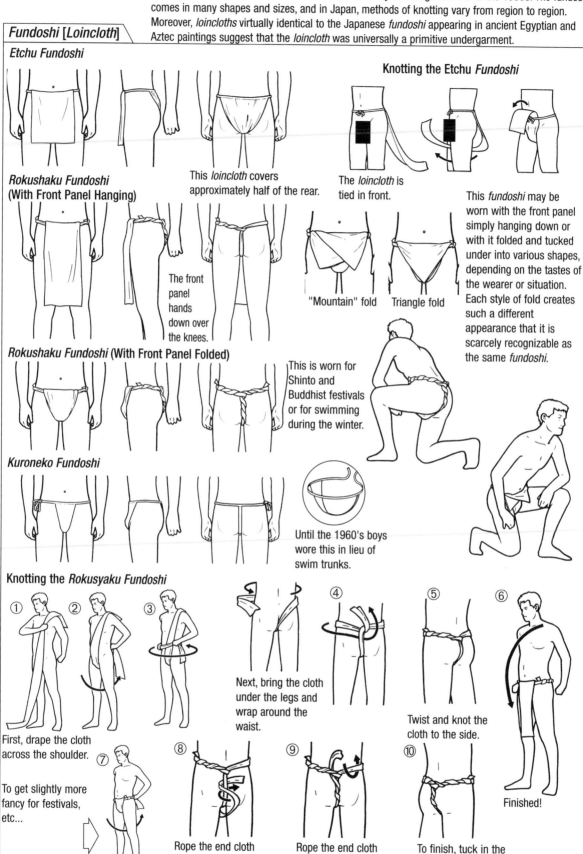

This *loincloth* covers approximately half of the rear.

The *loincloth* is tied in front.

Rokushaku Fundoshi (With Front Panel Hanging)

The front panel hands down over the knees.

"Mountain" fold Triangle fold

This *fundoshi* may be worn with the front panel simply hanging down or with it folded and tucked under into various shapes, depending on the tastes of the wearer or situation. Each style of fold creates such a different appearance that it is scarcely recognizable as the same *fundoshi*.

Rokushaku Fundoshi (With Front Panel Folded)

This is worn for Shinto and Buddhist festivals or for swimming during the winter.

Kuroneko Fundoshi

Until the 1960's boys wore this in lieu of swim trunks.

Knotting the *Rokusyaku Fundoshi*

① ② ③

First, drape the cloth across the shoulder.

To get slightly more fancy for festivals, etc...

④ Next, bring the cloth under the legs and wrap around the waist.

⑤ Twist and knot the cloth to the side.

⑥ Finished!

⑦

⑧ Rope the end cloth (panel normally worn hanging in front) around the rear vertical segment.

⑨ Rope the end cloth around the rear horizontal segment.

⑩ To finish, tuck in the end at the side.

Chapter 2
An Intimate History

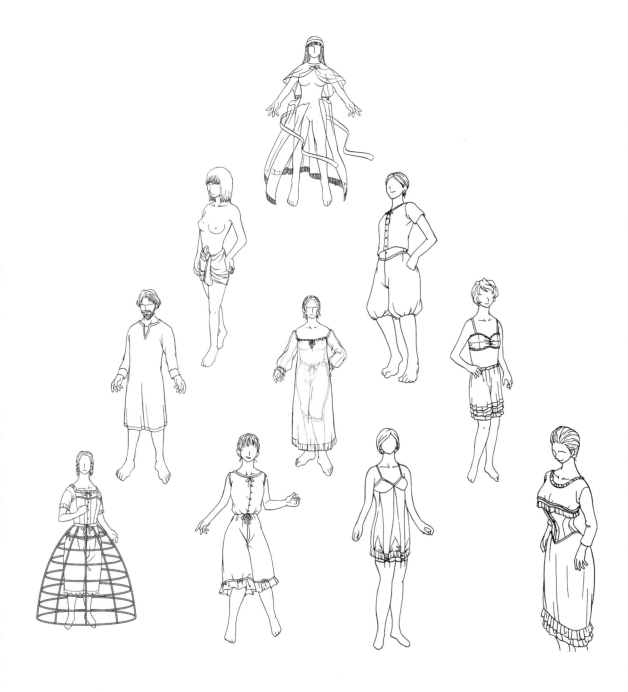

Antiquity (3000 B.C. to 300 AD)

As far as can be gleaned from looking at the historical record, practically no distinction was made in ancient times between under and outer garments. During this period, clothing would typically consist of a single cloth wrapped at the waist (a *loincloth*) and worn directly over the skin and constituted what we basically regard today as an undergarment.

Egyptian *Loincloth*: 3000 B.C.

Loincloth

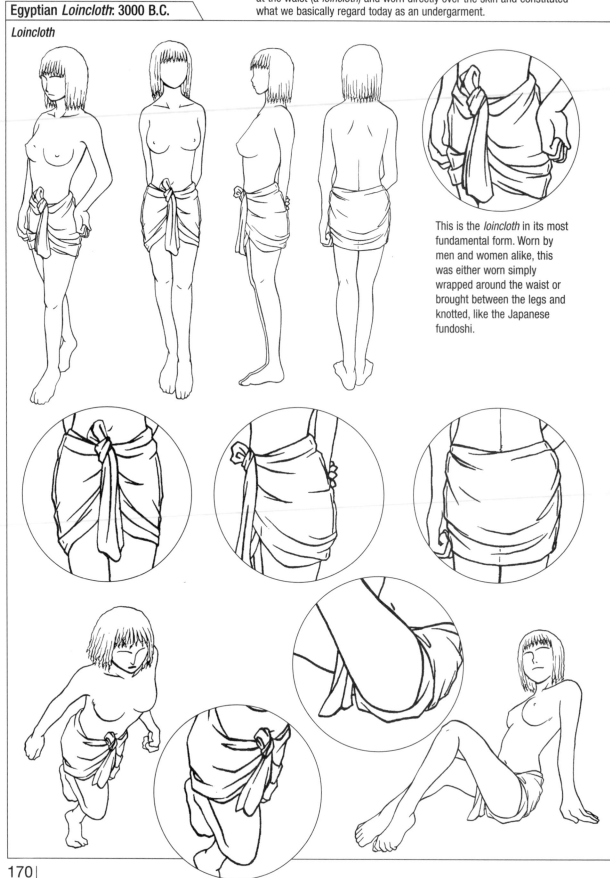

This is the *loincloth* in its most fundamental form. Worn by men and women alike, this was either worn simply wrapped around the waist or brought between the legs and knotted, like the Japanese *fundoshi*.

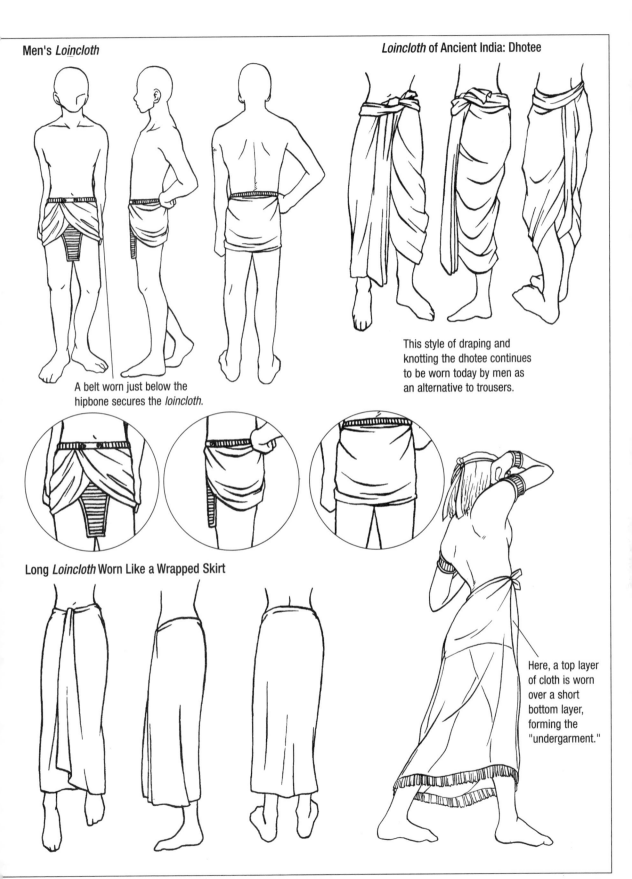

Men's *Loincloth*

***Loincloth* of Ancient India: Dhotee**

A belt worn just below the hipbone secures the *loincloth*.

This style of draping and knotting the dhotee continues to be worn today by men as an alternative to trousers.

Long *Loincloth* Worn Like a Wrapped Skirt

Here, a top layer of cloth is worn over a short bottom layer, forming the "undergarment."

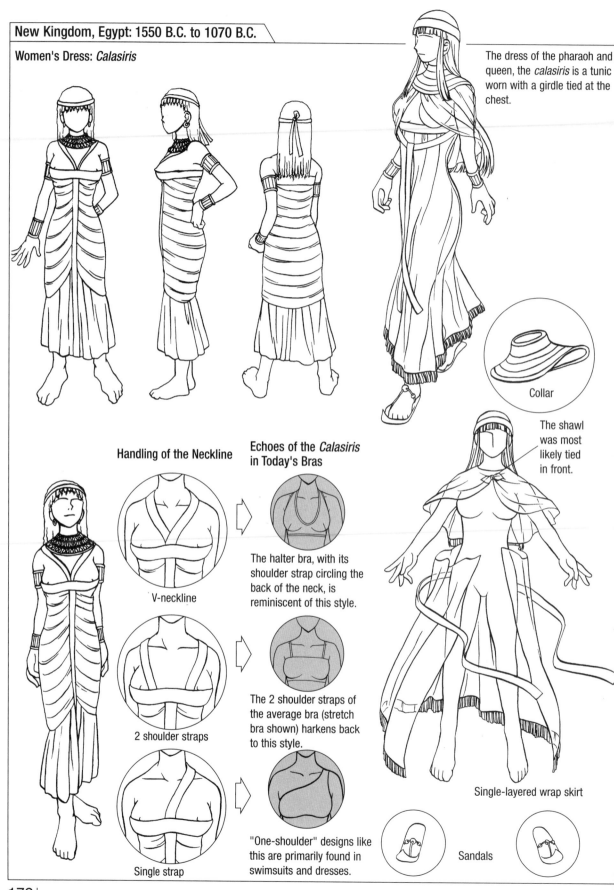

Women's Dress: *Calasiris*

The dress of the pharaoh and queen, the *calasiris* is a tunic worn with a girdle tied at the chest.

Collar

The shawl was most likely tied in front.

Handling of the Neckline

V-neckline

2 shoulder straps

Single strap

Echoes of the *Calasiris* in Today's Bras

The halter bra, with its shoulder strap circling the back of the neck, is reminiscent of this style.

The 2 shoulder straps of the average bra (stretch bra shown) harkens back to this style.

"One-shoulder" designs like this are primarily found in swimsuits and dresses.

Single-layered wrap skirt

Sandals

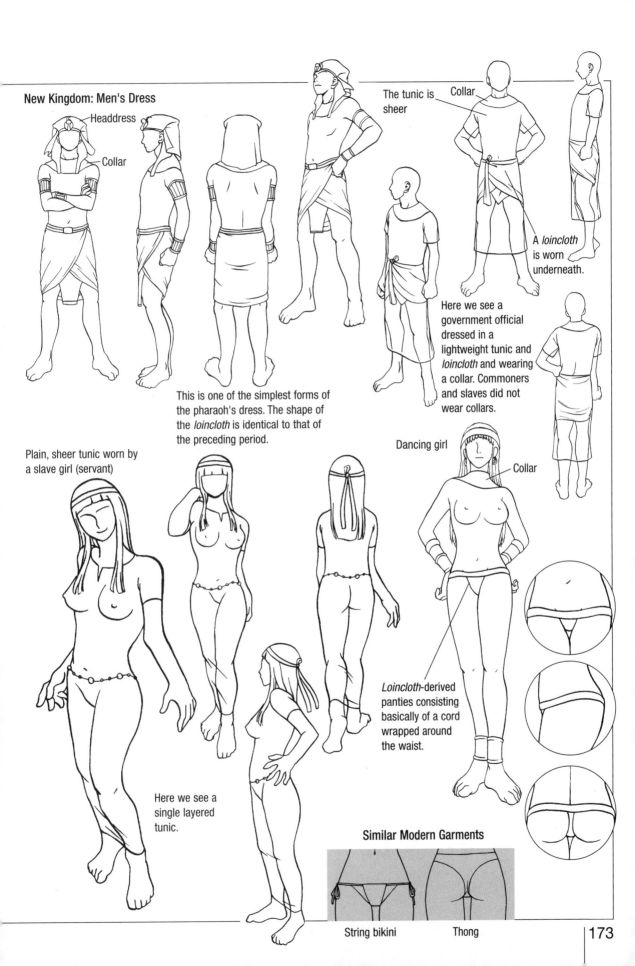

New Kingdom: Men's Dress

Headdress

Collar

The tunic is sheer

Collar

This is one of the simplest forms of the pharaoh's dress. The shape of the *loincloth* is identical to that of the preceding period.

A *loincloth* is worn underneath.

Here we see a government official dressed in a lightweight tunic and *loincloth* and wearing a collar. Commoners and slaves did not wear collars.

Plain, sheer tunic worn by a slave girl (servant)

Dancing girl

Collar

Loincloth-derived panties consisting basically of a cord wrapped around the waist.

Here we see a single layered tunic.

Similar Modern Garments

String bikini Thong

173

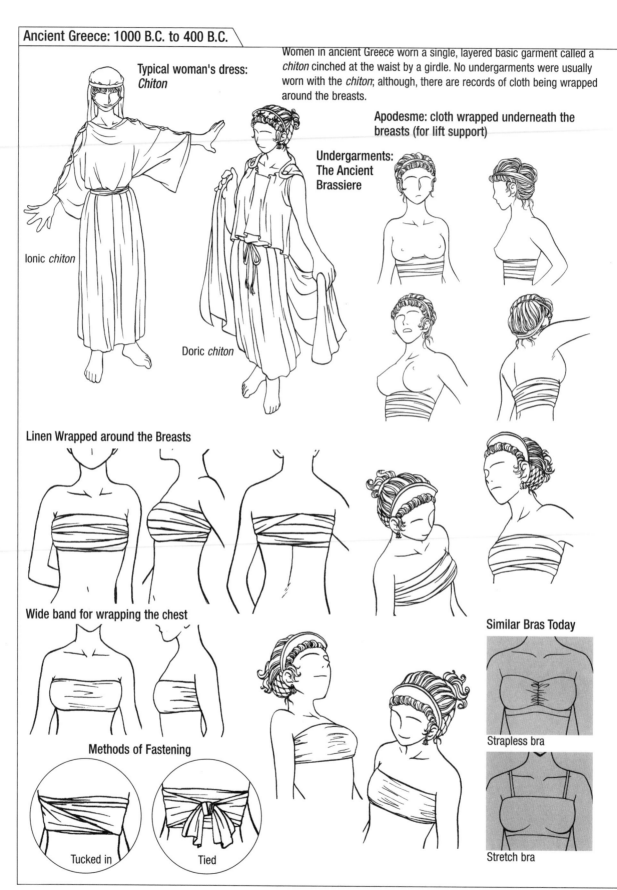

Typical woman's dress:
Chiton

Women in ancient Greece worn a single, layered basic garment called a *chiton* cinched at the waist by a girdle. No undergarments were usually worn with the *chiton*; although, there are records of cloth being wrapped around the breasts.

Ionic *chiton*

Doric *chiton*

Apodesme: cloth wrapped underneath the breasts (for lift support)

Undergarments:
The Ancient
Brassiere

Linen Wrapped around the Breasts

Wide band for wrapping the chest

Similar Bras Today

Strapless bra

Stretch bra

Methods of Fastening

Tucked in

Tied

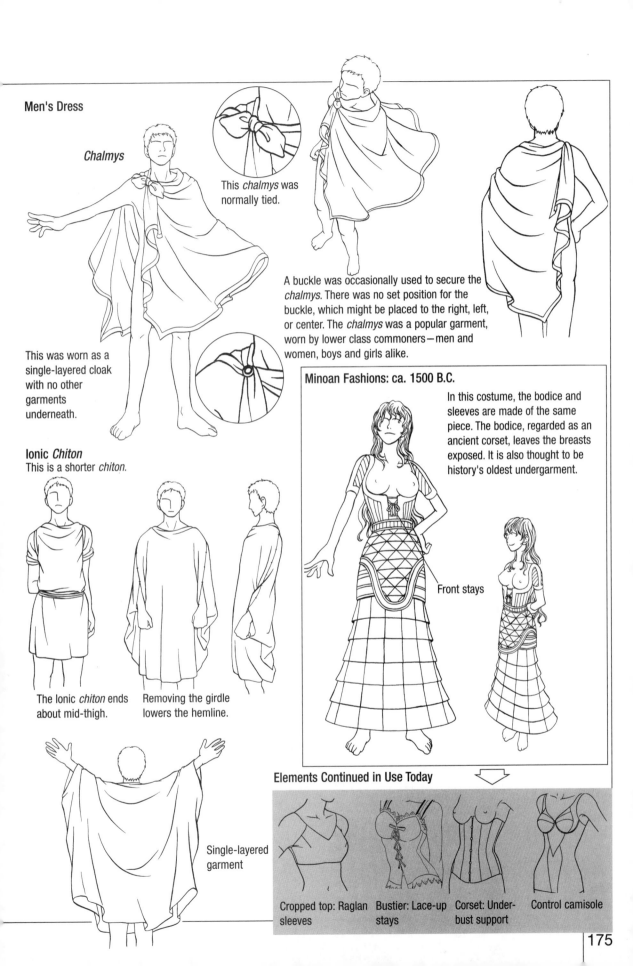

Men's Dress

Chalmys

This *chalmys* was normally tied.

This was worn as a single-layered cloak with no other garments underneath.

A buckle was occasionally used to secure the *chalmys*. There was no set position for the buckle, which might be placed to the right, left, or center. The *chalmys* was a popular garment, worn by lower class commoners—men and women, boys and girls alike.

Ionic *Chiton*

This is a shorter *chiton*.

The Ionic *chiton* ends about mid-thigh.

Removing the girdle lowers the hemline.

Single-layered garment

Minoan Fashions: ca. 1500 B.C.

In this costume, the bodice and sleeves are made of the same piece. The bodice, regarded as an ancient corset, leaves the breasts exposed. It is also thought to be history's oldest undergarment.

Front stays

Elements Continued in Use Today

Cropped top: Raglan sleeves

Bustier: Lace-up stays

Corset: Under-bust support

Control camisole

Women's Dress

Undergarments revealed

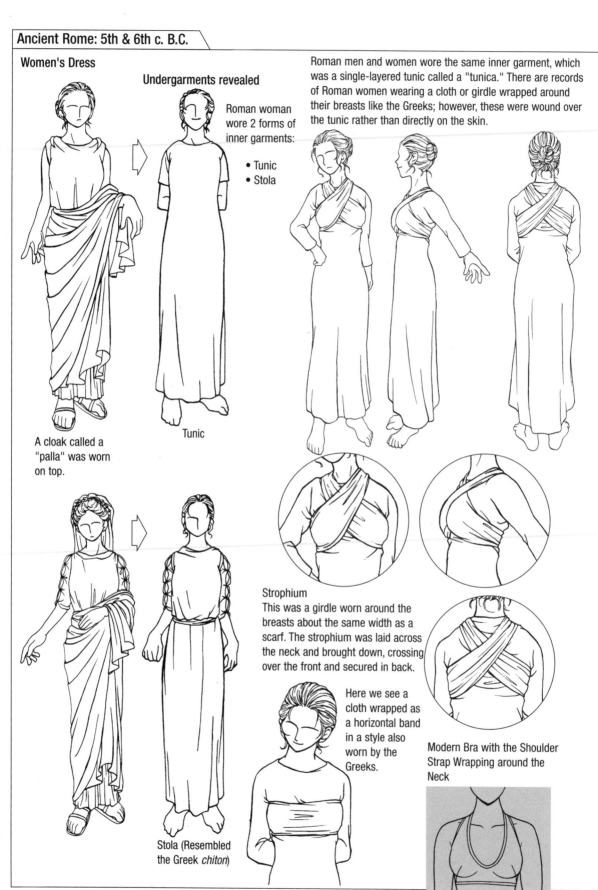

Roman woman wore 2 forms of inner garments:

- Tunic
- Stola

Roman men and women wore the same inner garment, which was a single-layered tunic called a "tunica." There are records of Roman women wearing a cloth or girdle wrapped around their breasts like the Greeks; however, these were wound over the tunic rather than directly on the skin.

A cloak called a "palla" was worn on top.

Tunic

Strophium
This was a girdle worn around the breasts about the same width as a scarf. The strophium was laid across the neck and brought down, crossing over the front and secured in back.

Here we see a cloth wrapped as a horizontal band in a style also worn by the Greeks.

Modern Bra with the Shoulder Strap Wrapping around the Neck

Stola (Resembled the Greek *chiton*)

Halter bra

Men's Dress

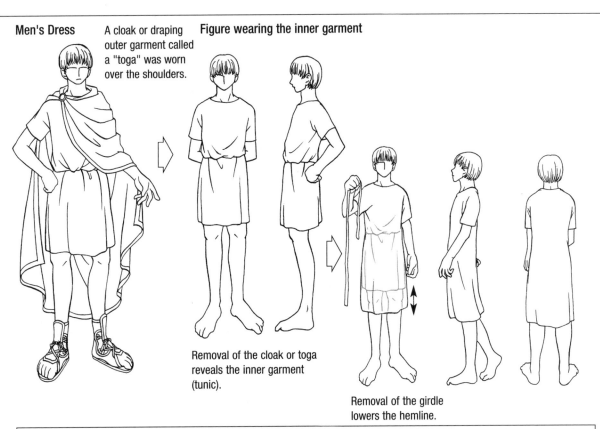

A cloak or draping outer garment called a "toga" was worn over the shoulders.

Figure wearing the inner garment

Removal of the cloak or toga reveals the inner garment (tunic).

Removal of the girdle lowers the hemline.

The Tunic: Inner Garment Favored from Antiquity to Medieval times

The tunic or *tunica* is a gown-like garment of lengths varying from groin-level and knee-length to long enough to cover the ankles. Sleeves also vary from long to short or sleeveless. The tunic might be worn in any number of different styles, including with a toga or other mantle-like garment on top or with the waist cinched.

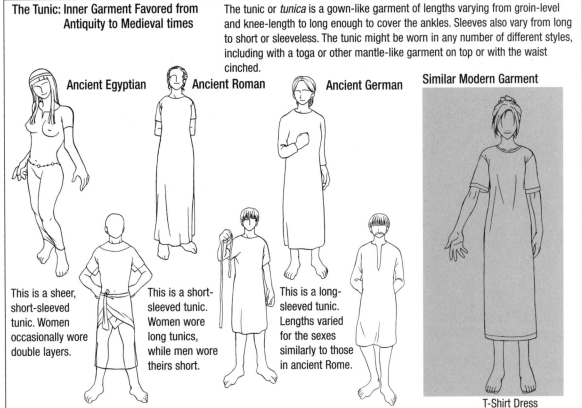

Ancient Egyptian

Ancient Roman

Ancient German

Similar Modern Garment

This is a sheer, short-sleeved tunic. Women occasionally wore double layers.

This is a short-sleeved tunic. Women wore long tunics, while men wore theirs short.

This is a long-sleeved tunic. Lengths varied for the sexes similarly to those in ancient Rome.

T-Shirt Dress

While the tunic was worn in ancient times as everyday dress, during the Middle Ages, a garment of similar cut became worn as an undergarment (eventually known as the "chemise").

Ancient Germany: 1500 AD to the Middle Ages

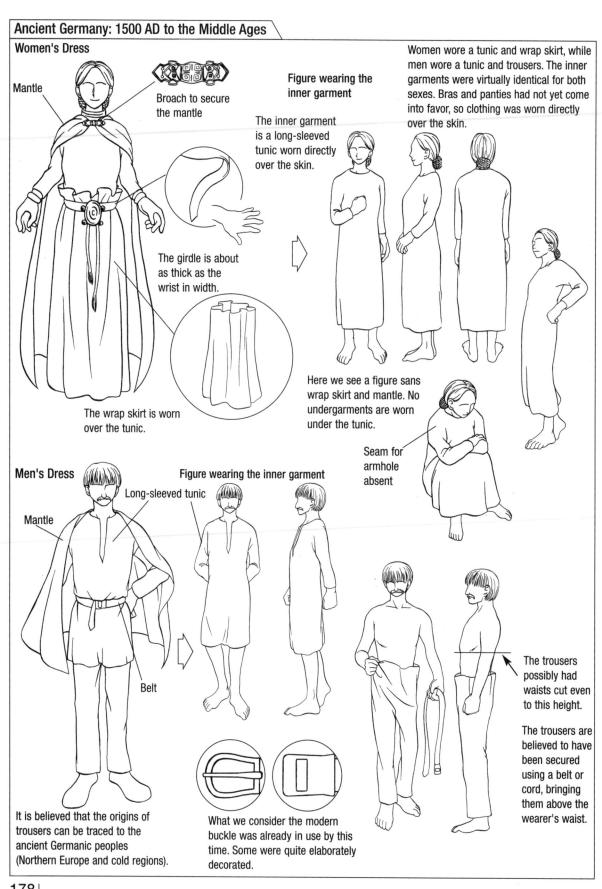

Women's Dress

Mantle

Broach to secure the mantle

The girdle is about as thick as the wrist in width.

The wrap skirt is worn over the tunic.

Figure wearing the inner garment

The inner garment is a long-sleeved tunic worn directly over the skin.

Women wore a tunic and wrap skirt, while men wore a tunic and trousers. The inner garments were virtually identical for both sexes. Bras and panties had not yet come into favor, so clothing was worn directly over the skin.

Here we see a figure sans wrap skirt and mantle. No undergarments are worn under the tunic.

Seam for armhole absent

Men's Dress

Mantle

Long-sleeved tunic

Belt

It is believed that the origins of trousers can be traced to the ancient Germanic peoples (Northern Europe and cold regions).

Figure wearing the inner garment

What we consider the modern buckle was already in use by this time. Some were quite elaborately decorated.

The trousers possibly had waists cut even to this height.

The trousers are believed to have been secured using a belt or cord, bringing them above the wearer's waist.

Middle Ages (Ca. 5th C. to 15th C.)

With numerous new nations and empires popping up on the scene, this is the period with the fewest records regarding undergarments. Historians infer from looking at what few paintings and murals as well as the undergarments of the preceding and succeeding periods (antiquity and the Renaissance, Baroque, and Rococo Periods) that this was a transitional period.

Germans, Goths, and Vikings (Ca. 5th to 10th C.)

Men's Dress

The trousers became shorter and evolved into true undergarments. In lieu of the long trousers, stockings made their appearance. The tunic began to be known as the chemise.

Mantle

Mantle Removed

Belt Removed

Over Tunic Removed

Double-layered tunic

Undergarment

Belt

Bare leg

Range of length (varied from wearer to wearer)

Women's Dress

The sleeves and hem of the tunic became longer, evolving into a gown.

Over Tunic Removed

Undergarment

Following normal dress, these pants would be so short that they would be completely covered.

Tunic worn tucked into pants

Modern Shirt and Briefs

Long-sleeved crewneck

Hem of tunic ends here.

The chemise is visible from the end of the sleeve to the hem.

The chemise is structured and cut similarly to the tunic; however, the inner garment worn directly over the skin had now become known as the "chemise."

Modern Garment

Round-necked mini full slip

The tunic and pants appear the same as a long-sleeved shirt and boxer shorts.

Boxers

*The chemise is considered the origin of the button-down shirt.

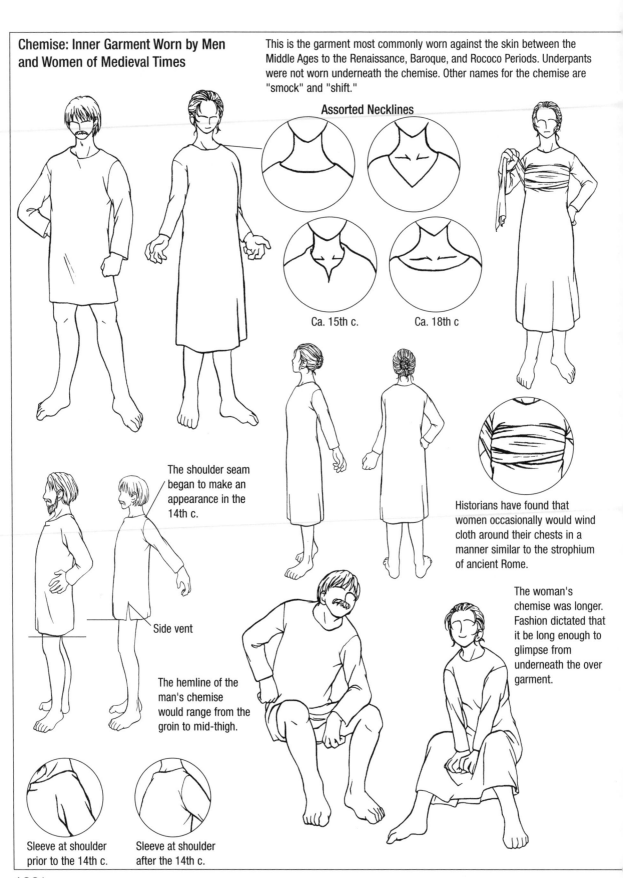

Chemise: Inner Garment Worn by Men and Women of Medieval Times

This is the garment most commonly worn against the skin between the Middle Ages to the Renaissance, Baroque, and Rococo Periods. Underpants were not worn underneath the chemise. Other names for the chemise are "smock" and "shift."

Assorted Necklines

Ca. 15th c.

Ca. 18th c

The shoulder seam began to make an appearance in the 14th c.

Side vent

The hemline of the man's chemise would range from the groin to mid-thigh.

Historians have found that women occasionally would wind cloth around their chests in a manner similar to the strophium of ancient Rome.

The woman's chemise was longer. Fashion dictated that it be long enough to glimpse from underneath the over garment.

Sleeve at shoulder prior to the 14th c.

Sleeve at shoulder after the 14th c.

180

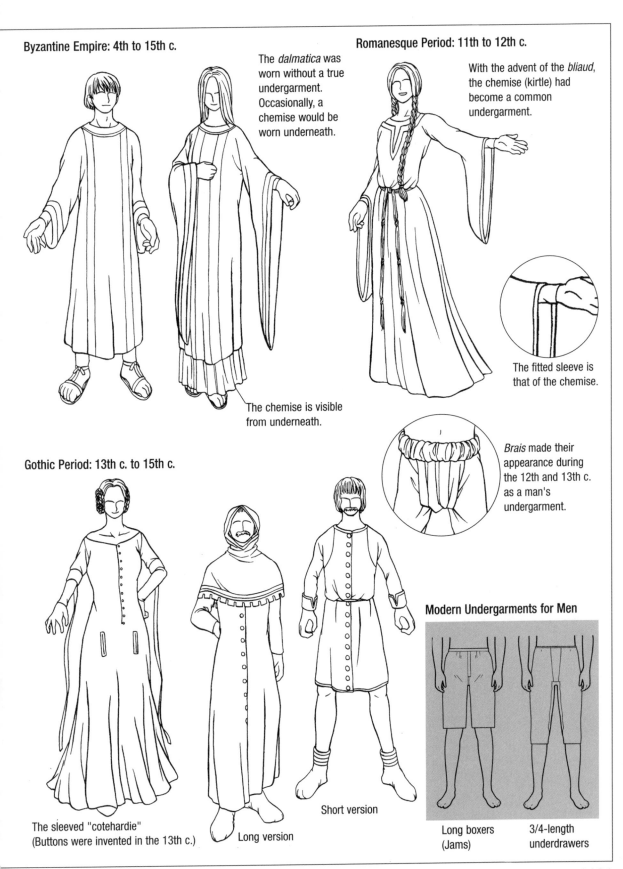

Byzantine Empire: 4th to 15th c.

The *dalmatica* was worn without a true undergarment. Occasionally, a chemise would be worn underneath.

The chemise is visible from underneath.

Romanesque Period: 11th to 12th c.

With the advent of the *bliaud*, the chemise (kirtle) had become a common undergarment.

The fitted sleeve is that of the chemise.

Brais made their appearance during the 12th and 13th c. as a man's undergarment.

Gothic Period: 13th c. to 15th c.

The sleeved "cotehardie" (Buttons were invented in the 13th c.)

Long version

Short version

Modern Undergarments for Men

Long boxers (Jams)

3/4-length underdrawers

181

Renaissance, Baroque, and Rococo Periods (Ca. Mid-15th C. to End of the 18th C.)

For this volume, we have grouped together the 3 major cultural periods, the Renaissance, Baroque, and Rococo Periods. It was during these periods that a plentitude of fashion accessories designed to reshape the figure made their first appearances. Fashions of exaggerated shapes were designed, and undergarments intended to enhance these shapes were devised.

Renaissance (Ca. Mid-15th C. to Early 17th C.)

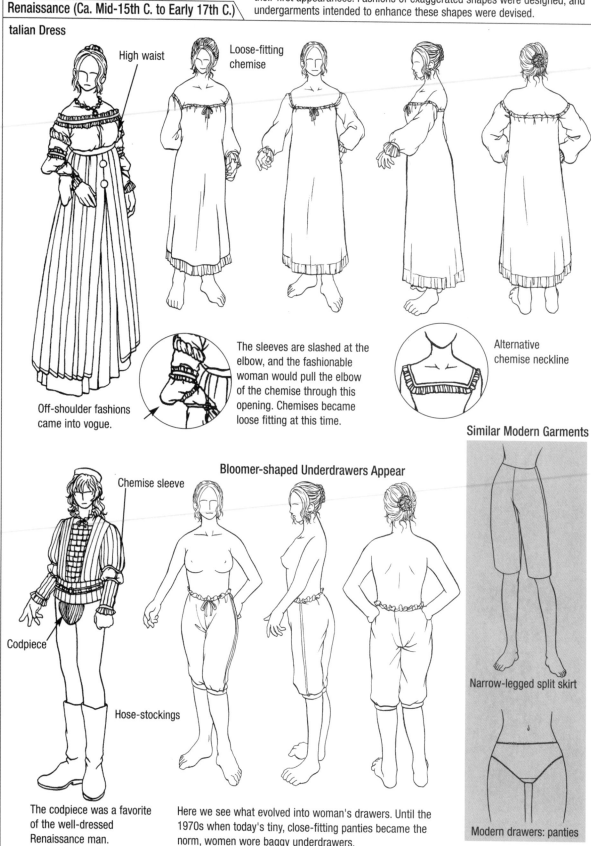

Italian Dress

High waist

Loose-fitting chemise

Off-shoulder fashions came into vogue.

The sleeves are slashed at the elbow, and the fashionable woman would pull the elbow of the chemise through this opening. Chemises became loose fitting at this time.

Alternative chemise neckline

Chemise sleeve

Bloomer-shaped Underdrawers Appear

Codpiece

Hose-stockings

The codpiece was a favorite of the well-dressed Renaissance man.

Here we see what evolved into woman's drawers. Until the 1970s when today's tiny, close-fitting panties became the norm, women wore baggy underwear.

Similar Modern Garments

Narrow-legged split skirt

Modern drawers: panties

182

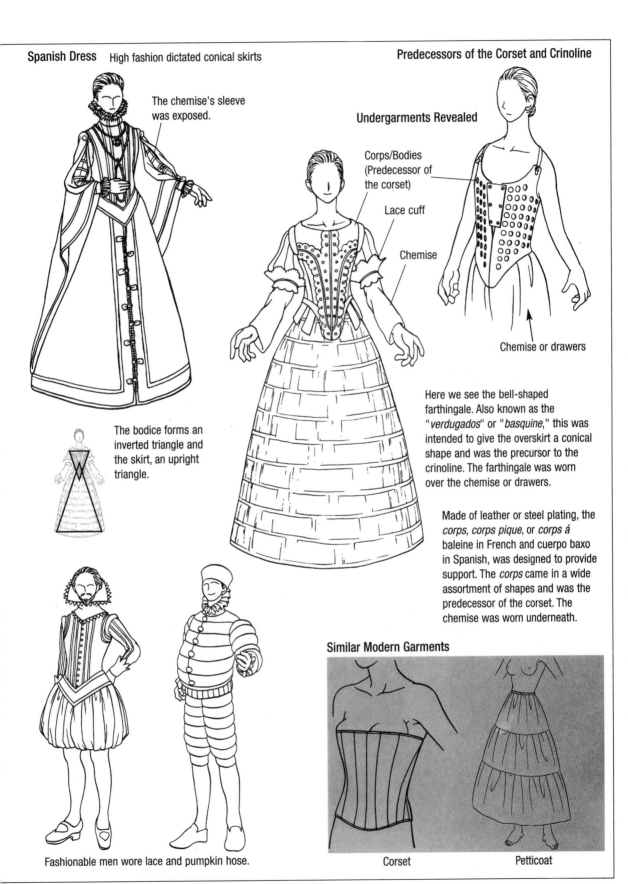

Spanish Dress High fashion dictated conical skirts

The chemise's sleeve was exposed.

The bodice forms an inverted triangle and the skirt, an upright triangle.

Fashionable men wore lace and pumpkin hose.

Predecessors of the Corset and Crinoline

Undergarments Revealed

Corps/Bodies (Predecessor of the corset)

Lace cuff

Chemise

Chemise or drawers

Here we see the bell-shaped farthingale. Also known as the "*verdugados*" or "*basquine*," this was intended to give the overskirt a conical shape and was the precursor to the crinoline. The farthingale was worn over the chemise or drawers.

Made of leather or steel plating, the *corps*, *corps pique*, or *corps á baleine* in French and cuerpo baxo in Spanish, was designed to provide support. The *corps* came in a wide assortment of shapes and was the predecessor of the corset. The chemise was worn underneath.

Similar Modern Garments

Corset

Petticoat

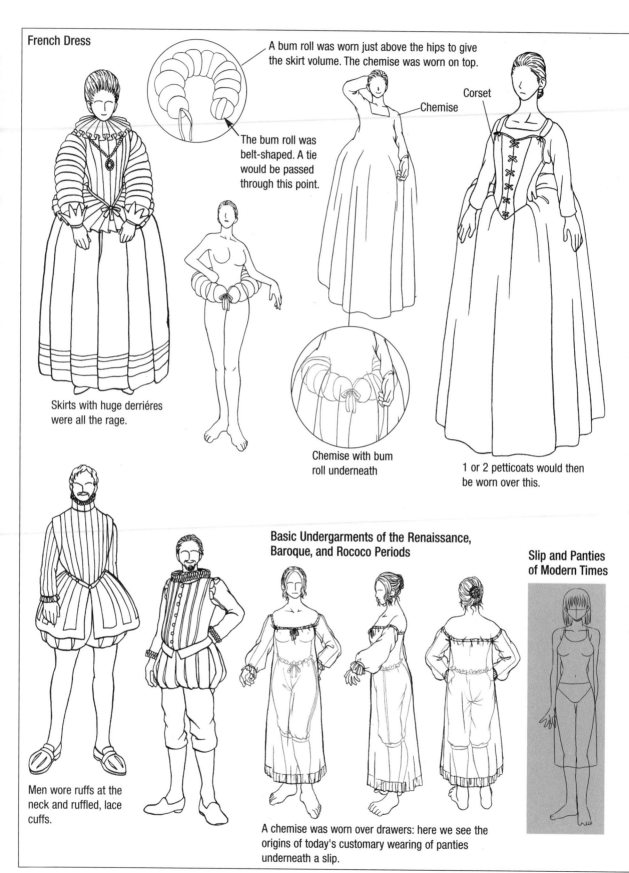

French Dress

A bum roll was worn just above the hips to give the skirt volume. The chemise was worn on top.

Chemise

Corset

The bum roll was belt-shaped. A tie would be passed through this point.

Skirts with huge derriéres were all the rage.

Chemise with bum roll underneath

1 or 2 petticoats would then be worn over this.

Basic Undergarments of the Renaissance, Baroque, and Rococo Periods

Slip and Panties of Modern Times

Men wore ruffs at the neck and ruffled, lace cuffs.

A chemise was worn over drawers: here we see the origins of today's customary wearing of panties underneath a slip.

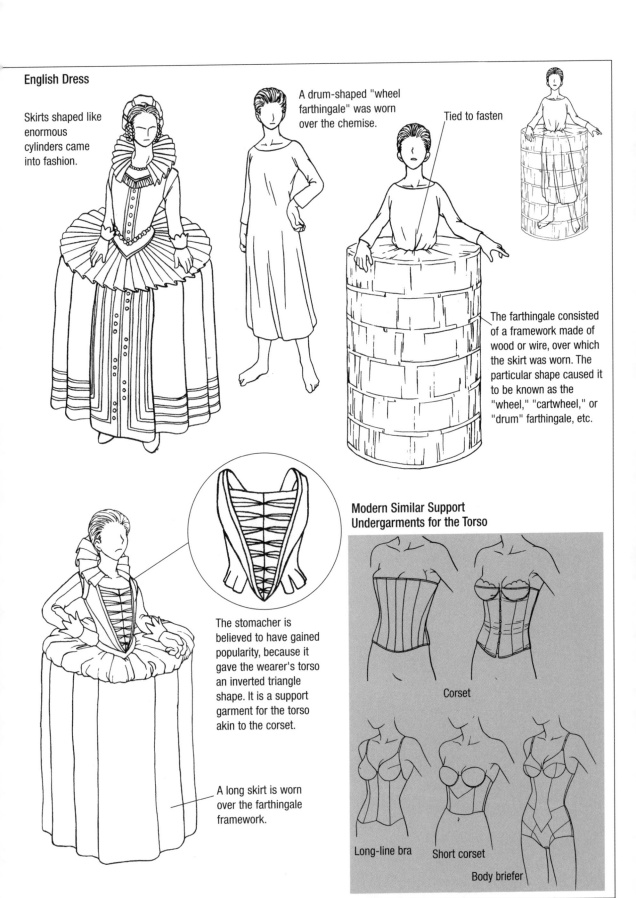

English Dress

Skirts shaped like enormous cylinders came into fashion.

A drum-shaped "wheel farthingale" was worn over the chemise.

Tied to fasten

The farthingale consisted of a framework made of wood or wire, over which the skirt was worn. The particular shape caused it to be known as the "wheel," "cartwheel," or "drum" farthingale, etc.

The stomacher is believed to have gained popularity, because it gave the wearer's torso an inverted triangle shape. It is a support garment for the torso akin to the corset.

A long skirt is worn over the farthingale framework.

Modern Similar Support Undergarments for the Torso

Corset

Long-line bra

Short corset

Body briefer

Dutch: Dominant Style of the Early Baroque (17th C.)

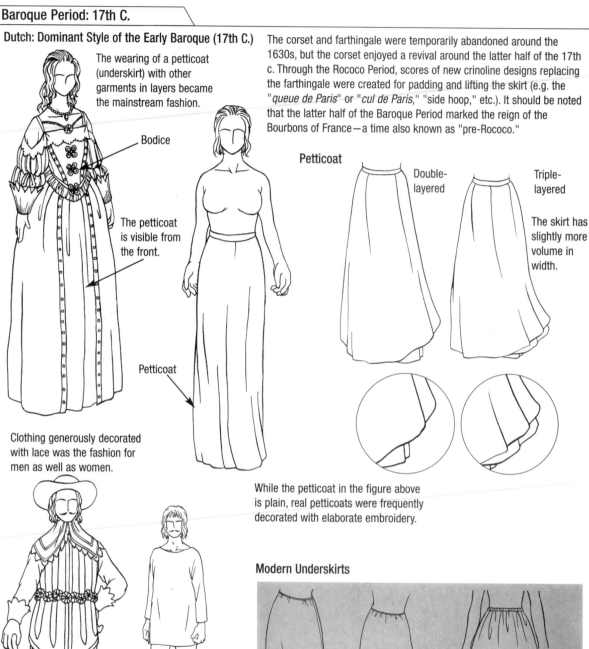

The wearing of a petticoat (underskirt) with other garments in layers became the mainstream fashion.

Bodice

The petticoat is visible from the front.

Petticoat

Clothing generously decorated with lace was the fashion for men as well as women.

Men still wore the chemise as an undergarment.

The corset and farthingale were temporarily abandoned around the 1630s, but the corset enjoyed a revival around the latter half of the 17th c. Through the Rococo Period, scores of new crinoline designs replacing the farthingale were created for padding and lifting the skirt (e.g. the "*queue de Paris*" or "*cul de Paris*," "side hoop," etc.). It should be noted that the latter half of the Baroque Period marked the reign of the Bourbons of France—a time also known as "pre-Rococo."

Petticoat

Double-layered

Triple-layered

The skirt has slightly more volume in width.

While the petticoat in the figure above is plain, real petticoats were frequently decorated with elaborate embroidery.

Modern Underskirts

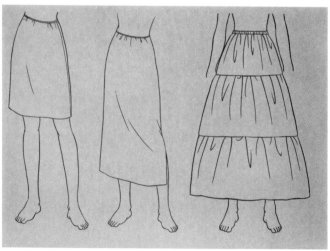

Half slip Long slip Long petticoat

French: Dominant Style of the Late Baroque (Pre-Rococo)

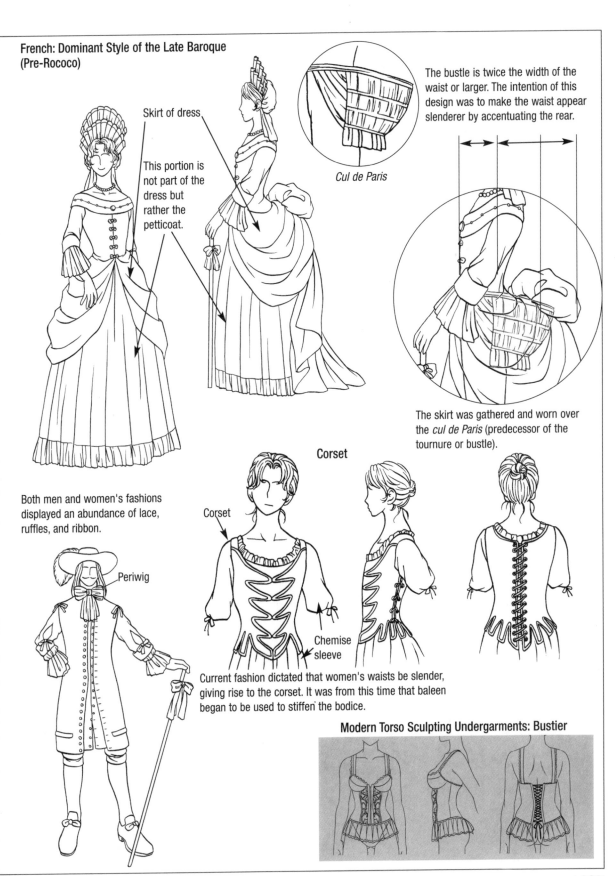

Skirt of dress

This portion is not part of the dress but rather the petticoat.

Cul de Paris

The bustle is twice the width of the waist or larger. The intention of this design was to make the waist appear slenderer by accentuating the rear.

The skirt was gathered and worn over the *cul de Paris* (predecessor of the tournure or bustle).

Both men and women's fashions displayed an abundance of lace, ruffles, and ribbon.

Periwig

Corset

Corset

Chemise sleeve

Current fashion dictated that women's waists be slender, giving rise to the corset. It was from this time that baleen began to be used to stiffen the bodice.

Modern Torso Sculpting Undergarments: Bustier

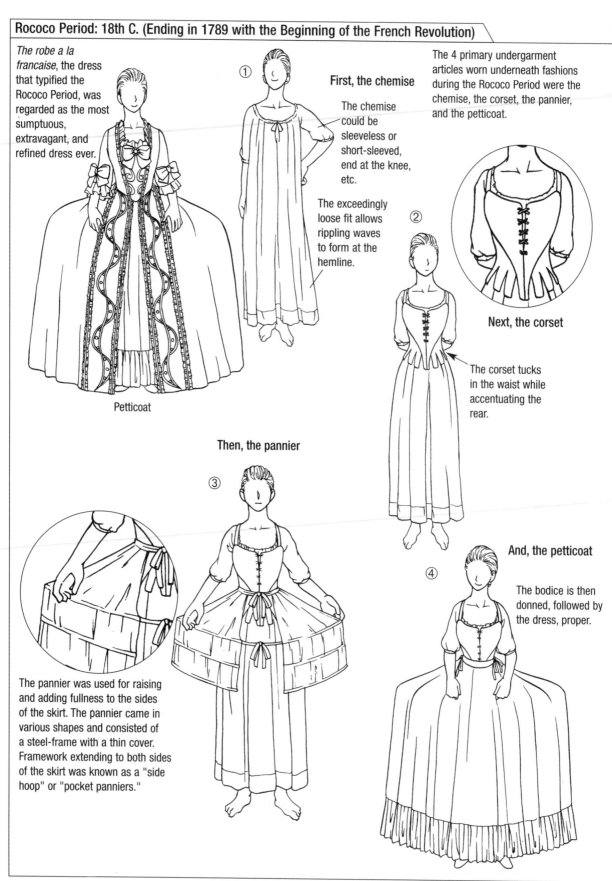

Rococo Period: 18th C. (Ending in 1789 with the Beginning of the French Revolution)

The robe a la francaise, the dress that typified the Rococo Period, was regarded as the most sumptuous, extravagant, and refined dress ever.

Petticoat

① First, the chemise

The chemise could be sleeveless or short-sleeved, end at the knee, etc.

The exceedingly loose fit allows rippling waves to form at the hemline.

The 4 primary undergarment articles worn underneath fashions during the Rococo Period were the chemise, the corset, the pannier, and the petticoat.

② Next, the corset

The corset tucks in the waist while accentuating the rear.

Then, the pannier

③

The pannier was used for raising and adding fullness to the sides of the skirt. The pannier came in various shapes and consisted of a steel-frame with a thin cover. Framework extending to both sides of the skirt was known as a "side hoop" or "pocket panniers."

And, the petticoat

④

The bodice is then donned, followed by the dress, proper.

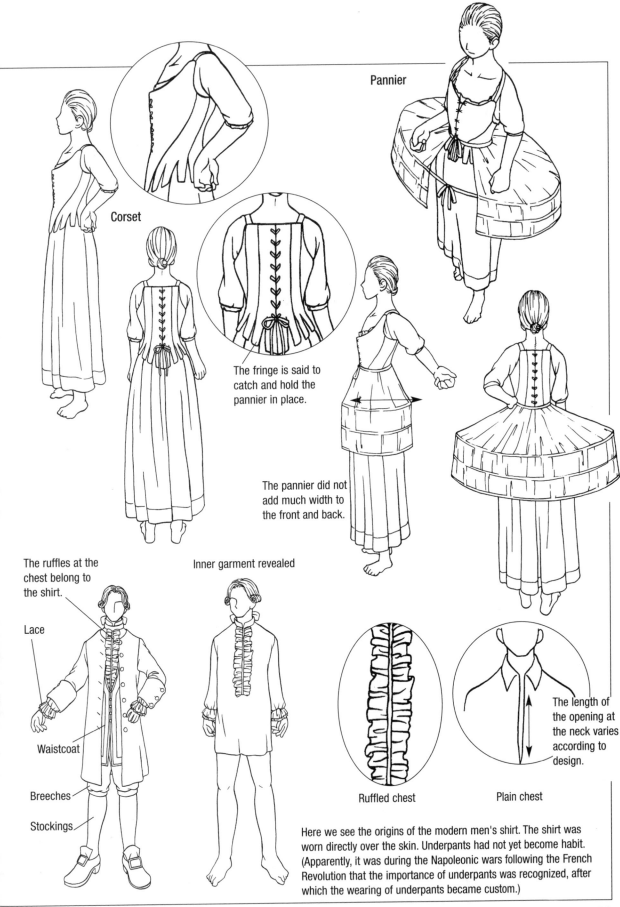

Corset

Pannier

The fringe is said to
catch and hold the
pannier in place.

The pannier did not
add much width to
the front and back.

Inner garment revealed

The ruffles at the
chest belong to
the shirt.

Lace

Waistcoat

Breeches

Stockings

The length of
the opening at
the neck varies
according to
design.

Ruffled chest

Plain chest

Here we see the origins of the modern men's shirt. The shirt was
worn directly over the skin. Underpants had not yet become habit.
(Apparently, it was during the Napoleonic wars following the French
Revolution that the importance of underpants was recognized, after
which the wearing of underpants became custom.)

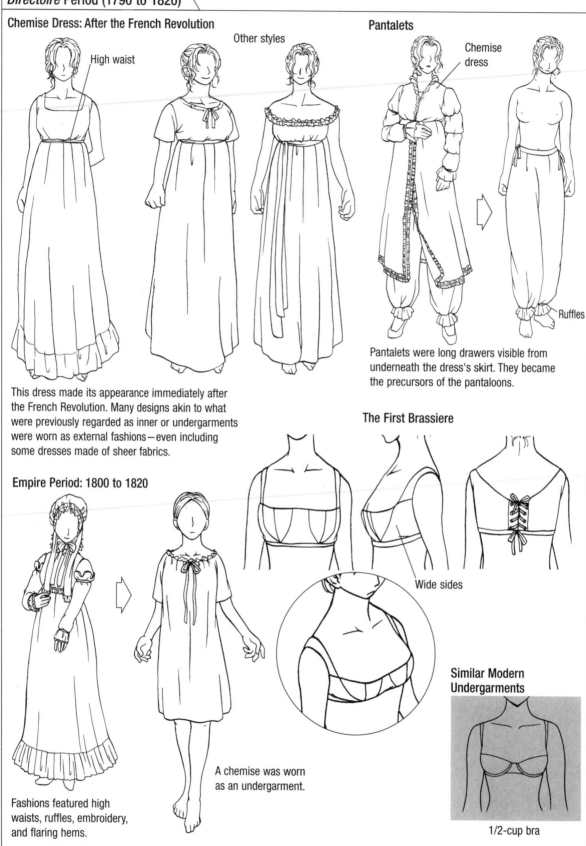

Directoire Period (1790 to 1820)

Chemise Dress: After the French Revolution

High waist

Other styles

This dress made its appearance immediately after the French Revolution. Many designs akin to what were previously regarded as inner or undergarments were worn as external fashions—even including some dresses made of sheer fabrics.

Empire Period: 1800 to 1820

Fashions featured high waists, ruffles, embroidery, and flaring hems.

A chemise was worn as an undergarment.

Pantalets

Chemise dress

Ruffles

Pantalets were long drawers visible from underneath the dress's skirt. They became the precursors of the pantaloons.

The First Brassiere

Wide sides

Similar Modern Undergarments

1/2-cup bra

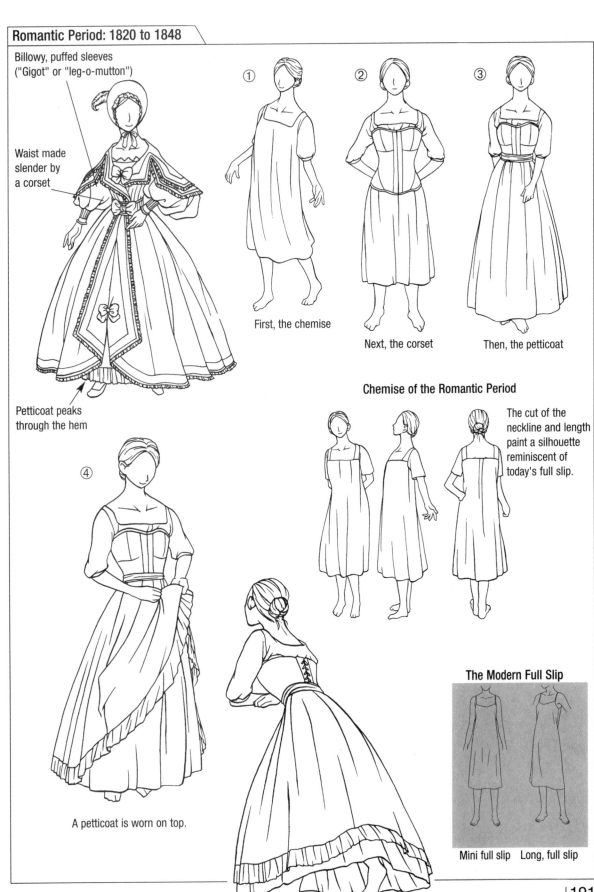

Romantic Period: 1820 to 1848

Billowy, puffed sleeves
("Gigot" or "leg-o-mutton")

Waist made
slender by
a corset

Petticoat peaks
through the hem

① First, the chemise

② Next, the corset

③ Then, the petticoat

Chemise of the Romantic Period

The cut of the neckline and length paint a silhouette reminiscent of today's full slip.

④ A petticoat is worn on top.

The Modern Full Slip

Mini full slip Long, full slip

Men's Fashions after the French Revolution

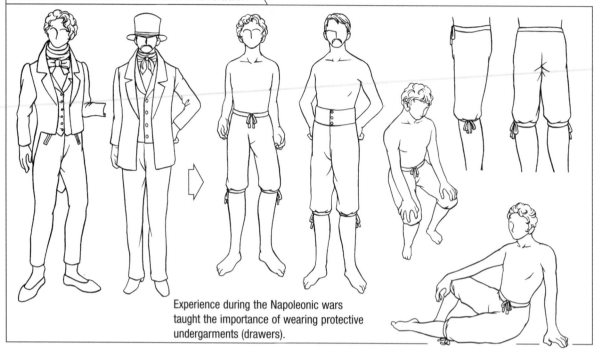

Experience during the Napoleonic wars taught the importance of wearing protective undergarments (drawers).

19th C. Drawers

Knee-length

Long

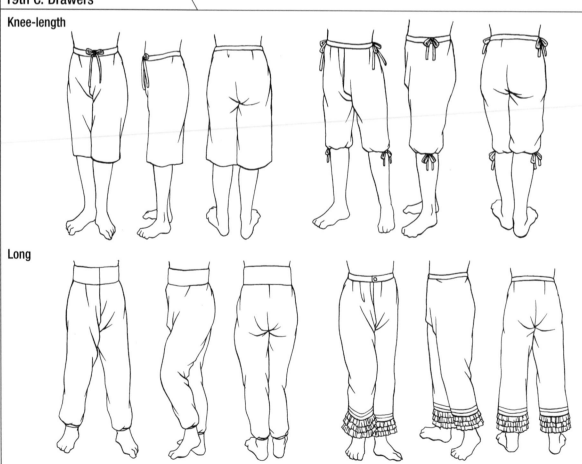

The Corset

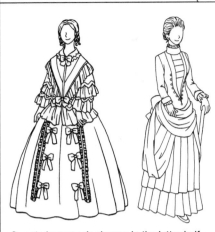

Corsets became de rigueur in the latter half of the 19th c. and were worn with crinolines, bustles, and other such fashions.

Corset Designs

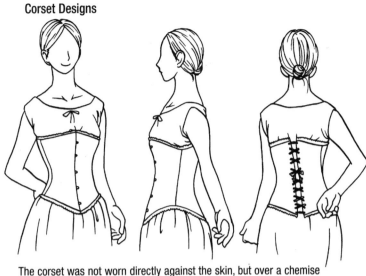

The corset was not worn directly against the skin, but over a chemise or other undergarment.

Assorted Corsets

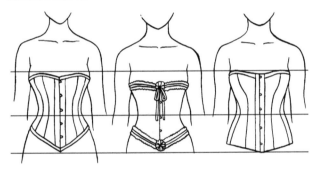

The corset served to create a clean line from the chest to the waist, while tapering the waist. The corset came in a wide variety of lengths and designs. Please note that while the majority of the figures in this book show the corset directly against the skin, the corset was not meant in actuality to touch the skin.

Modern Corsets

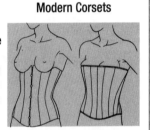

Here we see 2 types: the under bust corset, covering the torso from the abdomen to just under the breasts and the standard corset, which also covers the breasts.

Corset Covers

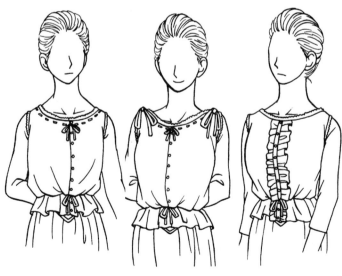

Corset covers were worn with dresses of thin fabrics or revealing necklines to prevent the corset from becoming visible. Under-bodices were corset covers with sleeves, while the camisole was a loosely fitting corset cover with shoulder straps.

Drawstrings were used to adjust the neck and waist.

Plain

Decorated with ribbons

Decorated with ruffles

Camisole

Starting in the 1840s, dresses with widely flaring skirts (ball dresses) became the rage. A crinoline cage was worn underneath the ball dress to give it its desired shape. In general, ball dresses were referred to as crinoline dresses. Initially, petticoats were made of stiff fibers, but these were then followed by the birdcage-shaped crinoline, which was developed around 1855.

The Crinoline: From 1855

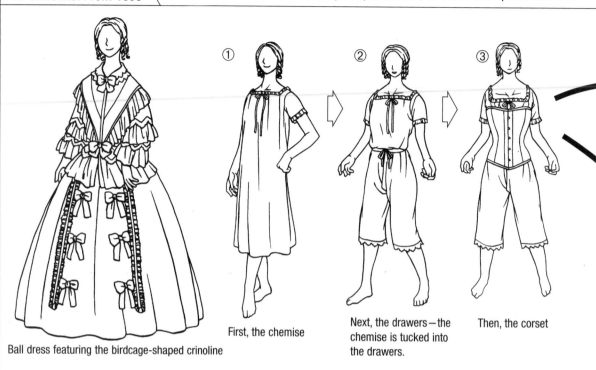

Ball dress featuring the birdcage-shaped crinoline

① First, the chemise

② Next, the drawers—the chemise is tucked into the drawers.

③ Then, the corset

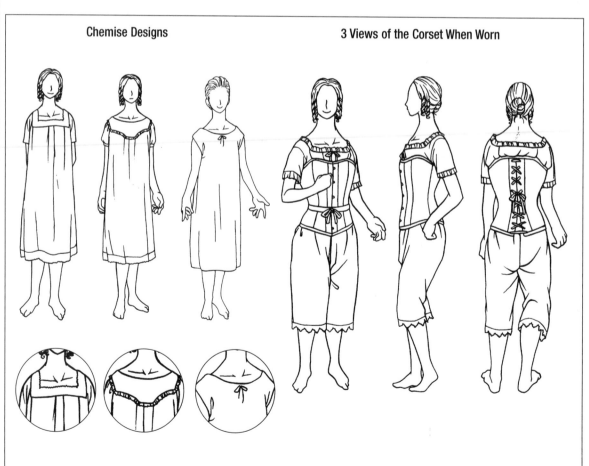

Chemise Designs

3 Views of the Corset When Worn

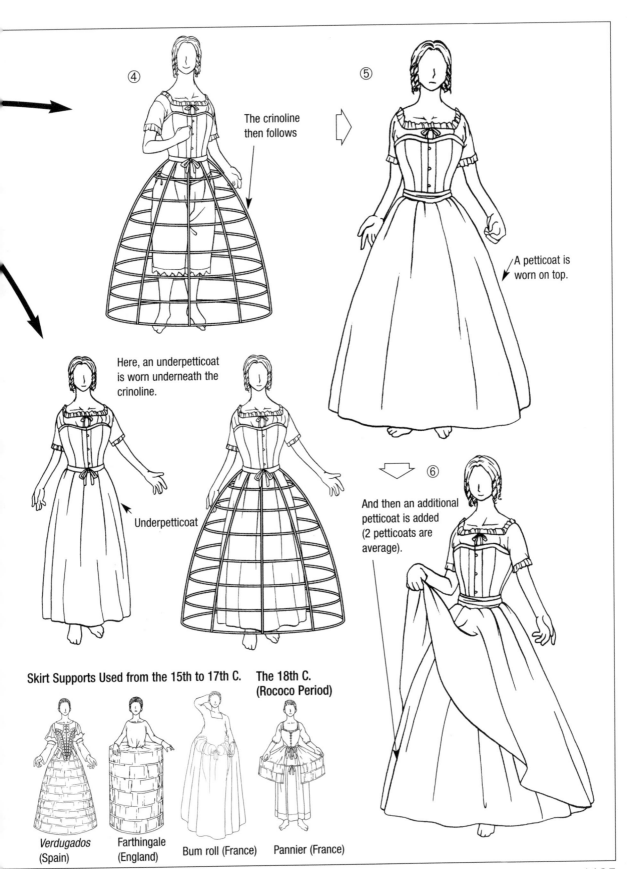

④

The crinoline
then follows

⑤

A petticoat is
worn on top.

Here, an underpetticoat
is worn underneath the
crinoline.

Underpetticoat

⑥

And then an additional
petticoat is added
(2 petticoats are
average).

Skirt Supports Used from the 15th to 17th C. **The 18th C.
(Rococo Period)**

Verdugados
(Spain)

Farthingale
(England)

Bum roll (France)

Pannier (France)

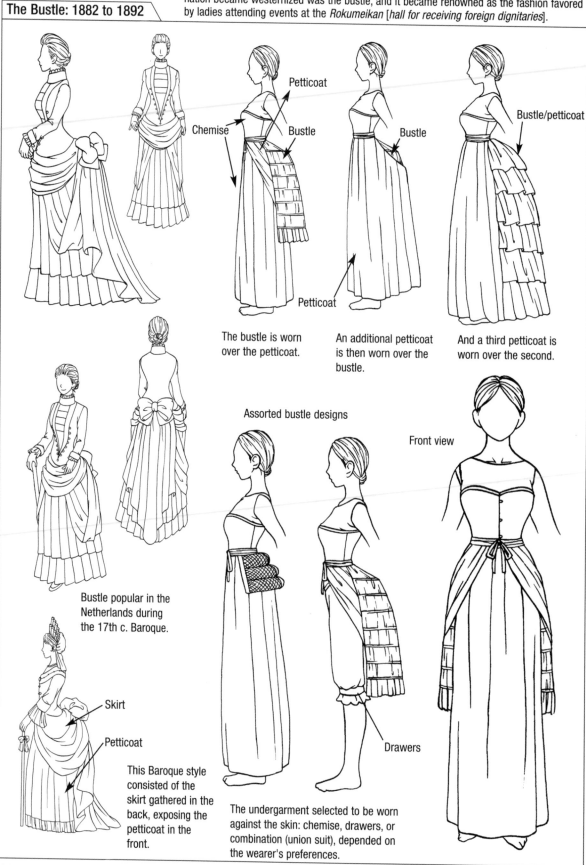

The birdcage-shaped, flaring crinoline dresses were transformed, and framework expanding the back of the skirt became all the rage. This rear support was known as the "bustle." The first European dress style to enter Japan during the Meiji Period (1868-1912), when the nation became westernized was the bustle, and it became renowned as the fashion favored by ladies attending events at the *Rokumeikan* [*hall for receiving foreign dignitaries*].

The Bustle: 1882 to 1892

Chemise

Petticoat

Bustle

The bustle is worn over the petticoat.

Bustle

Petticoat

An additional petticoat is then worn over the bustle.

Bustle/petticoat

And a third petticoat is worn over the second.

Bustle popular in the Netherlands during the 17th c. Baroque.

Assorted bustle designs

Front view

Skirt

Petticoat

This Baroque style consisted of the skirt gathered in the back, exposing the petticoat in the front.

Drawers

The undergarment selected to be worn against the skin: chemise, drawers, or combination (union suit), depended on the wearer's preferences.

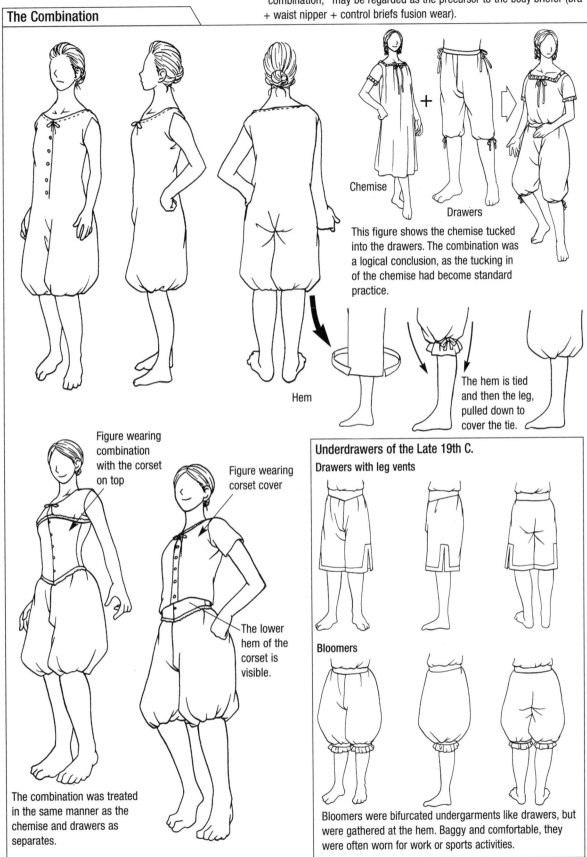

In the 1870s, a new type of undergarment was born, combining the chemise and drawers. This new undergarment, called the "union suit" or "combination," may be regarded as the precursor to the body briefer (bra + waist nipper + control briefs fusion wear).

The Combination

Chemise

Drawers

This figure shows the chemise tucked into the drawers. The combination was a logical conclusion, as the tucking in of the chemise had become standard practice.

Hem

The hem is tied and then the leg, pulled down to cover the tie.

Figure wearing combination with the corset on top

Figure wearing corset cover

The lower hem of the corset is visible.

The combination was treated in the same manner as the chemise and drawers as separates.

Underdrawers of the Late 19th C.
Drawers with leg vents

Bloomers

Bloomers were bifurcated undergarments like drawers, but were gathered at the hem. Baggy and comfortable, they were often worn for work or sports activities.

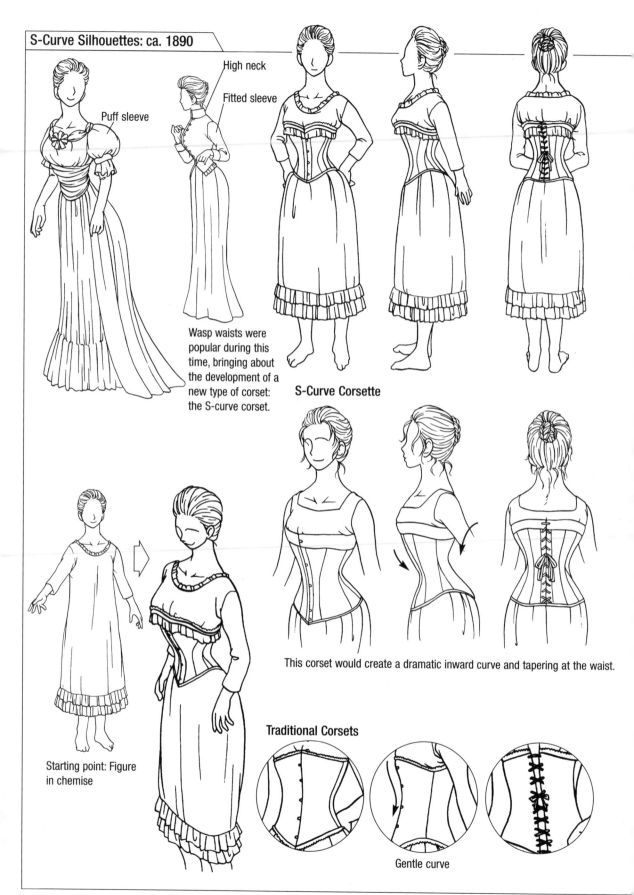

S-Curve Silhouettes: ca. 1890

Puff sleeve

High neck

Fitted sleeve

Wasp waists were popular during this time, bringing about the development of a new type of corset: the S-curve corset.

S-Curve Corsette

This corset would create a dramatic inward curve and tapering at the waist.

Starting point: Figure in chemise

Traditional Corsets

Gentle curve

S-Curve Corset Designs

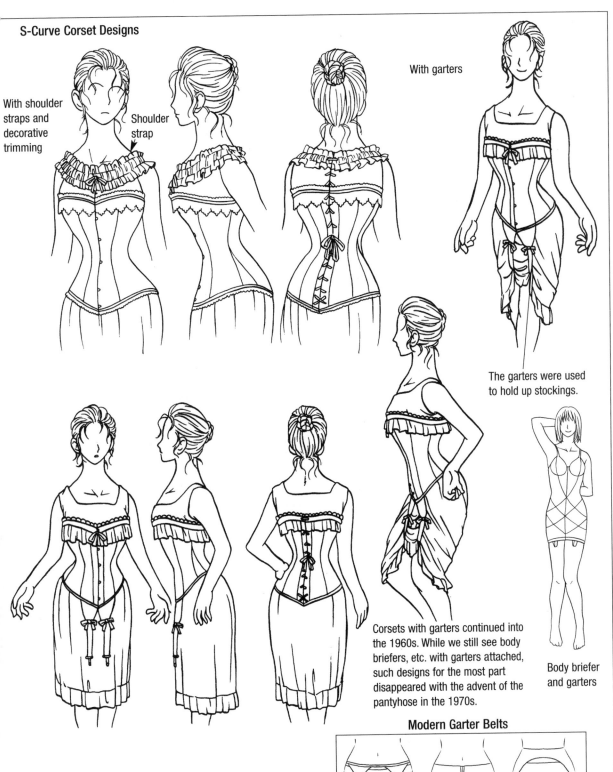

With shoulder straps and decorative trimming

Shoulder strap

With garters

The garters were used to hold up stockings.

Corsets with garters continued into the 1960s. While we still see body briefers, etc. with garters attached, such designs for the most part disappeared with the advent of the pantyhose in the 1970s.

Body briefer and garters

Modern Garter Belts

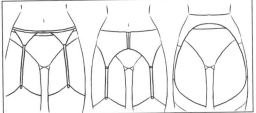

Today's mainstream fashions lean toward garter belts as separates.

Chemises Worn over Drawers and Petticoats

These were worn on top of the chemise, the drawers, the corset, and (if worn) the corset cover.

Empire Chemise

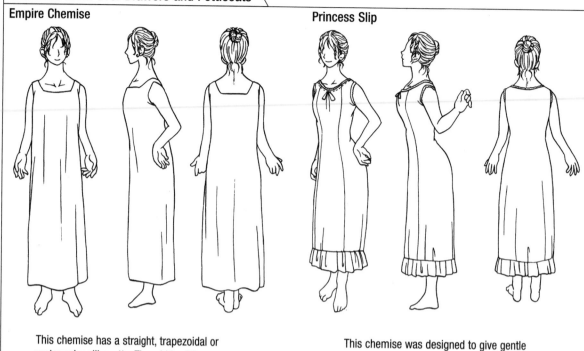

This chemise has a straight, trapezoidal or rectangular silhouette. The width of the neckline from the back varies from design to design.

Princess Slip

This chemise was designed to give gentle curves to the silhouette, creating an hourglass form. The flounces at the hem were intended to facilitate movement.

Elliptical Petticoat

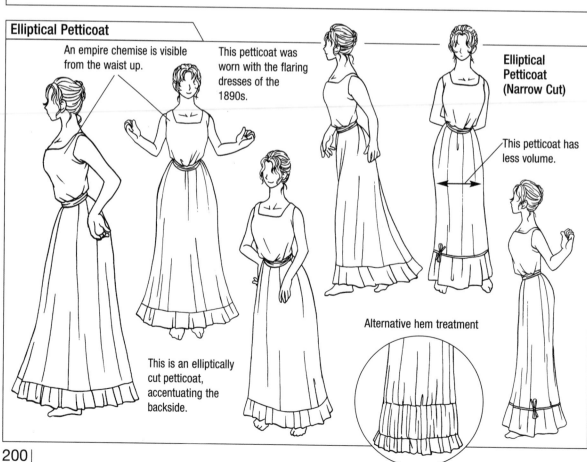

An empire chemise is visible from the waist up.

This petticoat was worn with the flaring dresses of the 1890s.

Elliptical Petticoat (Narrow Cut)

This petticoat has less volume.

This is an elliptically cut petticoat, accentuating the backside.

Alternative hem treatment

The 20th Century (1910s to 1960s)

1910s: Slim Was In

Explosive changes occurred in fashion and undergarment history in the 1920s and 1930s following the First World War (1914 to 1918) and then in the 1950s and 1960s following the Second World War (1939 to 1945) From the 1970s and onward, we mostly see the development or continuation of styles already in existence. On the following pages appear the most revolutionary of designs developed up through the 1960s.

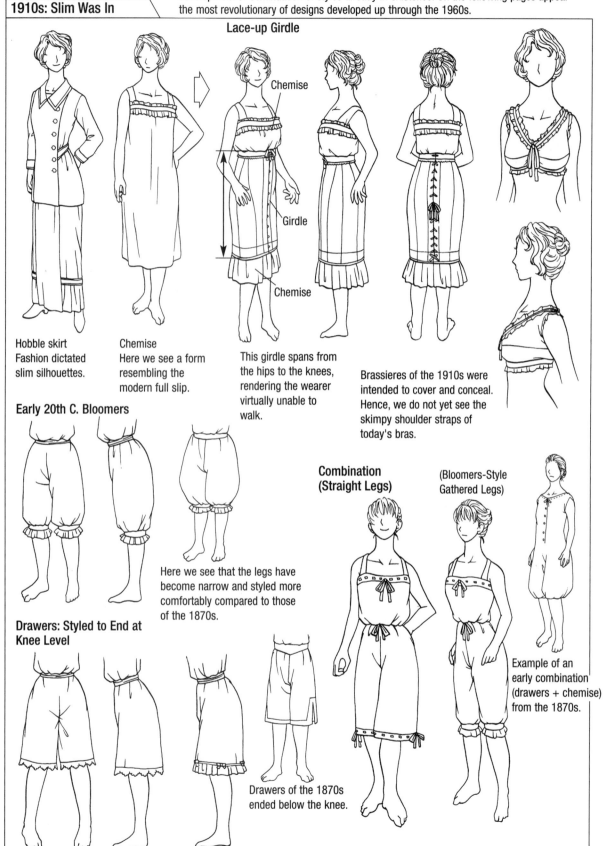

Lace-up Girdle

Chemise

Girdle

Chemise

Hobble skirt
Fashion dictated slim silhouettes.

Chemise
Here we see a form resembling the modern full slip.

This girdle spans from the hips to the knees, rendering the wearer virtually unable to walk.

Brassieres of the 1910s were intended to cover and conceal. Hence, we do not yet see the skimpy shoulder straps of today's bras.

Early 20th C. Bloomers

Here we see that the legs have become narrow and styled more comfortably compared to those of the 1870s.

Drawers: Styled to End at Knee Level

Drawers of the 1870s ended below the knee.

Combination (Straight Legs)

(Bloomers-Style Gathered Legs)

Example of an early combination (drawers + chemise) from the 1870s.

201

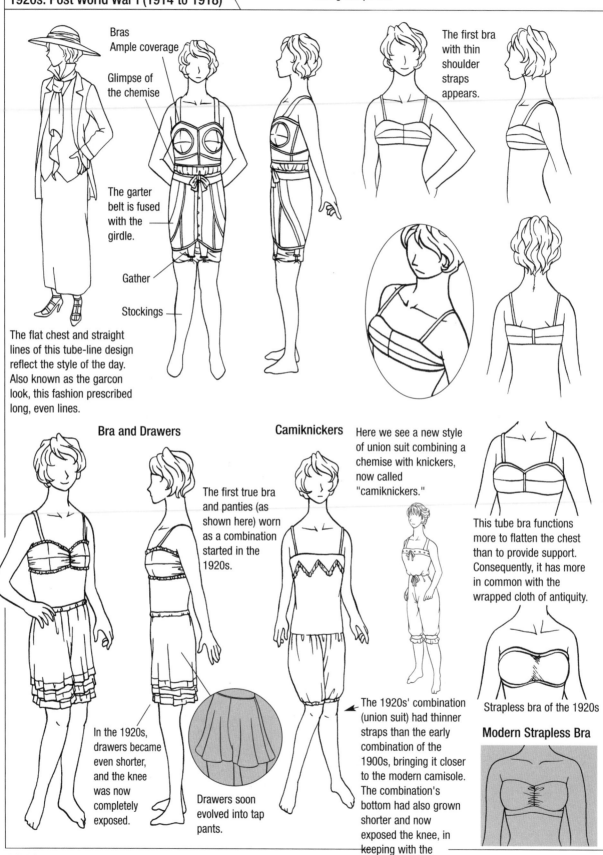

In the 1920s, the ideal beauty sported a slim figure with straight lines. The first true bras and garter belts made their appearance during this period.

Bras
Ample coverage

Glimpse of the chemise

The garter belt is fused with the girdle.

Gather

Stockings

The flat chest and straight lines of this tube-line design reflect the style of the day. Also known as the garcon look, this fashion prescribed long, even lines.

The first bra with thin shoulder straps appears.

Bra and Drawers

The first true bra and panties (as shown here) worn as a combination started in the 1920s.

Camiknickers

Here we see a new style of union suit combining a chemise with knickers, now called "camiknickers."

This tube bra functions more to flatten the chest than to provide support. Consequently, it has more in common with the wrapped cloth of antiquity.

In the 1920s, drawers became even shorter, and the knee was now completely exposed.

Drawers soon evolved into tap pants.

The 1920s' combination (union suit) had thinner straps than the early combination of the 1900s, bringing it closer to the modern camisole. The combination's bottom had also grown shorter and now exposed the knee, in keeping with the 1920s-style of drawers.

Strapless bra of the 1920s

Modern Strapless Bra

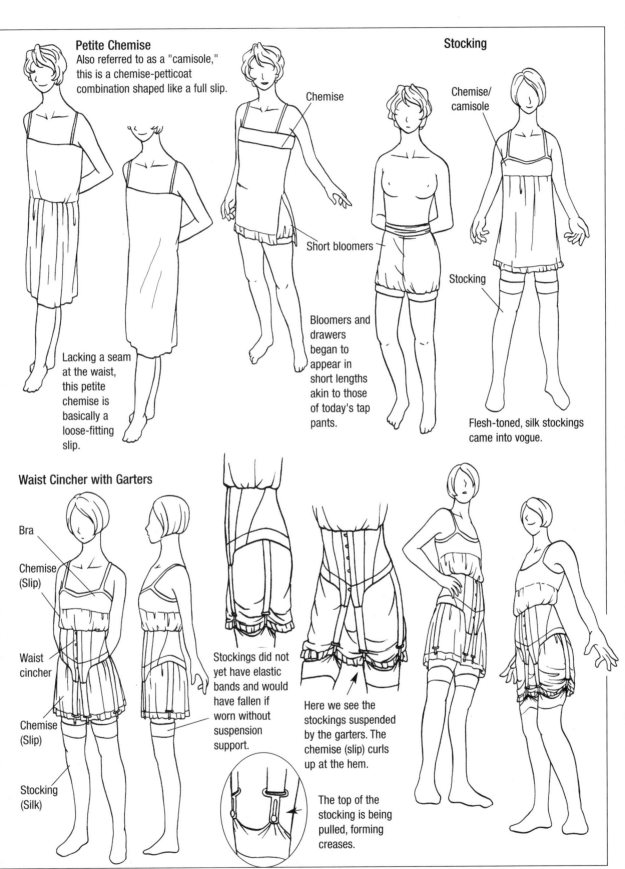

Petite Chemise

Also referred to as a "camisole," this is a chemise-petticoat combination shaped like a full slip.

Lacking a seam at the waist, this petite chemise is basically a loose-fitting slip.

Chemise

Short bloomers

Bloomers and drawers began to appear in short lengths akin to those of today's tap pants.

Stocking

Chemise/camisole

Stocking

Flesh-toned, silk stockings came into vogue.

Waist Cincher with Garters

Bra

Chemise (Slip)

Waist cincher

Chemise (Slip)

Stocking (Silk)

Stockings did not yet have elastic bands and would have fallen if worn without suspension support.

Here we see the stockings suspended by the garters. The chemise (slip) curls up at the hem.

The top of the stocking is being pulled, forming creases.

When stockings first made their appearance around the 16th c., they were a men's clothing item. Women began to wear stockings in the 17th c.

It is believed the full slip appeared during these years as a new undergarment worn over the bra and girdle. We also see bra designs identical to those worn today.

1930s: Pre-World War II

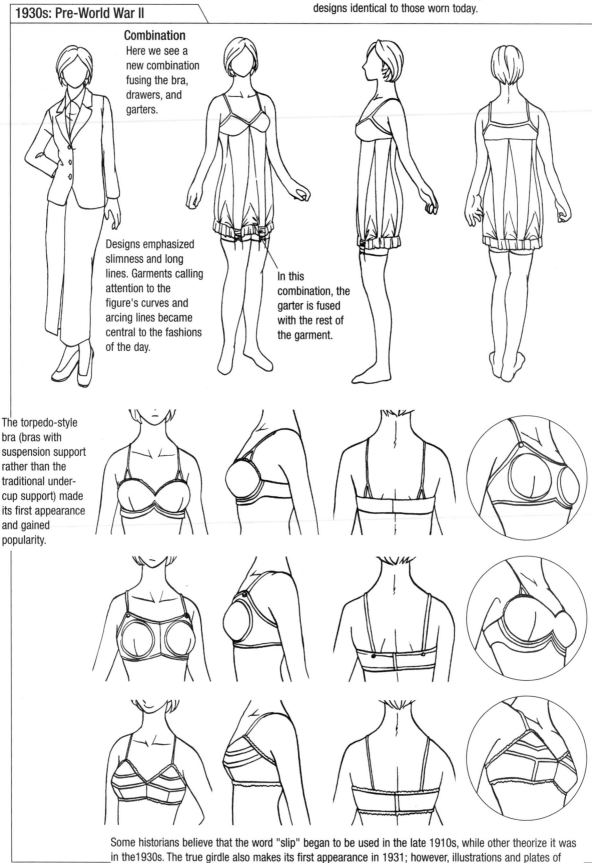

Combination
Here we see a new combination fusing the bra, drawers, and garters.

Designs emphasized slimness and long lines. Garments calling attention to the figure's curves and arcing lines became central to the fashions of the day.

In this combination, the garter is fused with the rest of the garment.

The torpedo-style bra (bras with suspension support rather than the traditional under-cup support) made its first appearance and gained popularity.

Some historians believe that the word "slip" began to be used in the late 1910s, while other theorize it was in the 1930s. The true girdle also makes its first appearance in 1931; however, illustrations and plates of girdles appear in print before then (in the 1920s).

The waist nipper, long-leg girdle, and garter belt all made their appearance during this period, as well as the all-in-one—an advanced version of the combination. Furthermore, drawers had finally evolved into the modern tap pants.

1947 to 1959: Post World War II

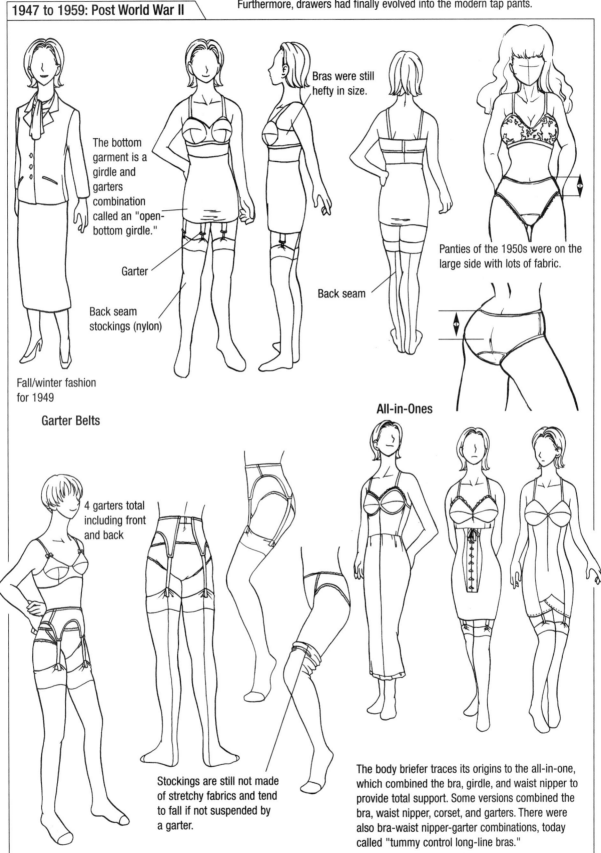

Bras were still hefty in size.

The bottom garment is a girdle and garters combination called an "open-bottom girdle."

Garter

Back seam stockings (nylon)

Fall/winter fashion for 1949

Garter Belts

4 garters total including front and back

Stockings are still not made of stretchy fabrics and tend to fall if not suspended by a garter.

Back seam

Panties of the 1950s were on the large side with lots of fabric.

All-in-Ones

The body briefer traces its origins to the all-in-one, which combined the bra, girdle, and waist nipper to provide total support. Some versions combined the bra, waist nipper, corset, and garters. There were also bra-waist nipper-garter combinations, today called "tummy control long-line bras."

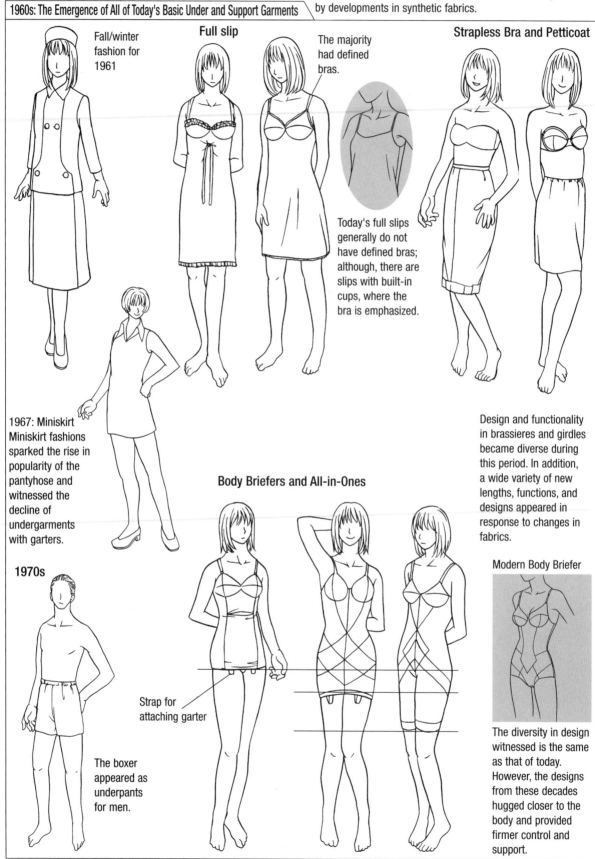

During this time, what common fashions were considered in vogue would change every few months. For undergarments, this time was called "the underwear revolution," brought about by developments in synthetic fabrics.

1960s: The Emergence of All of Today's Basic Under and Support Garments

Fall/winter fashion for 1961

Full slip

The majority had defined bras.

Today's full slips generally do not have defined bras; although, there are slips with built-in cups, where the bra is emphasized.

Strapless Bra and Petticoat

Design and functionality in brassieres and girdles became diverse during this period. In addition, a wide variety of new lengths, functions, and designs appeared in response to changes in fabrics.

1967: Miniskirt
Miniskirt fashions sparked the rise in popularity of the pantyhose and witnessed the decline of undergarments with garters.

Body Briefers and All-in-Ones

Strap for attaching garter

1970s

The boxer appeared as underpants for men.

Modern Body Briefer

The diversity in design witnessed is the same as that of today. However, the designs from these decades hugged closer to the body and provided firmer control and support.

206

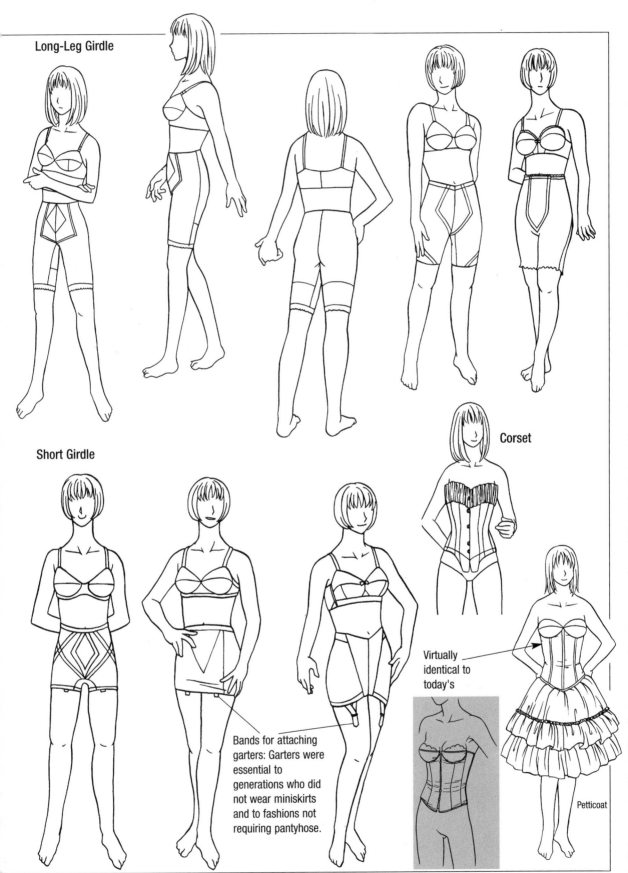

Long-Leg Girdle

Short Girdle

Corset

Virtually
identical to
today's

Bands for attaching
garters: Garters were
essential to
generations who did
not wear miniskirts
and to fashions not
requiring pantyhose.

Petticoat

Under and Inner Wear

Antiquity (3000 B.C. to 300 AD)

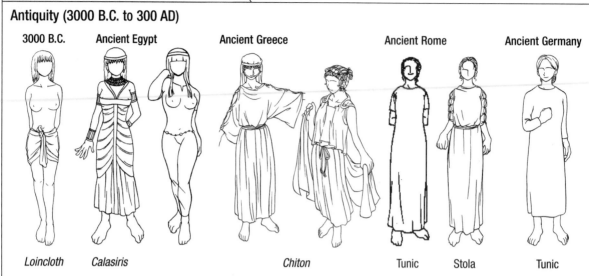

3000 B.C.	Ancient Egypt	Ancient Greece	Ancient Rome	Ancient Germany
Loincloth	*Calasiris*	*Chiton*	Tunic Stola	Tunic

Middle Ages: ca. 5th C. to 15th C.

Renaissance, Baroque, and Rococo Periods: ca. Mid-16th C. to Late 18th C.

Renaissance Baroque Period Rococo Period

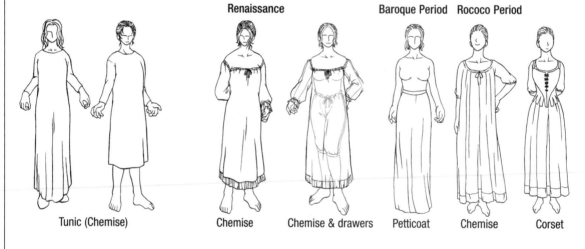

Tunic (Chemise) Chemise Chemise & drawers Petticoat Chemise Corset

Modern Day: Late 18th C. to Early 20th C

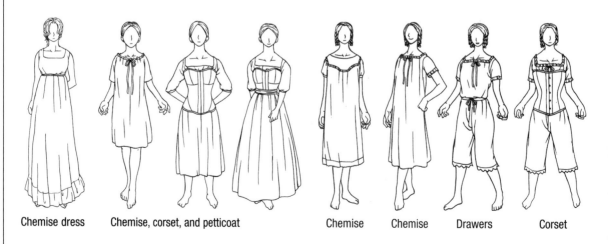

Chemise dress Chemise, corset, and petticoat Chemise Chemise Drawers Corset

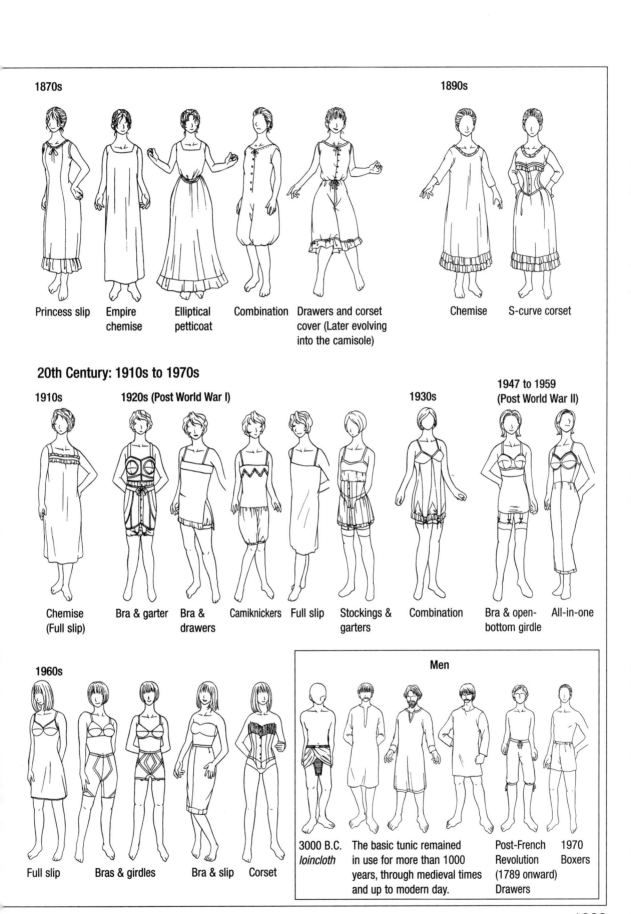

1870s

Princess slip

Empire
chemise

Elliptical
petticoat

Combination

Drawers and corset
cover (Later evolving
into the camisole)

1890s

Chemise

S-curve corset

20th Century: 1910s to 1970s

1910s

1920s (Post World War I)

1930s

**1947 to 1959
(Post World War II)**

Chemise
(Full slip)

Bra & garter

Bra &
drawers

Camiknickers

Full slip

Stockings &
garters

Combination

Bra & open-
bottom girdle

All-in-one

1960s

Full slip

Bras & girdles

Bra & slip

Corset

Men

3000 B.C.
loincloth

The basic tunic remained
in use for more than 1000
years, through medieval times
and up to modern day.

Post-French
Revolution
(1789 onward)
Drawers

1970
Boxers

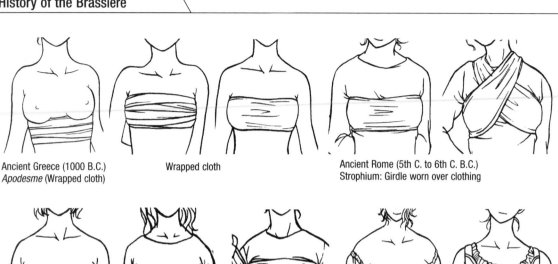

Ancient Greece (1000 B.C.)
Apodesme (Wrapped cloth)

Wrapped cloth

Ancient Rome (5th C. to 6th C. B.C.)
Strophium: Girdle worn over clothing

From the Middles Ages (ca. 5th c. to 15th c.) to the
Renaissance, Baroque, and Rococo Periods (16th c. to
end of the 18th c.), no undergarments other than the
chemise were usually worn.

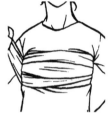

During the Middle Ages, a
cloth was sometimes worn
wrapped around the tunic.

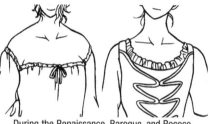

During the Renaissance, Baroque, and Rococo
Periods, the corset was often worn over the
chemise to shape the bust.

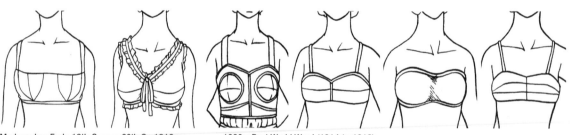

Modern day: Early 19th C.
Early brassiere

20th C.: 1910s

1920s: Post World War I (1914 to 1918)

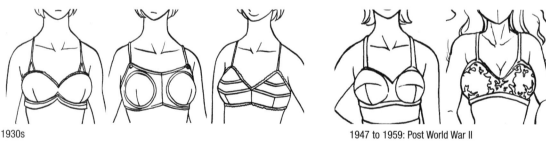

1930s

1947 to 1959: Post World War II

1960s

2000 and on

Chapter 3
Drawing Intimates

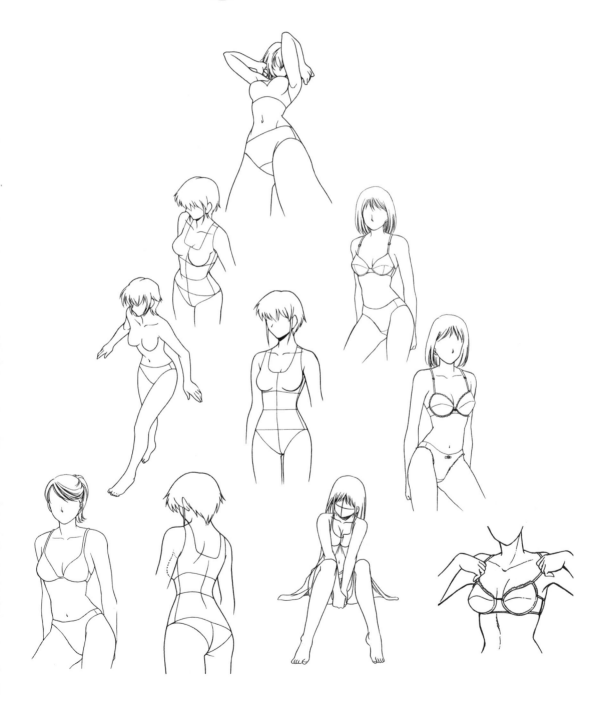

Basic Figure Forms Useful to Drawing

Full Figure Views by Angle

Front View

Centerline

Base chest line

Waist line

Hip line

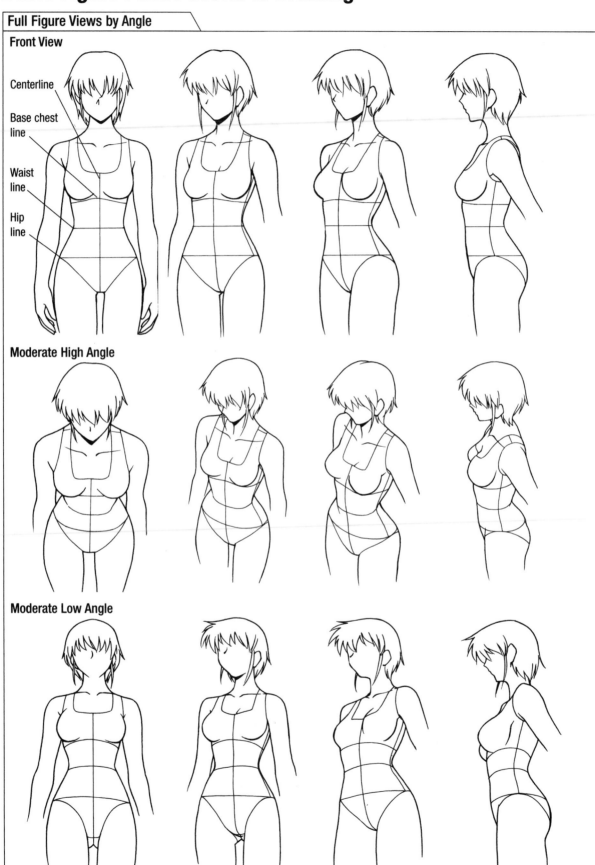

Moderate High Angle

Moderate Low Angle

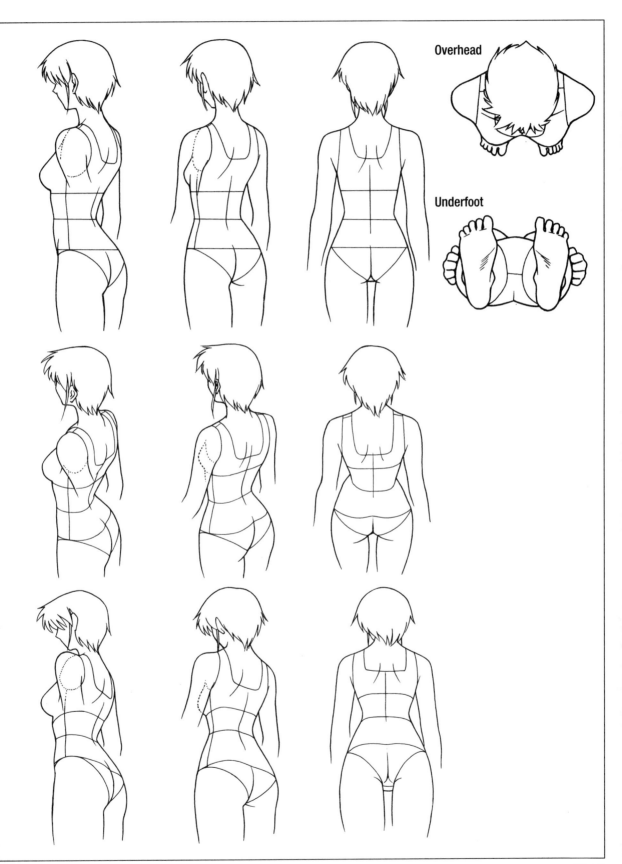

Overhead

Underfoot

Using the Basic Figure Forms

These 4 guidelines: the centerline, Base chest line, waist line, and hip line will assist you in drawing underwear and swimsuits.

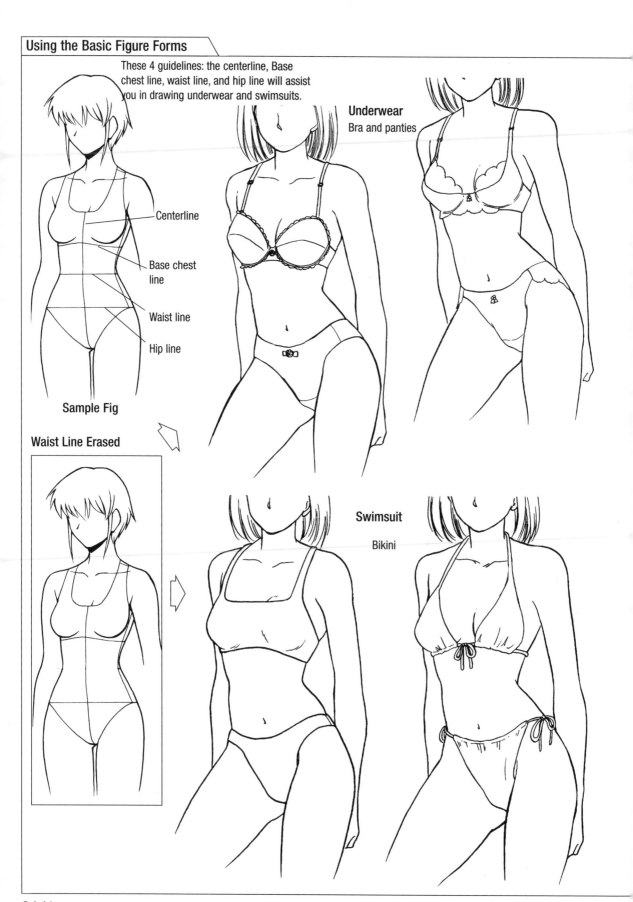

Centerline

Base chest line

Waist line

Hip line

Sample Fig

Waist Line Erased

Underwear
Bra and panties

Swimsuit

Bikini

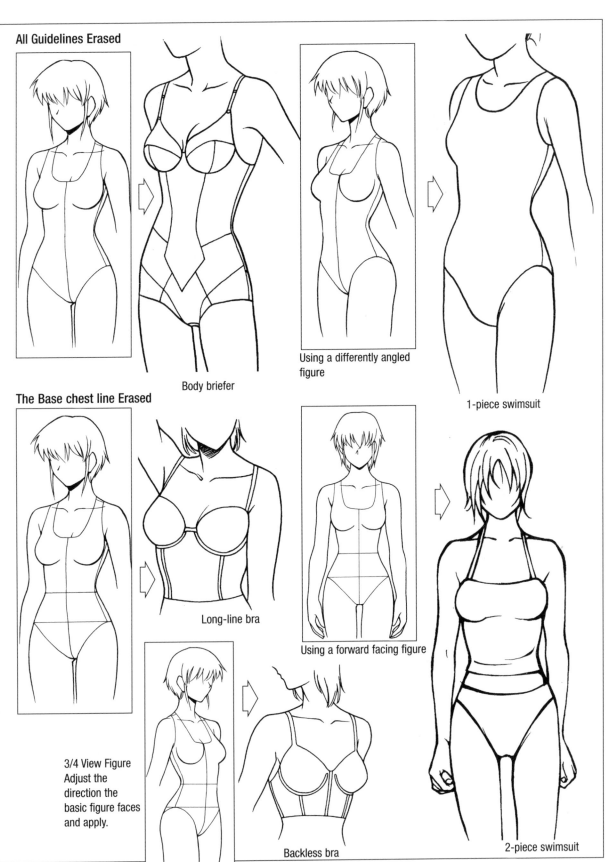

All Guidelines Erased

Body briefer

Using a differently angled figure

1-piece swimsuit

The Base chest line Erased

Long-line bra

Using a forward facing figure

3/4 View Figure
Adjust the direction the basic figure faces and apply.

Backless bra

2-piece swimsuit

Panties from Different Angles

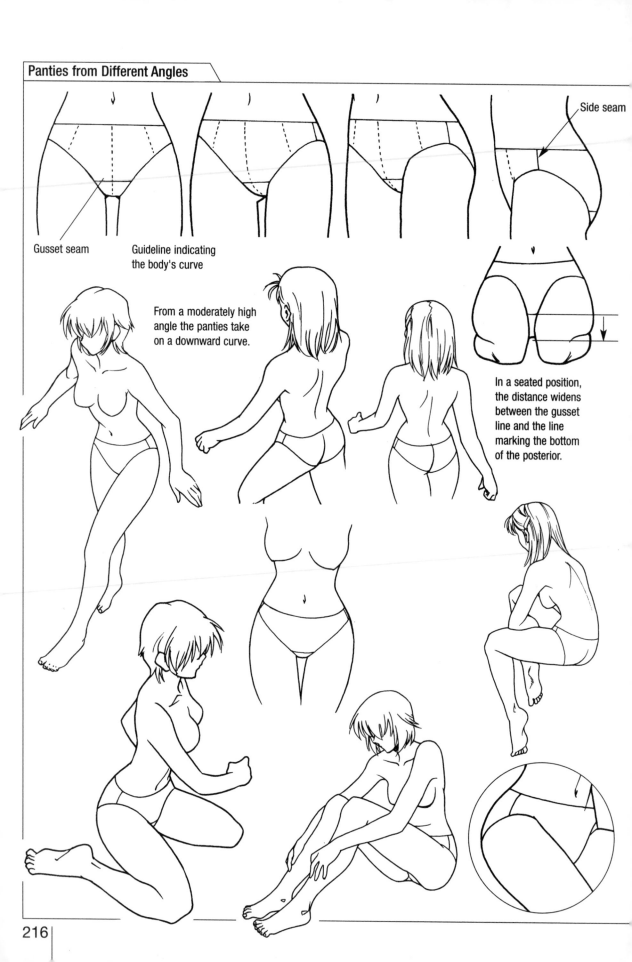

Gusset seam

Guideline indicating the body's curve

Side seam

From a moderately high angle the panties take on a downward curve.

In a seated position, the distance widens between the gusset line and the line marking the bottom of the posterior.

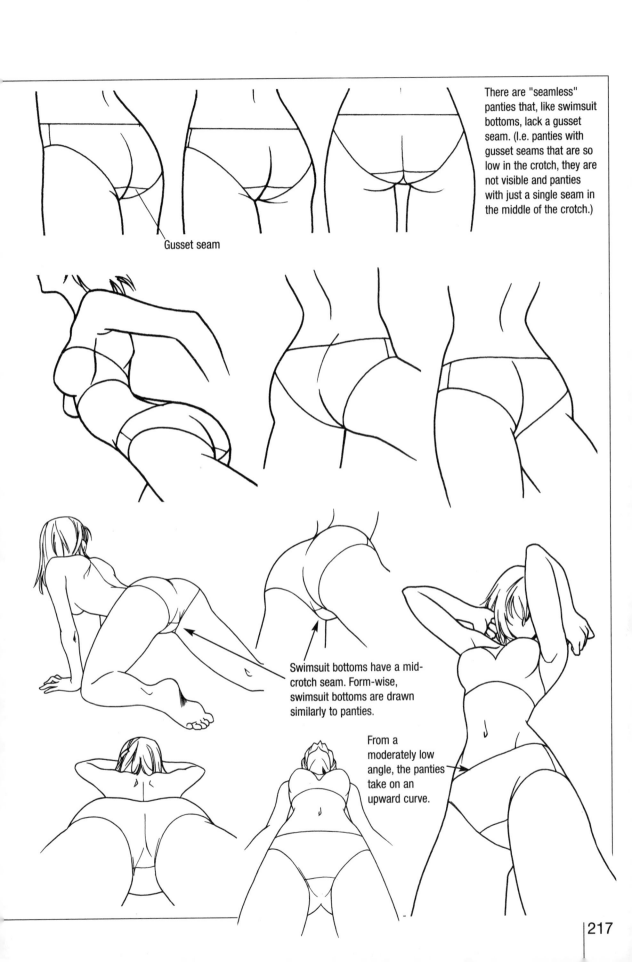

Gusset seam

There are "seamless" panties that, like swimsuit bottoms, lack a gusset seam. (I.e. panties with gusset seams that are so low in the crotch, they are not visible and panties with just a single seam in the middle of the crotch.)

Swimsuit bottoms have a mid-crotch seam. Form-wise, swimsuit bottoms are drawn similarly to panties.

From a moderately low angle, the panties take on an upward curve.

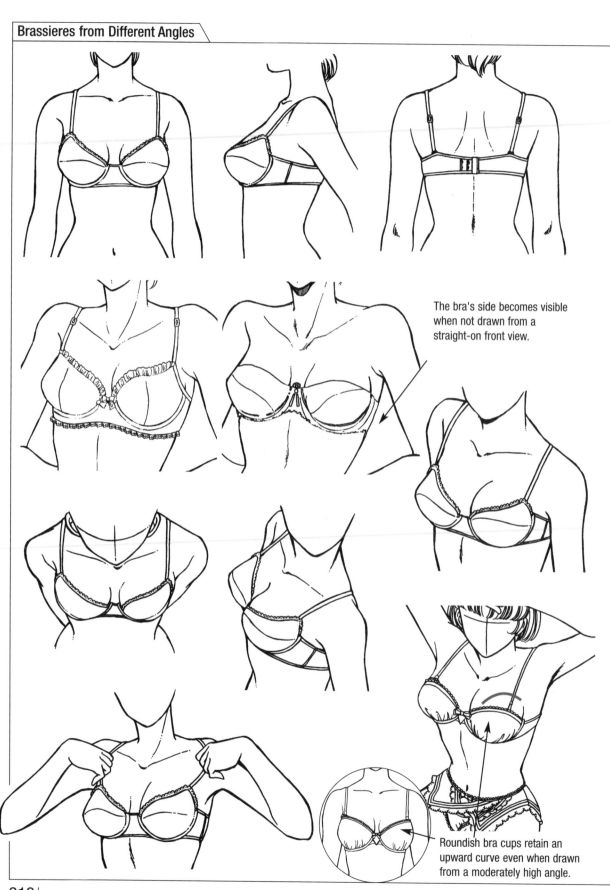

The bra's side becomes visible when not drawn from a straight-on front view.

Roundish bra cups retain an upward curve even when drawn from a moderately high angle.

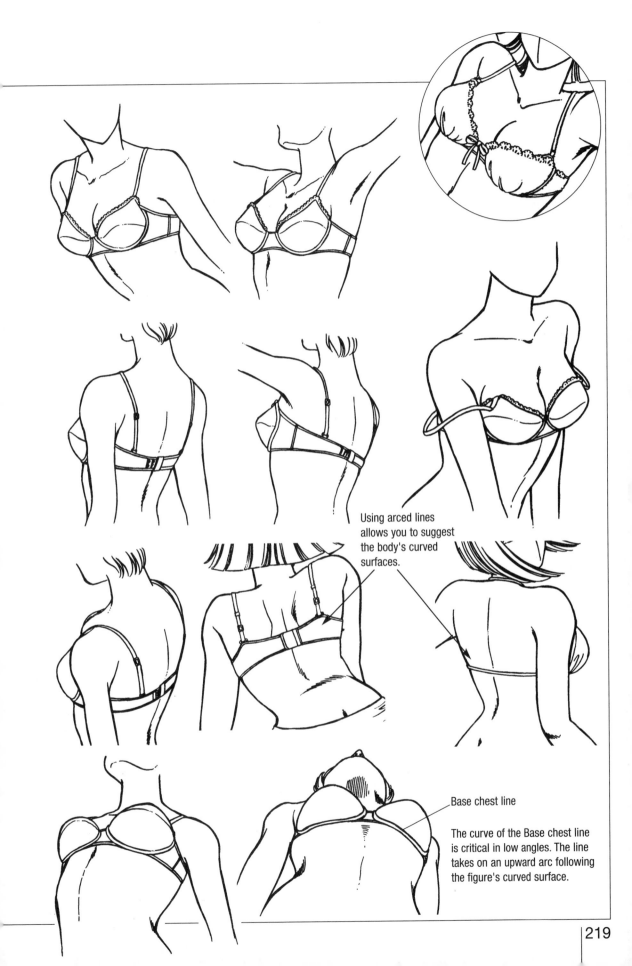

Using arced lines allows you to suggest the body's curved surfaces.

Base chest line

The curve of the Base chest line is critical in low angles. The line takes on an upward arc following the figure's curved surface.

Slips from Different Angles

Angles

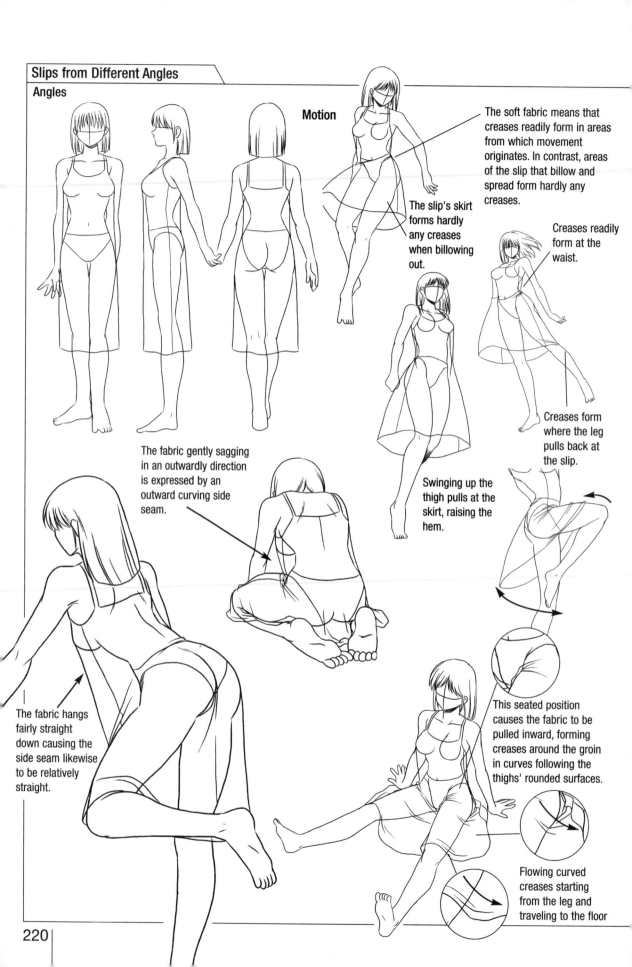

Motion

The soft fabric means that creases readily form in areas from which movement originates. In contrast, areas of the slip that billow and spread form hardly any creases.

The slip's skirt forms hardly any creases when billowing out.

Creases readily form at the waist.

Creases form where the leg pulls back at the slip.

Swinging up the thigh pulls at the skirt, raising the hem.

The fabric gently sagging in an outwardly direction is expressed by an outward curving side seam.

The fabric hangs fairly straight down causing the side seam likewise to be relatively straight.

This seated position causes the fabric to be pulled inward, forming creases around the groin in curves following the thighs' rounded surfaces.

Flowing curved creases starting from the leg and traveling to the floor

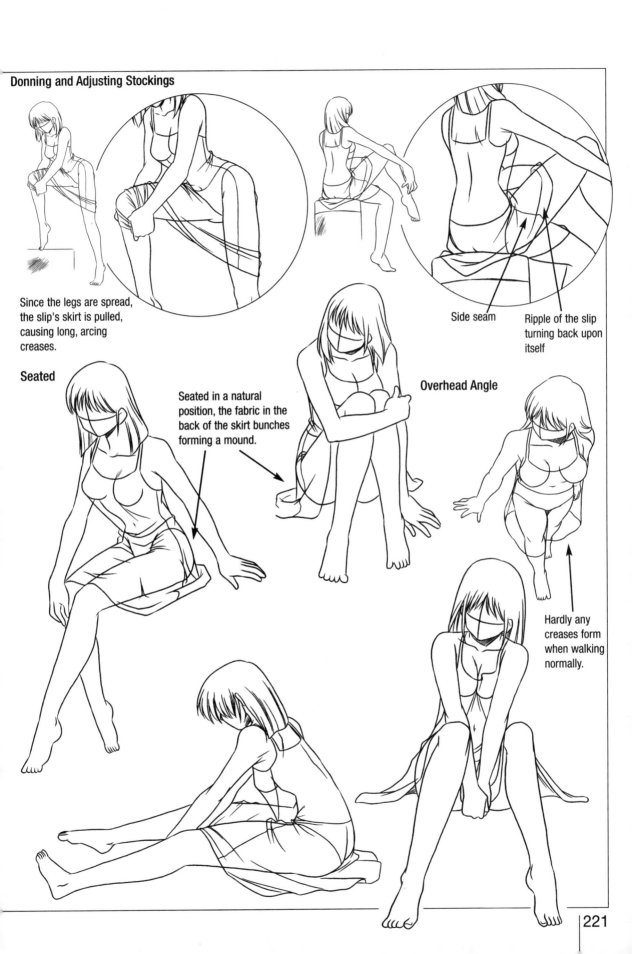

Donning and Adjusting Stockings

Since the legs are spread, the slip's skirt is pulled, causing long, arcing creases.

Side seam

Ripple of the slip turning back upon itself

Seated

Seated in a natural position, the fabric in the back of the skirt bunches forming a mound.

Overhead Angle

Hardly any creases form when walking normally.

Drawing Undergarments I: Brassieres

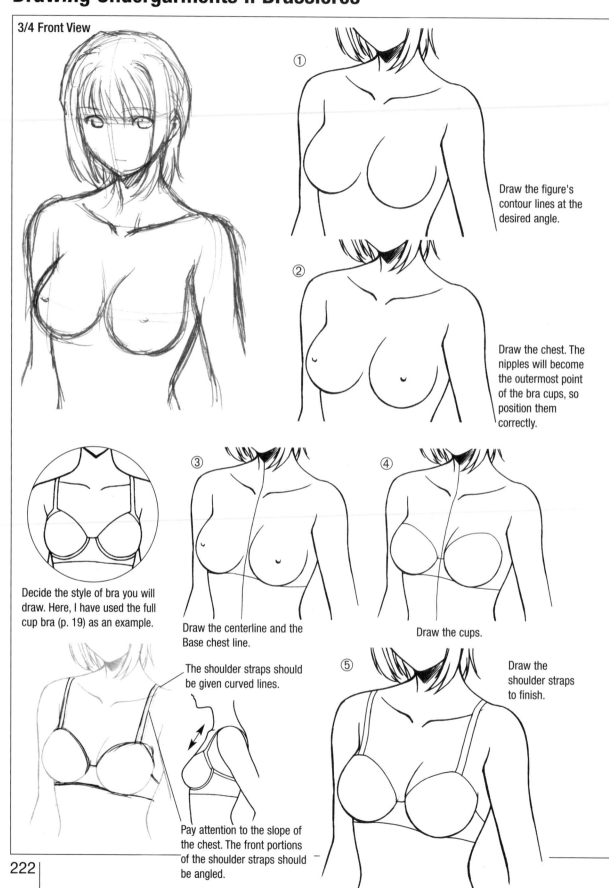

3/4 Front View

① Draw the figure's contour lines at the desired angle.

② Draw the chest. The nipples will become the outermost point of the bra cups, so position them correctly.

Decide the style of bra you will draw. Here, I have used the full cup bra (p. 19) as an example.

③ Draw the centerline and the Base chest line.

④ Draw the cups.

⑤ Draw the shoulder straps to finish.

The shoulder straps should be given curved lines.

Pay attention to the slope of the chest. The front portions of the shoulder straps should be angled.

Sample Finishing Touches

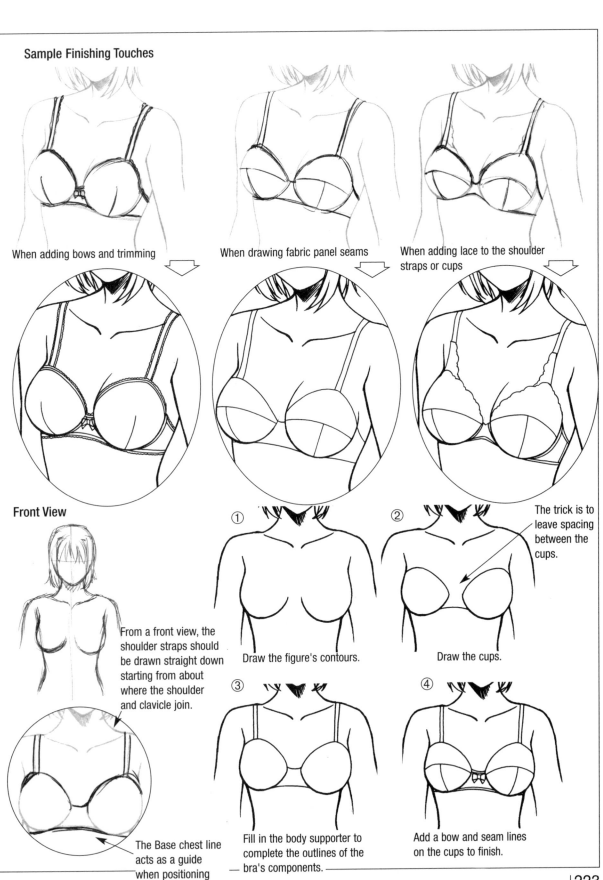

When adding bows and trimming

When drawing fabric panel seams

When adding lace to the shoulder straps or cups

Front View

From a front view, the shoulder straps should be drawn straight down starting from about where the shoulder and clavicle join.

The Base chest line acts as a guide when positioning the bra cups.

The trick is to leave spacing between the cups.

① Draw the figure's contours.

② Draw the cups.

③ Fill in the body supporter to complete the outlines of the bra's components.

④ Add a bow and seam lines on the cups to finish.

223

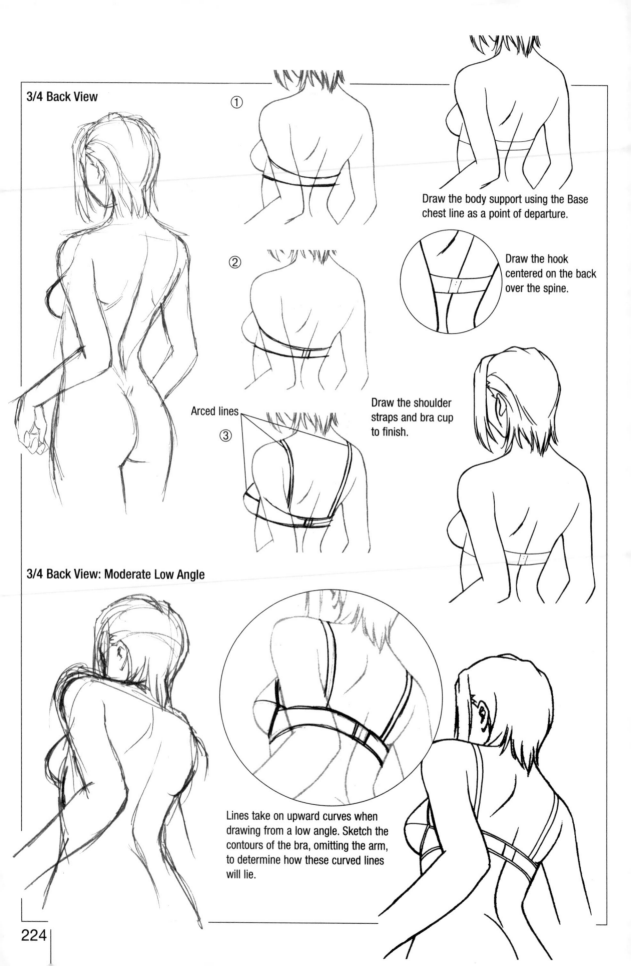

3/4 Back View

①

Draw the body support using the Base chest line as a point of departure.

Draw the hook centered on the back over the spine.

②

Draw the shoulder straps and bra cup to finish.

Arced lines
③

3/4 Back View: Moderate Low Angle

Lines take on upward curves when drawing from a low angle. Sketch the contours of the bra, omitting the arm, to determine how these curved lines will lie.

Drawing Undergarments II: Panties

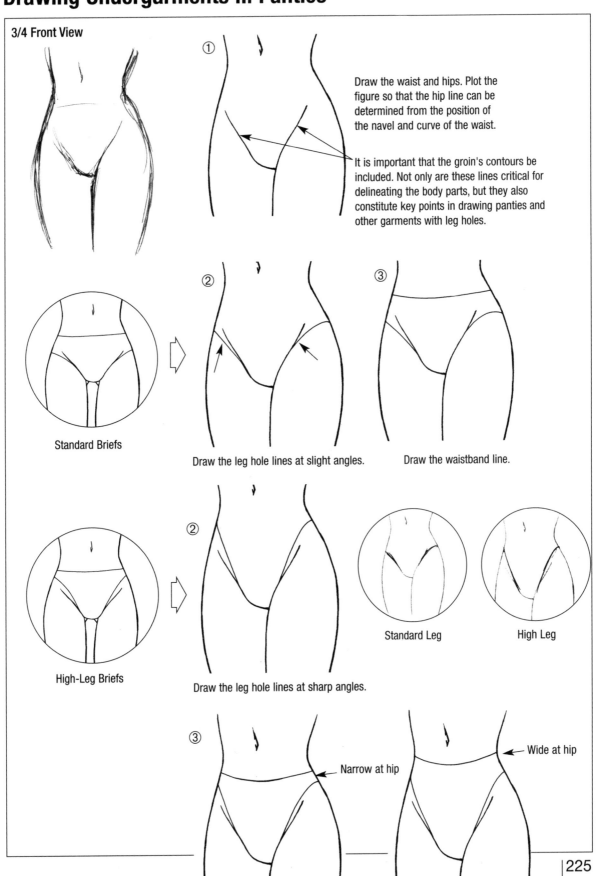

3/4 Front View

① Draw the waist and hips. Plot the figure so that the hip line can be determined from the position of the navel and curve of the waist.

It is important that the groin's contours be included. Not only are these lines critical for delineating the body parts, but they also constitute key points in drawing panties and other garments with leg holes.

Standard Briefs

② Draw the leg hole lines at slight angles.

③ Draw the waistband line.

High-Leg Briefs

② Draw the leg hole lines at sharp angles.

Standard Leg

High Leg

③ Narrow at hip

Wide at hip

Adding Decorative Elements to Panties in 3/4 Front View

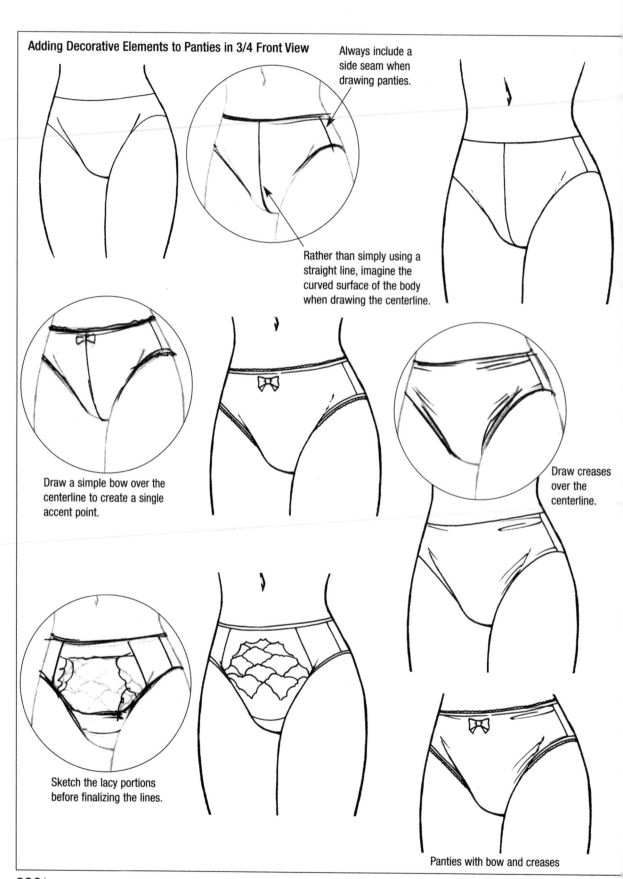

Always include a side seam when drawing panties.

Rather than simply using a straight line, imagine the curved surface of the body when drawing the centerline.

Draw a simple bow over the centerline to create a single accent point.

Draw creases over the centerline.

Sketch the lacy portions before finalizing the lines.

Panties with bow and creases

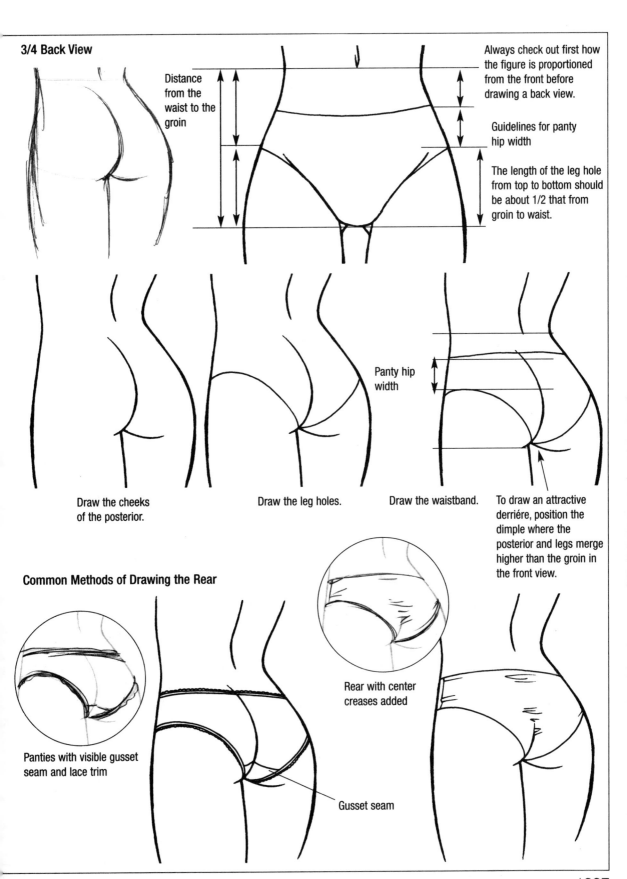

3/4 Back View

Distance from the waist to the groin

Always check out first how the figure is proportioned from the front before drawing a back view.

Guidelines for panty hip width

The length of the leg hole from top to bottom should be about 1/2 that from groin to waist.

Draw the cheeks of the posterior.

Draw the leg holes.

Panty hip width

Draw the waistband.

To draw an attractive derriére, position the dimple where the posterior and legs merge higher than the groin in the front view.

Common Methods of Drawing the Rear

Panties with visible gusset seam and lace trim

Rear with center creases added

Gusset seam

Basic Forms for Drawing Men's Underwear

Briefs and boxers are not normally worn together. However, I drew them together on these pages for your reference. Briefs have a close fit, while in contrast boxers are loose and roomy.

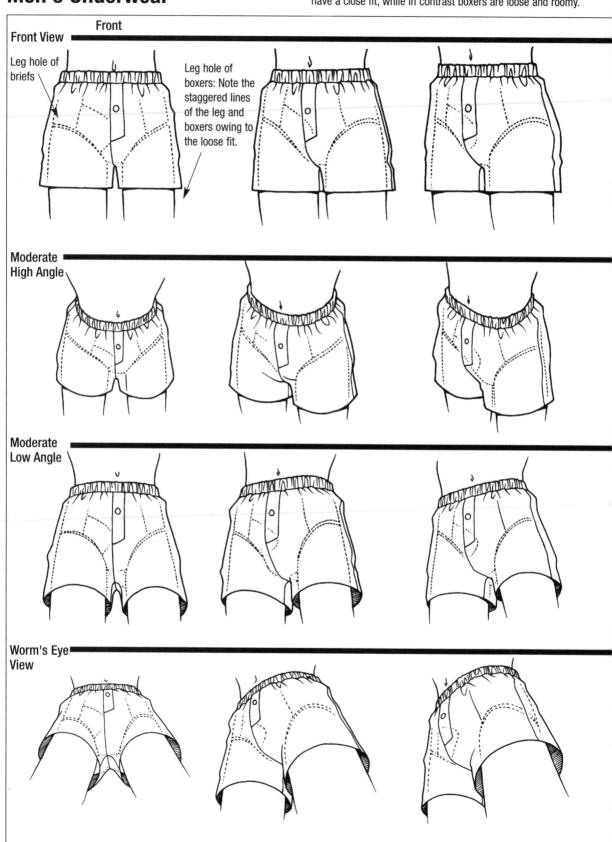

Front View

Front

Leg hole of briefs

Leg hole of boxers: Note the staggered lines of the leg and boxers owing to the loose fit.

Moderate High Angle

Moderate Low Angle

Worm's Eye View

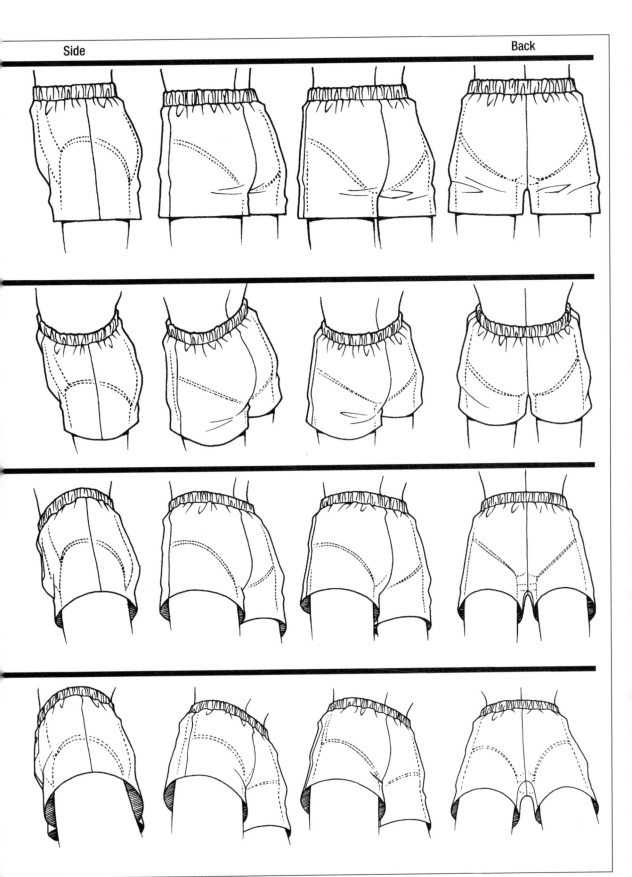

Wearing Boxers

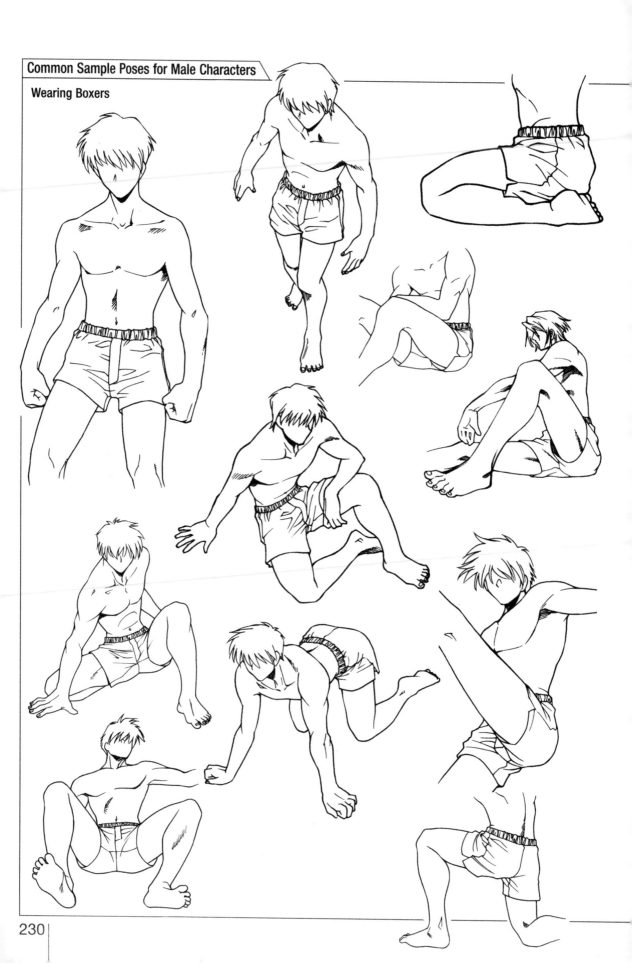

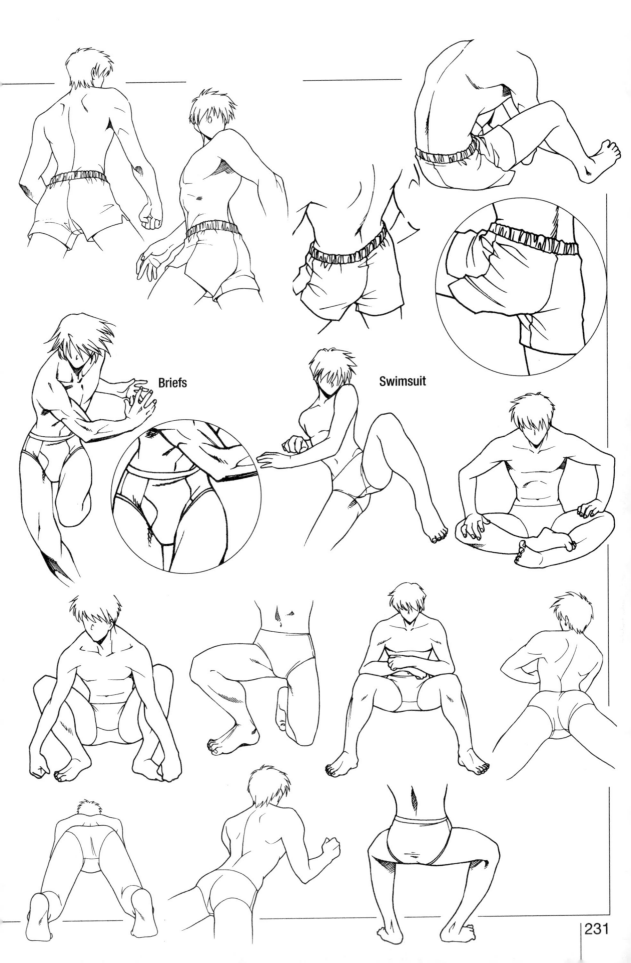

Briefs

Swimsuit

Differences between Underwear and Swimwear

While underwear and swimwear appear quite similar, since they do exhibit differences in seams and hooks (methods of securing), take care when drawing close-ups. Furthermore, underwear tends to be made of thinner fabrics than swimwear, while swimwear has a snugger fit. When using a realistic drawing style, swimwear often takes on a coarser appearance owing to its inherently thicker fabric.

Characteristics of Undergarments

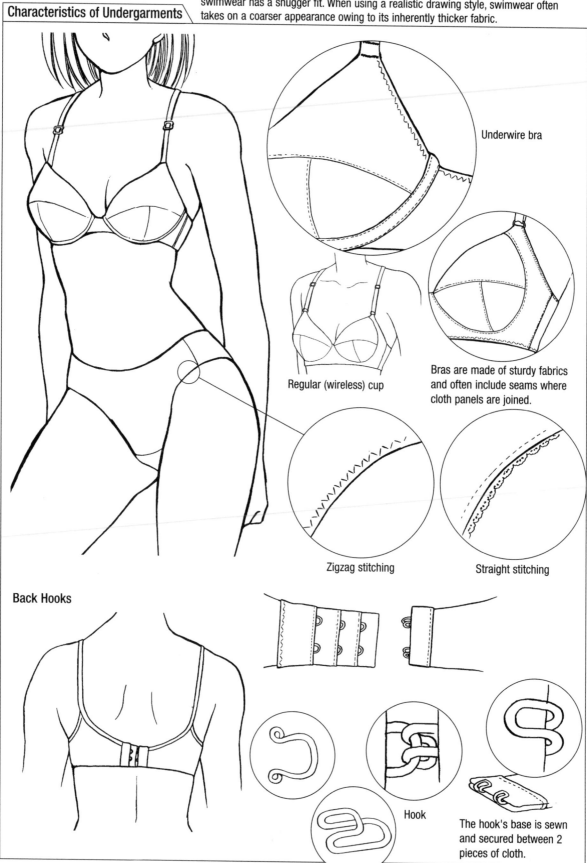

Underwire bra

Regular (wireless) cup

Bras are made of sturdy fabrics and often include seams where cloth panels are joined.

Zigzag stitching

Straight stitching

Back Hooks

Hook

The hook's base is sewn and secured between 2 pieces of cloth.

Front Hooks

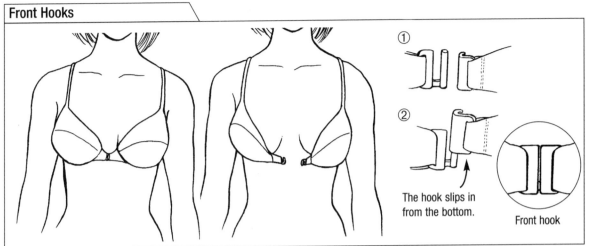

①

② The hook slips in from the bottom.

Front hook

Swimsuits

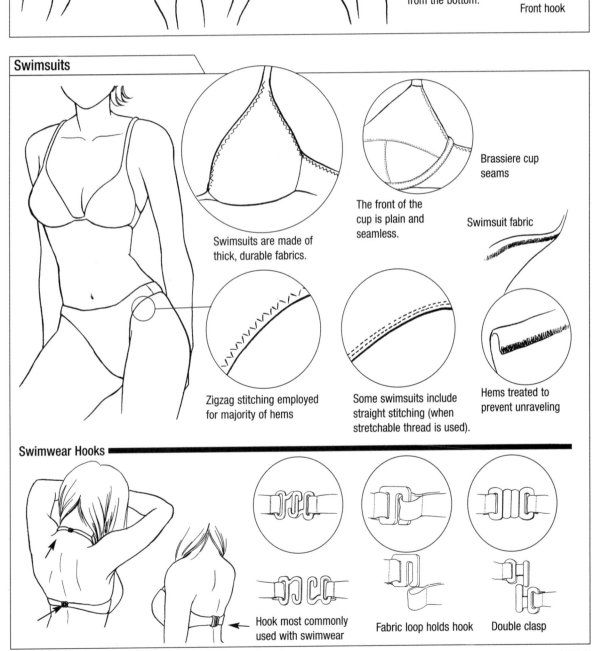

Swimsuits are made of thick, durable fabrics.

The front of the cup is plain and seamless.

Brassiere cup seams

Swimsuit fabric

Zigzag stitching employed for majority of hems

Some swimsuits include straight stitching (when stretchable thread is used).

Hems treated to prevent unraveling

Swimwear Hooks

Hook most commonly used with swimwear

Fabric loop holds hook

Double clasp

Undergarment Structure

Shoulder Straps

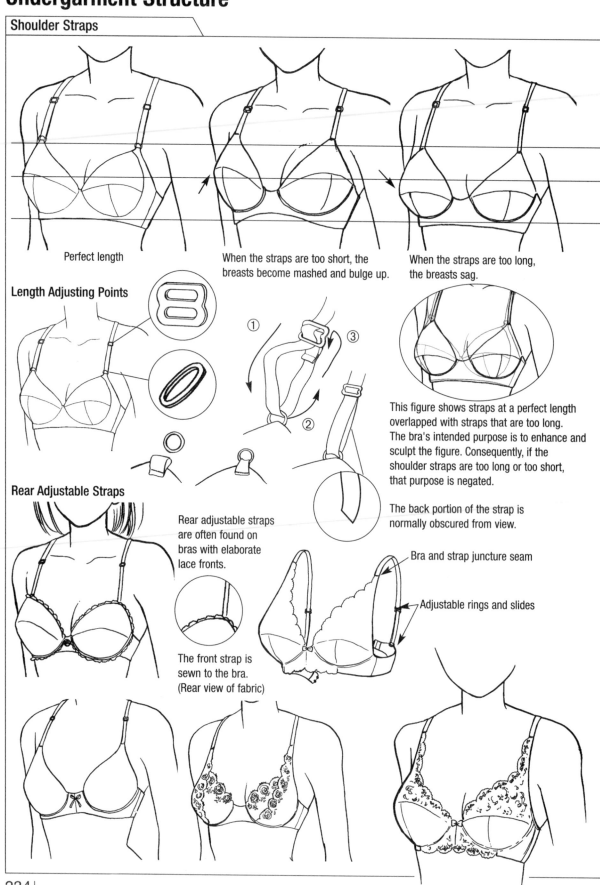

Perfect length

When the straps are too short, the breasts become mashed and bulge up.

When the straps are too long, the breasts sag.

Length Adjusting Points

This figure shows straps at a perfect length overlapped with straps that are too long. The bra's intended purpose is to enhance and sculpt the figure. Consequently, if the shoulder straps are too long or too short, that purpose is negated.

The back portion of the strap is normally obscured from view.

Rear Adjustable Straps

Rear adjustable straps are often found on bras with elaborate lace fronts.

Bra and strap juncture seam

Adjustable rings and slides

The front strap is sewn to the bra. (Rear view of fabric)

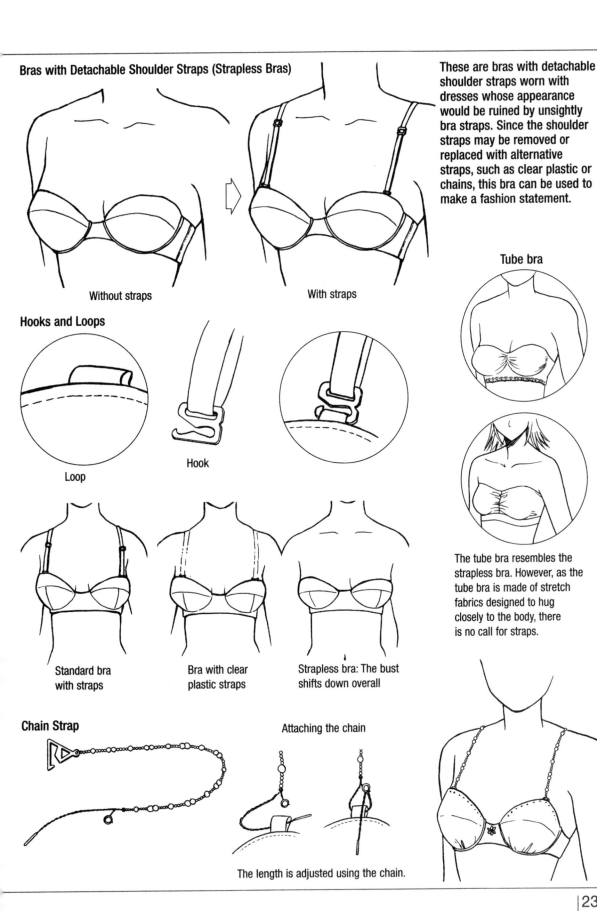

Bras with Detachable Shoulder Straps (Strapless Bras)

Without straps

With straps

These are bras with detachable shoulder straps worn with dresses whose appearance would be ruined by unsightly bra straps. Since the shoulder straps may be removed or replaced with alternative straps, such as clear plastic or chains, this bra can be used to make a fashion statement.

Hooks and Loops

Loop

Hook

Standard bra with straps

Bra with clear plastic straps

Strapless bra: The bust shifts down overall

Tube bra

The tube bra resembles the strapless bra. However, as the tube bra is made of stretch fabrics designed to hug closely to the body, there is no call for straps.

Chain Strap

Attaching the chain

The length is adjusted using the chain.

Structure of Panties

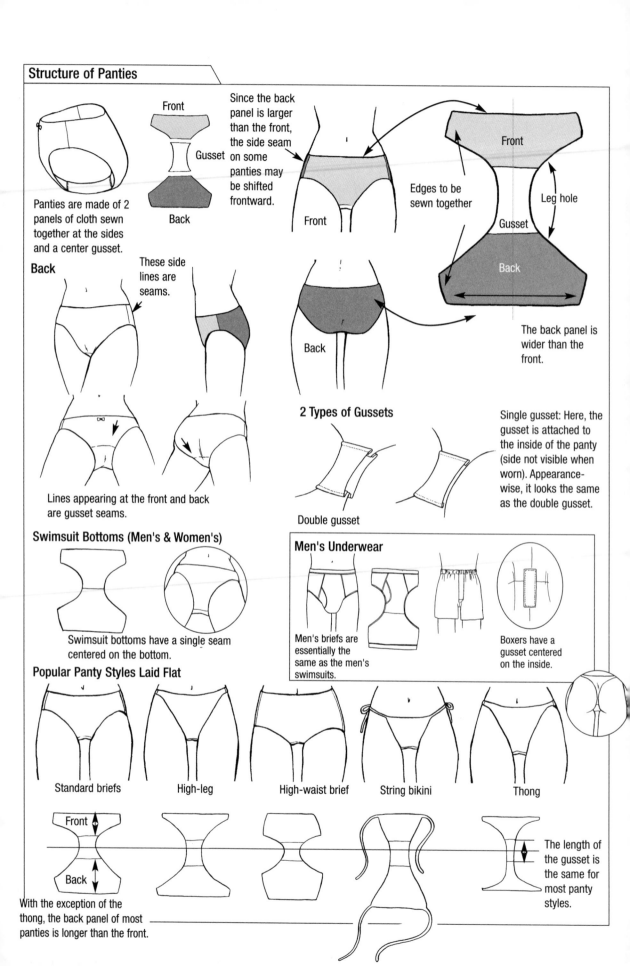

Panties are made of 2 panels of cloth sewn together at the sides and a center gusset.

Front

Gusset

Back

Since the back panel is larger than the front, the side seam on some panties may be shifted frontward.

Front

Edges to be sewn together

Front

Leg hole

Gusset

Back

Back

The back panel is wider than the front.

Back

These side lines are seams.

Lines appearing at the front and back are gusset seams.

2 Types of Gussets

Double gusset

Single gusset: Here, the gusset is attached to the inside of the panty (side not visible when worn). Appearance-wise, it looks the same as the double gusset.

Swimsuit Bottoms (Men's & Women's)

Swimsuit bottoms have a single seam centered on the bottom.

Men's Underwear

Men's briefs are essentially the same as the men's swimsuits.

Boxers have a gusset centered on the inside.

Popular Panty Styles Laid Flat

Standard briefs　High-leg　High-waist brief　String bikini　Thong

Front

Back

The length of the gusset is the same for most panty styles.

With the exception of the thong, the back panel of most panties is longer than the front.

Zigzag Hems

Edging stitched with stretchable thread.

When not worn, the hem puckers.

When worn, the hems stretch removing the puckering and producing a clean zigzag.

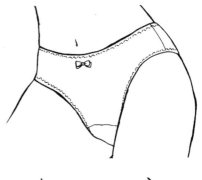

Straight-stitched Hems

Panty with elasticized edging

When not worn, the edging bunches.

When worn, the fabric stretches, revealing clean, straight-stitched hems.

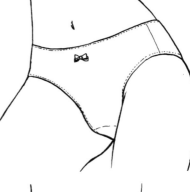

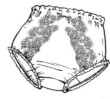

Panty with wide elastic waistband

The edging does not change much in appearance whether worn or not.

Edging stitched with stretch thread reveals a clean, straight stitch when worn.

Lace Panties

Elastic

Lace

Exterior view

Interior view

The leg hole scrunches up.

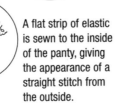

A flat strip of elastic is sewn to the inside of the panty, giving the appearance of a straight stitch from the outside.

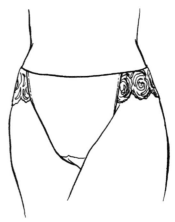

Like elastic, lace is able to stretch.

Exterior view: Leg with wide swath of lace

Swimsuit bottom

For the swimsuit, both the fabric and the stitching stretch (zigzag stitching used for hems).

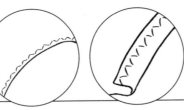

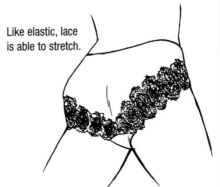

Interior view: The hem is folded over and secured using a zigzag stitch.

Author's Profile

Hikaru Hayashi

1961	Born in Tokyo.
1986	Graduated with a degree in the Social Sciences and Humanities from Tokyo Metropolitan University with a major in Philosophy.
1987	Received a hortative award and honorable mention for his work on Shueisha Inc.'s *Business Jump* and served as assistant to Hajime Furukawa.
1989	Worked on Shueisha's *Shukan Young Jump* while apprenticing under Noriyoshi Inoue.
1992	Published his debut work based on a true story, "Aja Kongu Monogatari" ["The Story of Aja Kongu"] in Bear's Club.
1997	Founded the manga design and production studio, Go office.
1998	Authored *How to Draw Manga: Female Characters*, *How to Draw Manga: Male Characters*, *How to Draw Manga: Couples*, and *How to Draw Manga: Illustrating Battles*.
1999	Authored *How to Draw Manga: Bishoujo around the World*, *How to Draw Manga: Bishoujo/Pretty Girls*, *How to Draw Manga: Occult & Horror*, and *How to Draw Manga: More about Pretty Gals*.
2000	Authored *How to Draw Manga: Animals*
2001	Authored *How to Draw Manga: Giant Robots*, published by Graphic-sha. Ms. Hayashi continues to author and produce publications.

Kimiko Morimoto

1969	Born in Tokyo
1989	Graduated with a degree in Design from the Tokyo Tanaka Chiyoda Fukushoku Senmon Gakko [the Tanaka Chiyoda Fashion Institute of Tokyo], and used her expertise in fashion and skills in manga and illustration to work as an illustrator and to contribute manga artwork for business-related descriptive materials.
2001	Published *My Birthday* and *Puchi Birthday* under Setsuwa Co., Ltd., and *Pichi Lemon* under Gakken Co., Ltd. Today, Ms. Morimoto is active in a wide number of projects, including contributions to Benesse Corporation's Promotional Training Seminar, to Fusan's *Tamago Club* and *Kokko Club*.

HOW TO DRAW MANGA Costume Encyclopedia Series

Costume Encyclopedia Vol. 1
Everyday Fashion
ISBN4-7661-1257-1

Costume Encyclopedia Vol. 2
Intimate Apparel
ISBN4-7661-1433-7

Costume Encyclopedia Vol. 3
Sexy Sports Wear
ISBN4-7661-1434-5

Graphic-sha Publishing Co., Ltd.